# The Youngest Parents

# Robert Coles

*with Robert E. Coles, Daniel A. Coles,*
*and Michael H. Coles*

# The Youngest Parents

*Photographs by Jocelyn Lee and John Moses*

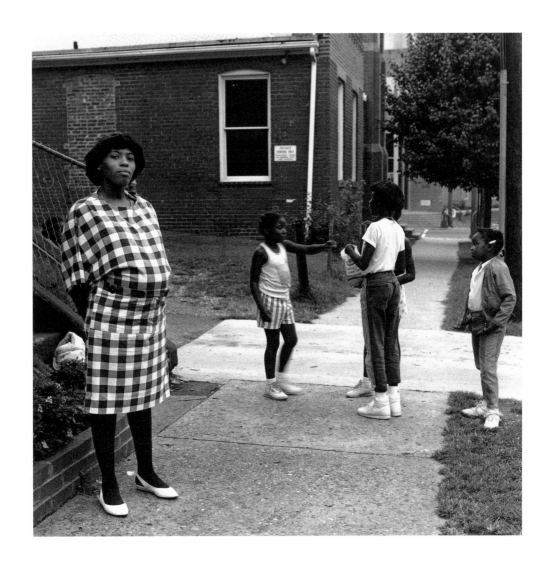

# *Teenage Pregnancy as It Shapes Lives*

*A DoubleTake Book*

*published by the Center for Documentary Studies*

*in association with W. W. Norton & Company*

*New York • London*

*The Youngest Parents:*
*Teenage Pregnancy as It Shapes Lives*
© 1997 by Robert Coles
Photographs © 1997 by Jocelyn Lee
Photographs © 1997 by John Moses

The text of this book is composed in Ehrhardt.
Manufacturing by Tien Wah Press
Book design by Molly Renda
Typesetting by The Marathon Group
Cover photograph by Jocelyn Lee
Frontispiece: Alexandria, Virginia, 1989.
Photograph by John Moses.

*Library of Congress Cataloging-in-Publication Data*
Coles, Robert.
The youngest parents : teenage pregnancy as it
shapes lives / text by Robert Coles : with Robert
E. Coles, Daniel A. Coles, Michael H. Coles :
photographs by John Moses and Jocelyn Lee.
    p.   cm.
"A DoubleTake book."
Includes bibliographical references.

1. Teenage parents—United States—Case studies.
2. Teenage pregnancy—United States—Case
studies.   I. Coles, Robert E.   II. Coles, Daniel A.
III. Coles, Michael H.   IV. Title
HQ 759.64.C85   1997
305.235—dc21
96-47258
ISBN 0-393-04082-8
ISBN 0-393-31996-2 PBK

W. W. Norton & Company, Inc.
500 Fifth Avenue, New York, New York 10110
http://web.wwnorton.com
W. W. Norton & Company, Ltd.
10 Coptic Street, London WC1A 1PU

1 2 3 4 5 6 7 8 9 0

Center for Documentary Studies
at Duke University
1317 West Pettigrew Street
Durham, North Carolina 27705
http://www.duke.edu/doubletake/

To order books, call W. W. Norton at
1-800-233-4830.

*We thank the young men and women who have given their time to us, shared their stories with us, allowed us to learn of them, from them. We dedicate this book to them and to their children.*

# Contents

*Introduction*

In 1986, officers of the Henry Kaiser Foundation in California approached me with a request: would I be interested in talking with teenage girls who are pregnant, in the hope of learning about their lives, their hopes and worries, their attitudes toward their (child-bearing) condition? Yes, I said. Moreover, as the officers knew, I'd already been talking with adolescent youths in Boston, in Baltimore, and in New York City, under the sponsorship of the Joseph P. Kennedy Foundation and the Schumann Foundation, and many of those young people were pregnant (or indeed, mothers already), or were men soon to be (or already) fathers. Some of these youths I'd known as children—boys and girls I'd interviewed in the late 1960s and early 1970s, under the sponsorship of the Ford Foundation. Until I spoke with the officers of the Kaiser Foundation, however, I was not inclined to use pregnancy as a primary lens—a means of looking at how young women and their boyfriends come to terms with their lives. I was, rather, paying attention to a range of other "variables"—class and race, the use of drugs and alcohol, the moral and spiritual values particular parents espoused, directly or by implication. Now I was asked to bear down hard on an aspect of adolescent sexuality—the kind that results in pregnancy; and too, on adolescents as parents, rather than as the older children, the youths I had been considering them to be.

Soon enough, in the late 1980s (1987 through the end of 1990) my sons and I began to talk with teenagers who were pregnant and with their boyfriends, many of them in the neighborhoods of greater Boston, but a good number elsewhere: in Washington, D.C., in North Carolina and West Virginia, in New York City and Baltimore, in California and New Mexico. We wanted to meet young people who were black and white and of Hispanic background; who were city dwellers, or who lived in small towns or rural regions; who were from poor families or who belonged to reasonably well-off families. We knew that teenage pregnancy (not terminated by abortion) is not rare in our ghettoes, and so, much of our work was done there—sustained contact with young men and women for several years. Specifically, one of us (Robert E. Coles) followed, in Washington, D.C., seven pregnant young women and their boyfriends, for two years. They were interviewed weekly during the pregnancy, and monthly after the child was born. The conversations took place in the homes of the young people—who were initially contacted with the help of the community medicine department of Georgetown Medical School. Two of us (Robert Coles and Michael Coles) worked in Boston; we followed a similar line of inquiry, though we kept in touch with the pregnant women and their boyfriends for a longer time (up to four years in a few instances). We followed fifteen young women and fifteen young men intensively. We also occasionally met with groups of women and men in clinics (The Children's Hospital) and schools (Madison Park High School, the Jeremiah Burke High School)—once a month during a school year, or in the course of visits made to a hospital clinic. Our work in the South, in Appalachia, and out west was done by all four of us: visits made to interview particular youths, whom we got to know with the help of schools and hospital clinics. One of us (Daniel Coles) worked as a medical student in California and New Mexico (rotations in pediatrics and obstetrics), and later, as a pediatric resident in North Carolina; another of us (Robert E. Coles) traveled extensively through West Virginia,

while living in Washington and doing the interviews just mentioned. Michael Coles traveled to all of these regions to pursue follow-up interviews with young people who had initially been in touch with his brothers, now his colleagues. Two of us (Robert Coles and Robert E. Coles) did a series of interviews in North Carolina: in Durham with white and black youths, and in Johnston and Sampson Counties with Hispanic youths. All in all, we talked with one hundred and twenty-five young women and men, eighty-four of them for over a year, forty for over two years, eighteen for over three years.

That said, we had a difficult time figuring out what to do with the information we acquired. We did write up some of our work for our medical colleagues;[1] and we did write up some of our thoughts for a more general audience.[2] But we hesitated long and hard before we felt ourselves prepared to come forward with this book, because, frankly, we were searching for an overall perspective, a point of view—we were, after all, four white men, three of us physicians, one a medical student, all of a relatively privileged background, who were the ones trying to decide what we had been told by scores of young women and young men whose prospects, often enough, aren't very promising, and whose assumptions aren't always those we ourselves hold. In 1992, actually, we were ready to put the entire project aside, much to the chagrin of those at the Kaiser Foundation who had helped initiate it. As I looked at the usual mound of typed, tape-recorded interviews, at the journal entries and notes we had accumulated, as I read what others of various political and cultural persuasions had to say, and as I listened to the alarm and perplexity of my medical colleagues, my friends who are ministers and priests to

1. For example: "Children Who Become Parents: A Challenge to Physicians," by R. E. Coles, *Family Medicine*, Vol. 22, No. 1, 1990.

2. In an Introduction to *Before Their Time: Four Generations of Teenage Mothers*, by Joelle Sanders (Harcourt Brace Jovanovich, 1991).

churches located right in the ghettoes of Boston, of Washington, D.C., I began to wonder whether we were the persons to try to sort out the various aspects of this major social (and medical and psychiatric) matter. Who knows, for instance, what we may have missed—not been told, or not noticed, heard, paid heed, given who we were, are!

But I have been returning more recently (from 1993 to 1996) to the neighborhoods in Boston where much of this work was done, and too, have been visiting once again the rural sections of North Carolina—now alongside college students from Harvard and Duke and the University of North Carolina who are trying to be tutors, mentors, to young people very much in need of an educational boost. I have been astonished at the willingness of many adolescent mothers and fathers to talk candidly about their lives to students their age or a little older, to share stories, to give voice to worries or hopes, or that mix of both that so often characterizes anyone's statements about this life. Indeed, I sat with a college student of nineteen, a young white woman of considerable moral energy, who (in 1993) was spending the summer as a mentor to young black women in a poor Boston neighborhood, and watched, listened, as she tried to work with one of those women, teaching English and math to a sixteen-year-old mother of a three-month-old girl. The college student had met the young mother when she was four months along, and kept in touch throughout the pregnancy. After the day's formal tutoring had been done, the young mother asked her teacher about her plans for the coming academic year—and then, about her plans for "after college." The student was shy, embarrassed, reticent. The mother noticed this shift in attitude, in behavior, and became a friendly, bemused critic: "No point in you holding back on me, when you tell me to give the world all I've got." A prolonged silence now prompted a rising apprehension in all of us. I started scrambling in my mind for some harmless comment that would break the ice, but came up with nothing. The college student looked down at the floor. Finally, the young mother spoke again: "There's a lot we don't

know here about what you can do when you're older. We need to know more." The college student now felt free to speak—assented enthusiastically to her student's comment. Then, a reverse—the younger of the two turned self-critical, personal: "I guess we shouldn't hold back; we should tell you a lot, so you'll know about us, just like we need to know about you."

Soon these two women were sharing some thoughts, experiences, expectations—a quick flow of conversation. As I sat and listened, I thought of the various young women somewhat like her I'd come to know: youths pregnant while in junior high school or high school; youths already mothers at, say, fifteen or seventeen, and no longer in school; youths trying hard to take care of babies, so often with no help, emotional or financial, from the fathers of those babies. I still wondered how to do justice to the lives of these young women, but I kept the words, the plea, really, of that young woman in mind as I picked up, yet again, transcripts and notes and some preliminary pages of writing. Still, I wasn't sure where to go with the above relics, as it were, of a research project, until I met one evening with a group of physicians and nurses, youth workers and social workers, ministers and teachers, who, day in, day out, try to connect with, be of help to, those who live in a Boston ghetto. They were talking about the psychological and social and moral struggles of the young people with whom they work. They also were talking, rather grimly, about the disappointments they have experienced in the course of their efforts—the women and men with whom they failed to connect, whom they failed to understand in important ways, no matter the effort. I had no hope that any research would remedy such a response. The issue, I thought, was not a lack of knowledge, but the felt exhaustion that accompanies a certain kind of utterly demanding, and often exasperating work. On the other hand, one of the doctors did say this: "I think I know how to help some of these kids. I try to teach them how to take care of themselves, and the babies they're carrying. But they are *kids*, and a lot of the time,

I feel I'm missing something—they're not telling me what's on their minds. Maybe they don't really know—I mean, what's giving them trouble. A lot of them *are* in trouble—and so am I, because I'm trying to figure out what to do (how to be of help) and the kids won't level with me, because they can't seem to level with themselves."

We all pondered that brief communication a minute or so without saying a word. I did so by going back in my thoughts to moments with such "kids," times when I was trying with all my might to comprehend a particular youth's purposes, aspirations, apprehensions, only to surrender before shrugged shoulders, averted eyes, utter silence, a glare or a sardonic smile, or talk all right, but hardly the kind meant to clarify matters. Under the circumstances, because I was trained in psychoanalytic child psychiatry, I summoned to mind words such as "evasive"—when, I slowly began to realize, the "kid" in question was not running away from me and my questions, but from the notion I had that such a line of inquiry made any difference. One "girl" of fourteen, already on the way toward motherhood, told me this: "I wish I could answer you—tell you what you're looking to know. Then you'd be successful with your research." I'd never before heard things put quite like that: a reminder to me that I had a future of success around the corner, but as for her—that was another matter. What she had to say, to learn from what she had to say, would help only her listener.

I ended up talking about that fourteen-year-old girl, and as I did, I realized that all the medical information I'd acquired—including the family history, the psychological history—came down to that moment, a conviction on her part that the word "success" belonged to others. Yet, she considered her baby, still inside her, as quite possibly one of those "others." He or she would grow up and be "different." He or she would "escape." When I asked for the object of that verb's action, I heard one word: "everything." When I asked for an instance, an example, I heard the word "everything" used again—now with a look sent my way, along

with a polite refusal to spell out any details. It was as if I was being told this: mister, if it all isn't obvious to you, by now, then I sure do feel sorry for you; and if it *is* obvious, but you want me to say the obvious—then I feel sorry for you on that account, too. Nevertheless, she was patting her stomach, thinking of "escape" for the child within, even as "everything" pointed in the other direction for her—no exit.

I ought to have asked her to spell out for me the various forms of liberation or deliverance that came to her mind, the scenarios that she entertained in her mind for that child yet to be born. But I was too slow on the draw; I was too preoccupied with figuring out the nature of her various "problems," and so I failed to ask about the specific hopes she entertained for the child who would, soon enough, be hers to feed, clothe, see through thousands of days and nights. A short year later she was far less affirmative about the child she had delivered, to the point that she urgently wanted her mother to quit her job, take care of the granddaughter, so she herself could go find her own kind of job: "I'd like to be a model, if I could trim myself down, but I know it'll be hard, and I might not get any job, I realize that, and the same could be for my little one, too, when she's grown." That story, all of us sitting in the room began to feel, needed consideration: the girl's initial hopes, the shift in her sense of things, told of changes in expectation many others also experienced. We agreed to go through our memories, share certain moments—hence the writing of parts of this book, meant initially to offer a contribution to a discussion in a seminar held not in a university building, or hospital clinic, but the basement of a ghetto church. The more we talked together, the more we wanted to focus our discussions on stories particular young men and women had to tell—and only thereafter, with them as guides of sorts, move to larger statements, conclusions. The more I talked, the more I would learn by hearing the response of others to what I had to say—men and women who, as mentioned, brought a different perspective (of race, of class, of occupation) to the table: teachers,

members of the clergy, social workers and youth workers, nurses. A ghetto seminar revived a flagging academic exercise.

Right off, I ask the reader's patience, as the narrative that follows winds its way through facts, assertions, surmises; through descriptions and self-descriptions, interpretations and self-interpretations: an observer trying to enlist the assistance of certain others as he explores a certain terrain—yet parting company with them from time to time, in order to go solo with information, with ideas, which have been offered or prompted by those others, but which get assembled at that remove known as the writer's struggle for coherence. But a coherence that insists on an un-qualified point of view, on consistency at all costs, will, I fear, quickly earn the well-known Emersonian condemnation. It is, certainly, foolish to let go of the many sides of an exceedingly complex matter; and a book that relies upon documentary presentation as well as psychological inter-pretation, had best let any number of contradictions, ironies, paradoxes have on paper the considerable life they assert (even enjoy) in various lives. "I'm really upset by this [her pregnancy]," a girl not yet sixteen told me, only to add: "I'm excited by all this, and I'm glad in a way it's happened." Then, a further chain of thoughts: "Sometimes a big cloud crosses the sun, and I get really nervous, and everything gets worse in my mind—I think I've got myself into a big trap, and the baby coming with me, too, and we'll never be able to get out. We'll just sit and count the days, but we won't be counting in some direction." A silence—after which she asked: "Do you see?" A nod from her listener, earnestly meant. But she had, in fact, been addressing herself as well as him, as she made clear with this terse, almost sardonic comment: "It's good you do, but a lot of the time I don't—I just can't figure out what I'm thinking! I go back and forth a lot about things. I'm here one minute and over there the next!"

Nor have we (who worked at making this book possible) tried to be the ones who will turn the zig and zag of lives such as hers into a linear road,

from precisely "here" to precisely "there." My sons and I have hoped to do justice to a particular aspect of "human actuality" (to call upon a phrase used by James Agee in *Let Us Now Praise Famous Men*)—hoped, that is, to be faithful students of these "youngest parents." I have sifted and sorted my way through years of work in an effort to get near that elusive "heart of the matter." So with John Moses, a North Carolina pediatrician and photographer, and Jocelyn Lee, a photographer; their visual inquiries are meant to provide further witness—to help us all *see*, as well as learn through reaching for words spoken, words summoned in reflection. The challenge, as always in documentary work, and in medical work as well, is that of complexity—how to convey it adequately: the psychological ups and downs, shifts and turns of these lives, the moral struggles, the special difficulties, but also the overall experience or context of pregnancy itself as it takes on various meanings for all of us, rich and poor, black and white, men and women, those in their twenties and thirties and forties as well as those in their adolescent years. We can only hope that this book renders adequately and justly that complexity, provides that context—gives those who come upon these narrative explorations, through language and photographs, a concrete, instructive, suggestive sense of who these young parents are, what hopes and worries, assumptions, and values inform their lives. Though this book, obviously, calls upon a "research project," initiated and realized mainly as a medical effort (how to understand certain young women and their boyfriends, and how to understand, especially, the way they regard and care for their babies, yet to be born or already born), and though we have reported some of our "findings" in the medical literature, we are here summoning the documentary tradition, hoping thereby to offer—as an obstetrician and pediatrician who practiced in New Jersey earlier in this century, Dr. William Carlos Williams, put it—"a sense of things, a sense of how it goes (and why) for some folks."

Needless to say, this book is a consequence, through and through, of

the young men and women whose words and pictures appear in it—and of the two photographers who got to know them, not to mention the three young men, my sons, who enabled me to meet those individuals, and who earned their confidence, and as it were, handed them along to me, someone much their senior. That image of "handing one another along," summoned by the novelist Walker Percy in the closing moments of *The Moviegoer,* gets close to the spirit of this effort, its "methodology," but also, of course, to its subject matter: life offering yet additional life to this world of ours, with all the attendant reasons for hope and worry, both.

# I. *Watching*

We stand there talking: Charles, who can't bear to be called Charlie, Vernon, who wanted to be addressed as V.J. (for Vernon, Jr.), and James, who dismisses out of hand the Jims of this world ("They be too many of them, that let themselves get called that"). All three are tall: six-foot-one Charles, six-foot-three V.J., and James a towering six feet four inches. I look up to them constantly as I talk, stretch all of my five feet eleven inches, and this late afternoon James calls that humble, striving posture to my attention: "You mind being short?" He smiles afterward, even as I realize (my mind's inclination, if not reflex) that we had just been talking about James's favorite uncle, only five years his senior, who had lost his job because a company had closed an office. "He's down, he's real down," James had told us— and then a sneer at those who put themselves in such a position of vulnerability: "It's best to make your own deals, and not be there for 'the man' to kick you one, if he wants." I had begun registering sadness on my face (for the uncle's bad luck) when I heard that remark and realized its implications: deal drugs, be an entrepreneur—and violate the law. I was now saddened in another way: I was now struggling to control my moral alarm, my disagreement with what I'd heard; and in some way my

silence was not a successful camouflage. James saw something in my eyes, maybe, that prompted him to tell me, through his question, that at five feet eleven I was a shrimp—that I, too, had constraints imposed on me, unyielding ones. For a second I feel annoyance, note to myself that the facts of genetics (one's height) are not to be equated with the facts of economics (the market's variability). After all, one can always seek another job, but the number of inches granted you is not a matter subject to one's will. Immediately, however, I'm trying to appear concerned, sympathetic—though I have no doubt that James and his two friends realize, in their own way, what has crossed my mind.

I try to steer us toward the subject at hand (for me, that is!). I try to get us talking about family life, about the kind of person each of them likes, and why. I ask about what matters to them, and why—I do so casually (so I hope), but I notice a look of bemused awareness in those three sets of eyes: oh yes, you, we're sure onto that shift of gears. But these are, finally, courteous gentlemen: they are willing to walk over to a bench in a nearby city playground and talk, yet again, about their lives, their loves, their longings.

"I don't know if I'll ever want to be married," Charles declares with considerable defiance—enough of it to prompt an adversarial retort, maybe a psychotherapeutic one, too (I begin to realize) from V.J., and less so, from James. They want to know why their friend would want to turn his back, in the long run, on a union that is blessed by church and state alike. After all, there comes a time when one tires of "the same old thing." That expression signals me to speak—ask for particulars, for definitions. Charles laughs, tosses my question back at me: "What do *you* mean?" I amplify, remind him why I'm there—to learn about how young men and women "get along." He has noticed my constant summons of that not especially precise inquiry, its elusive nature exactly suited to my hope that these three youths (as I sometimes, but only sometimes, thought of them), two of them sixteen, James seventeen, would themselves shoulder

the burden of our exchanges, tell me what is important to them, what counts.

That last word figured prominently in our talks. "What counts for me, when I meet a girl—it's her attitude," James declares. A pause—but before I could muster a question meant to clarify, an implied rebuke is sent my way: "Man, you're never satisfied!" Smiles all around, especially from the nervous, unsatisfied one. Pity then takes over, and too, the urge to tell of oneself that so significantly characterizes our humanity: "Well, I guess if someone's hungry—you should give him something to eat. Of course, if you're going through bad luck yourself, you've got yourself a problem. The same with sex! I know that. My grandma, she says, give to folks, when they've fallen down—help pick them up. But man, what if you're on the floor yourself, and there's nobody running to give anything to you, not a cup of coffee, and not a hand, so you can lift yourself up! So, you have to think of the girl—if she's had something bad happen in her life. But you have to think of yourself, too."

He stops now to catch his breath—as if he has been knocked for a loop himself, and needs a moment to recover, get himself walking again. His two friends recognize that to be the case—silently, unselfconsciously tilt bodily just a slight bit toward him, a gesture of solidarity, of shared understanding I will remember as much as the words that occasioned it. Then, the resumption of exposition—a response, I would only much later realize (from the vantage point of another world) to an essentially moral question: "Your girlfriend—if she's going to be [that]—should be ready to walk with you; it doesn't make any difference where: if you're going there, then she should want to be by your side. You know what I mean—stand by you, stand up for you? A lot of folks, they be ready to jump on guys—they say we're only out for ourselves, and we only want one thing, it's sex, that's all, and then we smile and go away, until the next time. They say we don't care (we don't care nothing) for them. Not so, that's not true, no sir! I tell you why—I tell you! I stand up for some-

one I lie down with; I do—and if I don't, I *should,* and if I didn't, there's got to be a reason, and that means something happened that got in my way, [to] prevent me from being the kind of friend I should have been to this girl. You see what I'm trying to say? You see, if you take something from someone, a person, then you owe something back, you do, and that's the bottom line, it truly is."

Some further thoughts, maybe some second thoughts or misgivings, seem to rise in him—his face registers perplexity, even as he scratches his head; and his two friends are quick to notice. "I agree with you, man," V.J. says, and he quickly explains what it is that elicits his assent, what strikes him as true: "If you become someone's partner—if it's a girl, and you've 'done it'—then that means a lot. People say, the guy, he'll just get dressed and walk away. Not true! He'll get dressed and walk away, but his girl, she's in his head! People say, no—she's out of his head, fast as he's out of her. No way! He'll be walking, and he remembers. I talk with guys, I hear [them]—they won't tell their girls what they're thinking, but their heads, they're full of stuff. Now, it's a street going in both directions, and a lot of the time, the girl will turn away before the guy. She'll be getting dressed and walking—even if he's still lying there in bed. She'll have someone else on her mind but him. Who? [I had, of course, asked.] I'll give you one guess. [A longer than expected silence ensued.] Man, you're slow on the draw today! The baby! That's what gets in the way—that's what will get your trouble going. The guy, he's not prepared. The girl, that's *all* she's wanting, all—all right it's what she *most* wants, more than the fun of it the guy is wanting."

Nods from his two buddies, and faces that tell of memories that inform that agreement. Soon names of young women are mentioned, and with them, stories get told, as if we are in a courtroom, and accusations have been made, and now must be challenged, proven false. I listen; I try to signal an intent to understand, if not agree; but I'm not convinced by what I hear—even as I convince myself that I have convinced those three

men that I'm at a minimum interested, much so, in their remarks, their considerable effort at persuasion. Finally, a break in our collective, relatively quiet narrative: a string of epithets shouted by Charles, who has spoken the least, mostly shook his head or moved it up and down or filled in sentences when one of his buddies found himself at a loss for words. After the exclamations, Charles once again clams up; but James offers a subdued philosophical commentary on young sex, its immediate, inviting pleasures, its soon enough vicissitudes: "With a girl, at first, you think you've discovered the United States of America, and it's you and her, and no one else is there. You're sparked, and she seems to be running with you, and there's nothing in the way—just the best time you can have. Then you discover that it's not so simple—the Indians, they're watching you. That's the truth!"

A pause—time for me to wonder about who those "Indians" are, and what they have in mind to do. James knows me by now, resumes his metaphorical journey by addressing my unexpressed inquiry: "I'll tell you who they are—her mother, mostly: she wants her daughter to show something for what she's put out! Then, there's the girl—she's turned into someone else, while she's doing her 'turning' with you! See what I mean? See, she's thinking 'baby' already, and you two have just got started. She's thinking that the fun for you is one thing, and the fun for her, it's different: minutes for you, and months for her, that's it. The Indians come out of hiding, and before you know it, you're looking at staying right where you are, and not trying to go traveling all over the place in this new country!"

He laughs about his history teacher, and her classroom lectures—little does she know how attentive he is to them, to their symbolic possibilities. I hear an extended riff on her from James, down the line, as we continue talking about what he generically calls the "different agendas of boys and girls." When I prod a bit, correct him by saying "men and women," he refuses the mix of compliment and criticism intended: "No

matter how old you be, there's a boy in you, and a girl." I am hardly entitled to disagree with such an assertion, whose essence is quite compatible with what Sigmund Freud gradually discovered almost a hundred years ago. Nor do James's observations of his teacher seem out of line—indeed, I note how carefully he glimpses, really, the emotional and moral drift of a particular classroom, even as he pays little heed to its intellectual details or overall substance: "She's teaching, mostly, the girls. She's given up on us, mostly. I guess she reads the writing on the walls—we've given up on her! When she starts with those presidents and the wars, I'm out of the school, thinking of who's running the show near my home. She always calls on the girls, and if they give the right answer, she's even more stuck on herself than before, and if they give the wrong answer, she coughs, that's how you know, and then she makes excuses for them. With a guy, she's ready to go shout 'Police!' whatever we say! She's always talking about our 'future children' in a 'few years'—see what I mean? She's talking to the girls—it's like she's decided they're going to have those kids pretty soon, and it's all our fault, but the girls can save the world, by being good mothers. She means good teachers. 'You can teach your little ones history at home, if you learn it here, so they'll have a real head start'—that's what she'll say, and we're supposed to stand up and clap and call her the smartest one till kingdom come!

"She has the girls in front of her, near, and us in the back, and she's scared of us, you can tell, but every once in a while she'll give one of us a look—I mean, a look-over!—just for a second, and then you know she's not only some bookworm! But most of the time she's giving us these lectures, about 'the fifty states that make up the United States,' and how they all got together, and they live in peace. Then she says we should all live in peace, too—and no shooting, and no drugs, and she's looking at us in the back of the room. I want to stand up and say we're being accused, and where's the evidence! The same with your girlfriend, when she gets pregnant: it's all your fault! If she was a better teacher [I

had asked for his suggestions in that regard] she'd stop telling us everything worked out the greatest in America, so it should likewise hereabouts. Hey, all the bad things you hear, in that class: the way this country went after the Indians—just killed them off; and after us, our people. I laugh, listening to her give us this song and dance about 'the United States,' and we should be good like it is. I'd like to see the history book that tells it like it is, and lets you know how it was, back then; and I'd like for our teacher to be fair about us, so the girls don't always get the nod, and the boys the no, no, no! That's the big problem, the way everyone is trigger-happy about us [boys], and with the girls, you're supposed to think every one of them is an angel who's been sent down here by God Almighty—except they're having these kids, and that's not what angels are supposed to do!"

The three men laugh bitterly at what one of them has said; and so doing, remove themselves a bit from our conversational flow. There is a sticky silence now—it won't yield to talk, even small talk. The smiles are gone from the faces. These three men are glowering, I decide; they are also shifting from foot to foot, scratching their heads or their necks or their shoulders, and finally, I notice, their lower abdominal area. What am I being shown, told, the ever self-conscious observer wonders—an uncoordinated dance of sorts, the movements not simultaneous, but in all three cases, from top downward. An unconscious act of solidarity, I surmise. Saying what? Scratching the head in perplexity—and just above the groin as a declaration of what the subject matter is? Maybe my thoughts tell me a lot about my own mind and no one else's, I speculate—and then, a comment of James's, turned into a question, leaves my mouth: "Isn't what you said about 'everyone,' that *they're* 'trigger-happy' about you guys, always ready to be on your case—isn't that what *they* say, that *you* guys are 'trigger-happy'?"

I'm surprised at myself. I start wondering what prompted that not-so-friendly question, that not-so-implicit rush to judgment. The three guys

laugh heartily, though—James, especially. He picks up right away on my eager, if not facile use of his language, the listening physician at work: "You got me!" A second's wait, then "doc," a word he only occasionally used. I am almost going to apologize for being smug, too clever by half, as the saying goes. But James and V.J. and Charles aren't offended—only amused, and on to me, the direction of my mind, as Charles (speaking openly, unguardedly at last) decides to let me know: "I guess you think we're fast on the trigger, but then we walk away cold—like all the folks do. I can understand! You see some guys, they don't care much for their girls, especially after they're pregnant, or getting bigger by the day—the week it is. But this here be a two-way street, man, it sure is! I know! I was with Louise, and I told her: I love you. I did! I meant it—the three words, I told her that. She kept on saying I was just talking, I didn't mean it. OK, I said, tell me how you know that! She never did tell me. She just kept saying, 'I know. I just know.' So I asked her, I wanted to know real bad: how can I prove it—show you? How? She'd keep shaking her head—no, no, no. So I said: 'Louise, it's you who won't let us really be together—trust each other! You have me a bad guy in your head, and you won't let go of it—that's what you think. You tell me you hope you have a girl—you just don't want any part of me. I'm not pushing for it to be a boy, but I hear you talk about your daughter, already, and you don't even know the answer, if it *is* a girl, and to me, you're saying: hey, go away, I don't want to remember anything about you.'

"That's someone 'pulling the trigger' on me, before I'd even be going in that direction, myself. The truth, the truth be—this: I've thought of being a daddy since I was a kid, a little kid. That's my big hope in life—and I mean to be a *good* daddy. You want to know what one is [a good daddy, I had asked], I'll tell you, and I don't need time to think, I've got it all in my head, up there: a good daddy is a man who is ready to stand up for his kids, no matter what. If it need be, he'll die for them. If it need be, he'll spend his life in pain, so his kids have a chance, a fighting

chance. A good daddy isn't the kind of guy who's boasting all the time: look at me, I'm a good daddy! You have these folks, they think they're better than you, and in their head, you're always down, and they're always up. I was in court [a year ago] and there was a man, a social worker, giving me the business, saying I wasn't worth *nothing,* and they brought in the minister, and he was adding his two cents, and talking a lot about Jesus, and He'll be sure to forgive me, but I've got to ask, to ask. Well, I'll tell you something, I know him [the minister], I know all about him, I know that he talks out of both sides of his mouth, every day, he does— he's a two-timer! is what my aunt says, and she knows, because he went after her like he was a train out of control, and she had to get protection, [from] her [two] brothers. My uncle [one of them] said, 'Charles, don't be fooled by someone says he's here to represent God, because he could be one of those snakes they'll mention in the Bible, in church.' "

Mention of church causes him to look away, in the direction, actually, of a nearby "tabernacle." He kicks once with his right leg, then puts his right hand on the knee of that leg, as if thereby to exert control over it. He muses—an effort to pursue the subject at hand sensibly, with a moderation he constantly fears he'll lose. "I want to be fair," he resumes. Then, perhaps in an effort to be so, he is silent again. For a moment he's ready to give up. He tells me to "ask the brothers" what they think, but V.J. and James offer no opinions, and it is clear, by the way they are looking at him, that they want to hear more from him. He starts himself up again with a joke about the dark cloud suddenly overhead, blocking the late afternoon sun, gives the event a larger significance: "No telling what's going on up there! He's the biggest Daddy of all, and He's got his eye on us, for sure." He stops, again seems stymied, perplexed, thwarted—the verbs rush to my mind, including the more ominous ones, "blocked," "conflicted." All at once, though, an outpouring. "He put us here, but He doesn't run us. It's all up to us. My grandma, she goes to church and she prays herself half crazy, I think. But it helps sometimes.

If you're going to be someone good, real good, you've got to have something you think is right, and you won't compromise. If going to church will help, then that's good. But me, I already know: I'd like to have a family, that's a good one, and I'd be there for everyone in it—the mother and the kids and me, we'd hang out together, and we'd be there for each other.

"The guys, like us, we get a bad rap from just about every single person. Does anyone say a single nice thing about us—a compliment? I ask you. [He addresses me.] I can tell what your answer is, even though you're not saying it! I can read it on your face!"

I get ready to deny the allegation, even as I have a go at him, psychiatrically, think to myself that he is accusing himself through me, that old standby of my kind—the use of others, through attribution, that is at the heart of projection. He doesn't go further, however: a visible smile breaks across his face, much to my relief, naturally, but to the pleasure of his two buddies, who now speak. V.J. admits that a lot of criticism comes the way of young men like himself, but understandably so, because "we sure do get into a lot of trouble, a lot of the time." He qualifies, points out that the misdemeanors and transgressions of blacks are noticeable, much more so than those of whites. His two friends nod in agreement, but James quickly does an about-face, turns out a powerful, concise, engaging polemic that is eminently self-directed, and all the more persuasive for its terse, confessional candor: "Excuses—when you look for excuses, you should know you're not just in hot water, it's boiling like mad! I'm no Muslim, but they have a point, the Muslims, when they say we should clean up our own act, and to hell with talking about whitey, and all whitey gets away with. That's not news; that's just the story." What "story," V.J. wants to know. "Of the country, America," James responds.

The sun has returned, but none of the three notice it, and I wonder if my interest in the event bespeaks of a nervous aestheticism as a counter

to a tough moral moment. Moreover, we are all self-conscious, because there I am, a card-carrying representative of that white world which these three fellows have learned to attend closely, fear, resent, and always, try to figure out. That last response is raised, a polite and considerate gesture directed at an outsider: "You can't be sure what whitey is going to do, so it's best to know where you're headed. That's the answer"— Charles's advice. With that, he resumes his disquisition on fatherhood: "You shouldn't be alone—if you are, you'll get lost. You need your folks. Your mother, you need her most, to start with; but what if she's alone, she doesn't have anyone to help steer her—she's in trouble, then. Lots of girls, they're still little, they're with their mothers, and now they're having their own kids, and for their mother it's just one more kid, and the kid's mother, she's a kid, and the 'old lady' hasn't got a man around, that's likely. So no one's there to put a hand on your shoulder. You see?"

He allows the briefest silence—he has asked a question, but the pacing of his delivery and the look he gives indicate that more is to come right away, that he has stopped a moment to be rhetorical rather than ask for assistance through an inquiry. "My daddy, he was there, with us, until I was seven, I think"—and now a longer silence. All three young men have lowered their heads a notch and shuffled a bit, and I find my own head down, my eyes on the playground's pebbled earth. I stand there, remembering my dad, and all the time we had together, all the things we did, all the trips we took, all he had to say to me, to uphold and criticize and urge and warn of—I'm with him, can see him so clearly, can feel *his* hand, the gentle touch of it on my back or shoulder; and then Charles continues: "All I heard when he left was my momma and big momma [his grandmother] calling him bad, bad, and you'd think he did the whole world in, and he should get 'the chair.' But he didn't like them shouting into his ears all the time, and he drank a six-pack a day, and they said he was a 'no-good one,' just for that. So, he walked out. Next thing, he was out West somewhere. He got himself a new fam-

ily, and he stuck with them. I heard all that from his sister. She doesn't like my momma, though they grew up together, and they were tight, real tight, until daddy took off. I've seen pictures of him, but he doesn't write, and he doesn't like to talk on the phone, and I know it: I'm a 'bad chapter' in his life, I bring back his troubles. That's what she says [his aunt], and I've got my pride.

"But I say, I don't want this to happen twice, don't you know. I mean, what if I got hooked into some life, where there was a kid, and I wasn't being treated right, just bossed and bossed, and kicked around: you no-count, low-down 'nigger'—I hear that, I've been told that by my own big momma. What a mouth she has! [It] makes you want to take an oath, your hand on the Bible! I'll never get myself into a situation like that, *no sir!*

"A man, a father should be treated with *respect!* That's the word; that's the truth! It's hard to get respect—a lot of folks, the girls you're going out with, they don't really respect you, they just don't. Why? [He had seen me readying to ask, during the second or two he took for some air, for collecting his thoughts.] They have something in mind for themselves, that's what: to get themselves pregnant, it's all they want from us, the juice! Sure, they'll whimper sweet things in your ear—why not: if you want something, you've got to convince someone to give it over to you! But every time I sleep with one of them, I'll notice: when it's over, they want you out—out of them, and out of their bed, and out of their house, and I'll tell you, out of their lives. Now, sure, you go talk with them, they'll sing you a song, and you'll be thinking: those poor gals, they miss their boyfriends; those poor gals, they want the father of their kid to come around! You want to hear something? You won't believe it, but you've got to listen: with money and with sex it's the same: they'll sweet-talk you, if they think they can get some bucks out of your pocket, a ten, a twenty, two twenties, anything, or your 'stuff' that makes kids. Then, you give all you've got, and they know it, and there's a new look

on their face—there sure as hell is: get out of my life, now; I got more important things to do than talk with you! Like what? Like making themselves look pretty, and holding on tight to their momma, while they're becoming one, themselves! That's how it is—it goes like that, man. The truth is, it does!"

My face is not as eagerly comprehending and uncritical as I'd like it to be, I realize a little too late. I've worked on keeping a scowl away, or a frown, but the eyes (I have a hunch) may have been a bit narrowed, betraying a skepticism that simply won't be banished. Maybe, I think with a self-protective rally, the issue is not me, but him: his own self-accusatory side, his own conscience, now aroused—so that whatever cues he was seeking, he would somehow find them, turn them to his own account. This silence that is now almost palpably surrounding us lets such thinking grow and grow in me—the words rumble across my mind, but don't, of course, find expression: projection, guilt and shame, distortion of perception. Meanwhile, I notice that Charles isn't, actually, looking at me at all—he's intent on seeing what his two buddies will make of his remarks, and so he searches their faces, alternately, for a message he ought to receive, take into consideration. James and V.J. are looking at each other—I note a fast wink offered by V.J., returned by James, who opens his mouth, begins to talk, but fizzles out quickly and unexpectedly: "This is heavy stuff, man, and people are looking to . . ."

He not only doesn't finish the sentence, he looks away from his buddies, from me, from the place where we are sitting—his eyes follow a distant car that is making enough noise for *that* to be its defining characteristic. James follows suit, but only for a second, and then, speaks two words—they are meant to sustain the movement away from our joint presence, meant to change the subject, but in fact they bring us right back to where we had been: "Some dude!"

He seems to realize what he has done, and seems, also, to assume we do, as well—and so, without explanation or apology, he embarks upon

his own soliloquy. "Hey, you got to watch out—no figuring out a lot of folks; but not only women, they're not the only ones! The broads, they can be sly, they can trick you, they can trip you up—but there's worse out there! Don't we know, you guys!"

He seemed charged for a long time of talk, but abruptly (to his own surprise, I realize), he stops. He repeats his last two words not vocally, but by a gesture: he glances at V.J., who does not return the look, and at Charles, who has turned his body in such a way that he entirely misses the direction of James's eyes. Again, we are all taken by surprise when James resumes: "See, these guys are like the monkey my old momma [grandmother] used to tell me—he'd hold his hands to his ears and say he couldn't hear any evil, none; and he'd cover up his eyes, and say he couldn't see any evil, none; and he'd have his fingers buried into his arms, somehow, so he couldn't be putting them on anything bad—so, he thought he was safe. Trouble is, someone can come and fool you pretty fast, pretty good!"

No more for a few seconds: let the message sink in, and let the two guys speak up. But they won't budge, though V.J. allows a thin smile to cross his face. All right, then—James takes off again, now for a longer ride: "I don't want to get into 'shoutin' with the brothers'! You guys, me—we're just starting out. Our age, you watch, mostly. That's it: we're watching. Sure, there's action—it starts early, and you get some. But we're not big-time studs here, not yet. I'm not counting! I'm not bragging, and I'm not apologizing. I'm just telling it like it is!

"Most girls, they don't know what they want, that's how I see it. They're kids. A guy, he has to grow up fast—faster than a girl. A girl's a girl; a boy, he's a guy after ten or so, or he be in *real* trouble! You go into the street, it's like you join the army. My uncle told me that. He's gone now. He caught a bullet by accident. He was minding his own business, hadn't done anything wrong; just caught it, and he 'passed,' right before everyone's eyes, a block from home. He'd gone to get himself

some music, some tapes, and next thing you know, they were playing church music—they had him laid out, looking nice, and we, filing by. That's what I mean: a girl can catch a bullet, too, I admit, but usually they're inside, cooking and cleaning and watching TV, and we're outside, doing—whatever. So, let's not give the girls a total bad rap! Some, they deserve it; some, I feel sorry for them—they're in trouble before they ever get into trouble (see what I mean?). Some, there are those—they're real special. There's my Mary Anne—she's sure good, and all. She'd like a baby, I know. But hell, so would I! We talk about what should happen—see! She's not slipping me a knock-out pill, you know! She's wanting to get through school. She has a job—she works in a store, selling stationery stuff. She tries to save some money. She shows me her [bank] book—she puts money in every week. It's getting longer and longer [the list of deposits]. I say: 'Mary Anne, what you thinking to do with all that?' She say, 'Give it to my kids.' I say, 'How many of them you going to have?' She say, 'One and one—a girl first, then a boy, or maybe the other way around.' I say, 'What if you end up with two boys or two girls?' She shakes her head and says, 'No way'! See what I mean—she isn't really thinking right, the way you have to when you go out on the street, and you have to have your head screwed on right, or you won't have a head at all, before you know it!

"I could be a daddy in less than a year, I know it. I probably will be one, soon. Every month Mary Anne says she's sure glad she's not with a child, but I'm sure she really wishes just the opposite. She knows I can see right through her when she says something like that. You want to hear something—this: her momma asked her if I was practicing some 'birth control thing'—coming there with condoms, because there sure isn't a baby showing up! No, ma'am—I hate them; they're no fun. I'd rather go someplace else, where the *gal* hates them, too, than wear one to please my honey-darling, even Mary Anne, and she knows that. But you see what I'm getting at—it's the momma, being ready to become a

grandma, talking it up, wanting it bad, real bad. Hey, she's saying to me: come on you guy, do your job, and no fooling around, and no waiting for something, just get her in shape to be a mother, and if you say good-bye, then, that's all right, because you've done your job, and now we can take over!

"I will say this, with someone like Mary Anne, she's not going to trick you. She looks you in the eyes and tells you what's on her mind— but even with her, if she got pregnant, it'd be between her and the baby, and she'd forget there's this third person, the one who got that egg all hopping and dancing, and ready to roll! That's the big problem: it's not only us guys, standing here, and saying we don't care, so long as we get laid. It's the girl, who says, I want it, I want you—but then, she'll be told there's a kid growing there, inside her stomach, and she doesn't have any thought of you, and to her, you've done your job, so good-bye. Sure, they'll want you back a year later, but it's more for the [dollar] bills they expect from you. That's not love! That's not treating you like a man, a father! That's trying to take you for a real ride, and you know what? The man, he isn't going to fall—not when he's been out in the world, and he knows what's the score. I say to Mary Anne, it's better that we be as straight with each other as you can be and I can be, then we'll still be friends. If something should happen, we'd still be close."

*If something should happen*—meaning, of course, if someone should begin to grow inside Mary Anne's belly, an event both Mary Anne and James anticipate as likely one minute, firmly preclude for the foreseeable future the next minute, and sometimes (in moments of shared boredom or frustration, moodiness) regard as an eminently welcome possibility, desirability. Each of them, in the mood to yearn for a child, anyway, is moved in that direction by the observable reality around them—so many fellow teenagers pregnant, so many youths boasting they've got someone pregnant. Each of them, too, has to wonder what it means *not* to join such a tidal wave of actualized fertility. It is such a matter—to resist a

prevalent custom—that worries these two the most: do they have the inner resources, a firm sense of themselves, their own hopes and values, that will enable them to stand apart, stand on their own, stand for something that is, relatively speaking, unusual, distinctive? "What's the trouble with you?"—James has had the question put to him often enough to take it seriously, to feel its sting. He catches the implication of pathology, be it bodily or of the mind. He shrugs and laughs, but he also wonders and even worries: his own version of twentieth-century psychological man. Why *is* he the only one, practically, who can't claim a child born already, or in the works? What is really responsible for his reluctance to encourage Mary Anne to throw caution to the winds, embark on a road traveled, it seems, by everyone they both know under twenty? She, too, has concerns about herself, her present situation as one of a rapidly (and visibly) diminishing cadre of childless young women, young women "who don't look like they're headed to be mothers." There is a finality to that expression, as James reports it: Mary Anne's words conveyed to him—the words of one of her friends, spoken to her with some evident and considerable alarm.

I listen to that line of thinking, its medical and psychiatric and moral undertones, with some consternation. It is as if I am carrying assumptions about what is "normal" (and too, proper) that are ill-suited for the situation in which I find myself; and, I realize, suddenly, the same may hold for James and Mary Anne, who at times, at least, have tried to hold high a view of their future that gives them "five or so" years to "be on your own, before that first baby comes along to join you"—another comment of Mary Anne's that James remembers vividly, alternately asserts as his own creedal ambition or mentions almost with embarrassment or shame: a strange peculiarity that more and more attracts the notice of others.

That last aspect of things—not yet being a biological father—weighs heavily on James, even on his two buddies, each of whom has fathered a

child, neither of whom has (since doing so) paid much attention to the mother in question, to her offspring. Charles and V.J. will tease him sometimes, call him a virgin—a version of that word not included in the dictionary: an adolescent who hasn't fathered a child and is getting closer and closer to his twentieth birthday. "Do you realize," V.J. once said to James, "you're becoming an old man, and there's no one to 'claim' you, no kid?" When I heard that question asked, I took note of the ironic use of the word "claim"—a private reflection on my part, I was sure (self-congratulation comes easier than one thinks under certain circumstances). But Charles was ready to play third man to his two friends, and unwittingly to take me on, as well: "What's this 'claim' you're talking? Do you go calling on your 'missus' and your little girl? She be two, and have you seen her even twice, once for each year?"

A fierce anger crosses V.J.'s face, only to dissolve with startling speed into a tight smile, confined to the mouth, as if he sees the irony, and wants to acknowledge it, but also feels judged, quite critically so. His response is to shake his head, mutter something scarcely audible about women who are fickle or mean-spirited or self-absorbed, and turn the tables on Charles, by asking what his 'count' is—how many times he's visited his former girlfriend and their one-year-old son. In a sharp reply, Charles says tersely: "Many, man, many." But V.J. is not persuaded: "Enough so the kid knows you better than those neighborhood dogs barking away?" That is tough, I think—a bit of bitterness that won't be ignored. Yet, Charles is now ready to spread his arms and legs both, do so with his face, as well, in a broad smile, become a teasing, but warm-spirited, conciliatory friend: "Hey, dude, you're the preacher, here, and you keep telling it to us, keep trying to make us into *nice* ones, *real nice* ones!"

That last mix of amused irony and placation doesn't go over well with James, however. He is worried that he may well be regarded as the one who is "nice"—that is, not grown up, really, and so, less than a true man.

He interrupts the dialogue between his friends just when one might think he'd ride it out to his advantage—the observer who is beyond the allegations being bandied back and forth: "What's wrong with being nice?" The two protagonists now become a reassuring audience, agree that "nothing" is wrong with being so described, defined—but they are no more convinced that such is the case than is James, who now wants to make a larger statement: "You know, if you can stay 'nice,' you can get somewhere, you can get your ass out of here." A sweep of his right hand, toward a street, a whole series of streets, and with the gesture, a movement of eyes toward all those nearby tenements—then nods: no argument, hey, no argument. But James knows the skepticism that his two friends feel; it lives strong in his own thoughts: "I'm not saying that if you stay away from trouble, you'll automatically be 'sprung.' You've got to do more—if you get yourself a good deal, you can get yourself a good car, and pretty soon, you can just move on out, go to a place where you live better, that's it. But if you get some girl 'going,' and then she's got herself a kid, and it's yours, and she wants some of your dough, and even if you say no, or you walk away and don't come back—it's 'on' you. Know what I mean? It's 'on' you—and it won't take long, besides, for you to be in the same place again. 'You mess around once, you mess around a second time, and pretty soon, you're just a guy who messes around'—that's what my uncle told me, and *does he know!*"

They all know about James's thirty-year-old uncle, who is a drug addict, and several times has come near death, by overdosing and by becoming a target for a dealer's gun. They all make deep grunts, and scowls come over their faces, even as their heads drop a notch or two. That uncle is some distant, cursed elder—his number is obviously up, and he'll be gone quite soon, they all agree. I am surprised, actually, at how long they dwell on the uncle—even though his life, they know, is not all that surprising or unique. It is as if this man is a voice of authority: *he* knows, he really does, how it all works, the gradual, steady, inex-

orable decline. Those who warn and chastise, but don't speak out of experience, aren't quite to be trusted—he, though, is a true veteran, a graduate of a certain school of life who has a lot to say, so James makes more than clear, as he stops to offer a biographical sketch of the man, a portrait all too convincing and pointed in its implications: "That guy, he was once 'nice.' I mean it! My grandma, she's still holding on to him, and saying he can lick all his problems, and come back to being that 'good boy,' she calls him. He was her favorite, you know—couldn't do no harm, no harm, no wrong, no wrong. My momma said she *hated* him, growing up, because any time she slipped and fell, there *he* was, being mentioned by her momma: you try to be like your little brother, and you'll turn out all right, and if you don't, you'll be in big, big trouble! Well, it sure didn't turn out that way, not even near!

"But that's the thing: he wasn't always in the mess he's now got himself in. There was that first step he took, that started it all, his falling down. You know what it was—I don't have to tell you! If it had been different—she was always getting high, even when she was a kid, hardly into junior high, that girl he got himself tied to: she took over his life, and when they were through, she had her kid, and he had his habit, that's what! So, he kept on and he met others, and I don't know how many he can 'claim' as his own, and maybe he doesn't know for sure, either—because your head can get fuzzy, fuzzy."

A moral tale that gives all three youths a noticeable stretch of silent pause—broken by James's unexpected resort to mathematics, and more: "We're over the halfway mark, toward him [the still unnamed uncle] in age! He's thirty, I think, just turned. He says that's a no-good birthday. Means you're getting real old. Not much time left for him. [His] kids getting on up there—but he doesn't know them. How many? [I had asked.] I don't rightly know—maybe four or five, maybe more. I don't think less. He just laughs when he's high—says, 'I wish them the best!' That's no good, but you see a lot of that. The guys, they'll be like that!

They want to 'have them' out there, but they turn their backs. You can blame it on the women a lot, but it's the men whistling Dixie, too.

"My uncle, he didn't start out bad. He didn't mean to turn all those girlfriends into mothers, then walk away. He tried to get a job. He *did* get jobs, then he'd lose them; he'd be laid off. He worked as a janitor. He worked in a garage. Best job ever, he said, was working in a wash place for cars: he'd wipe the cars off, then push them into the machine, for it to do the hard job. He liked that—said it gave him time to think, and he met some nice folks who took good care of their cars. The pay was better than any he'd ever got. Then, the place was robbed, and next thing, it closed down: end of job! After that he got cynical, Joe did. Know what I mean? He figured he had a hex on him—no way he was going to get the breaks. That was a time when everyone was having trouble finding work [an economic recession], and we got hit hardest here. Then you see the weak ones fall, you do! Joe had this club foot, you call it, when he was born, and that was just the start. Afterwards, it was his mother, with the tuberculosis, and his father, he was never around, and the grandma, she got sick, too. So a cousin helped, but Joe, he wasn't growing up in a good strong home, and so he was ready to fall on his face, when that [car wash] place stopped doing business.

"'Why not do drugs?' I recall a dozen times he asked that. 'Why not?' I never could come up with an answer, except to say you could go to jail, and you could o.d. But he laughed; he said the cops grab people who never did anything all the time—just for being a black man, that's all the wrong they did. And if you o.d., man, you're going out with no pain, just a big high, and next, sleep. Not bad! Look at all the people who get sick! They're in pain, bad pain. No medicine can touch them! They'd give anything to o.d., a lot of them. Joe, he says since you're going to go, anyway, someday, you might as well have fun—and he's had some!

"Of course, he's paying for it: just look at him. He's looking worse and worse! I don't think he'll be around for forty; maybe not thirty-five.

I see this one old girlfriend of his, and she has a boy, he must be ten, maybe twelve, and he's Joe, he's the spitting image. I say hello, and once I forgot, I called him 'little Joe.' I said, 'Hey there, little Joe,' and she didn't like it, his momma. Boy, she looked at me, it was as though she was firing an automatic, firing away. I just turned to go. I didn't want a fight! Then, you know what? She called after me. She said, 'James, stop for a minute.' Oh-oh, I thought: here comes plenty of trouble. I almost didn't; I almost started running in the opposite direction—but there was something in the way she spoke, I could hear it in her voice: she was really upset. So I approached her, and we got to talking. She said, 'How is he?' I said, 'OK.' She said, 'That's not what I keep hearing.' I said, 'He has his good days, and there are the bad ones.' She said, 'I'm still angry at him, I am, but I feel sorry for him. You know why?' I told her I didn't, so she told me, she said: 'He's a good man, even if he didn't do right by me and by this son of his, right here.' I said, 'I'm with you, I am.' She said, 'You know, I've been with plenty of men; I'm no spring chicken, like I used to be—and Joe, he's the only one of all of them who got to me.' That was real heavy stuff she was giving me! I just stood there. I didn't have a word in my mouth to speak back to her with! She kept looking in my eyes, and I kept looking in hers; and if you was there, you'd have thought we were starting to make out, but we weren't. She was putting her heart right out there, on her sleeve, and you know, I saw her eyes get that look, as if she was going to start crying: wet. That's when she told me she had to go, and she grabbed that boy, and they left, and to this day, I'll be thinking, I'll be walking, you know, or on the bus, or driving, and will remember that time with her on the street. She's been keeping her eye out for Joe, and that's what she told me, and he's her one, 'the one,' still. Same with him, I think—but he's 'gone,' you could say. With drugs, they take you away, and you're lost to everyone but yourself. That's how I see it."

A dark cloud hovers over us, in the sky, as an aspect of a day's reality, but figuratively as well. The three youths say nothing for seconds, for a full minute, for well over a minute. Charles breaks the ice with a terse "Funny thing"; and V.J. adds to it: "Strange, the way it goes." James has exhausted his supply of words, and is staring at the ground, which he occasionally kicks, not vigorously—almost as if he wants to express sadness, melancholy, rather than a fierce anger or combativeness. Charles spots a distant jet, high up, and wonders who is in it, and whether he'll ever get to step foot in an airplane. V.J. echoes the sentiment, but with some self-protective truculence: look, if any of them really wanted to go take a flying trip someplace, they could "raise the cash easy, real easy." He snaps his fingers—that easy. Then, more candidly—indeed, quite poignantly—he laughs, rises to a powerful statement: "I have no place I'm in a rush to go visit. I've never even been in the downtown [of Boston]— you know, where they have all the good stores, and like. I hear about them, but I've never taken the trip! You see—let's tell it like it is; let's put all the cards on the table, man, nothing stuck up the sleeve: we don't have much here, nothing compared to you folks. [A look at me, not a personal, angry look, but one meant to take advantage of my presence as a way of putting things quite explicitly on the record.] A white man, he's up there; a black man, he's down here. Sure, we can go way up and ride on planes—be an astronaut, they say. (One of the brothers is in training, I saw on TV.) But the exception doesn't prove the rule, my momma always told us: 'You be the exceptions, but don't forget what the rule is, or you'll get yourself into real trouble.' So, I remember! Best thing, I think, is to keep your eye out, keep your eye on everyone. Watch whitey, watch the white man. [He turns to me, again without personal animus: here's one, a concrete instance, but I'm not now inclined to move truculently from the general to the specific.] Watch your brothers, too: look at all the bad they—*we* do to each other! Watch the girls—they can have

you 'bound and gagged' before you know it! Watch yourself, that's what I guess I mean: no one will hurt you, if you know how to keep those eyes wide open! Down the street—a lot of trouble can come before you even know it's headed right your way!"

He stops talking; he looks carefully at his two friends, at me—and then toward the street. As if the larger world is intent on proving him exactly right, and is at his beck and call, a distant siren sounds, grows in the volume of its pressing noise, commands our notice, our reflection. A look of pride, of righteous pleasure crosses V.J.'s face briefly, replaced immediately by a frown. He is not in an "I told you so" mood; rather, he tells us, the siren stirs him to sorrow: "It's someone else, who's fallen." Something about that statement gets to all of us: our heads, responsively, fall. We stand and stare at the ground as the siren of the police car, now within our visual field, screeches. I wonder to myself, actually, why the noise is so relentlessly sent abroad in this forsaken territory. Surely everyone has long heard it and gotten out of the way, fled for cover. As if he has heard me, read me, V.J. explicates: "They scared themselves, and they want us to be scared." Finally, that late afternoon cry subsides, moves elsewhere, the cry of danger, of crime, of hurt and ruin and help-lessness and bitterness. The three men are still looking down at that dusty earth, lots of litter nearby, but as well, some green grass amidst the dominant dead kind—brown it's called, though it is really much closer to white in color. Eventually, V.J. breaks the silence, looks at his watch, reminds "the brothers" that they have their girlfriends to go visit, as does he. "Watch out," Charles says to V.J., as he takes the initiative in leaving. He looks back, fully aware of the knowing, ironic subtlety that has informed those two words, a listener who paid close heed to a speaker's outpouring. Now, the remaining two, ever the courteous gen-tlemen, ask me if I'd like them to walk me to my car. They are afraid for me, want to protect me, and they do so! I say good-bye and get into my

car and drive off, and I happen to notice in my rearview mirror that they are standing there, still, for a few seconds, watching intently, it seems, the trail of that departing vehicle, watching steadfastly (I think to myself) one world go elsewhere, even as they prepare to go about the evening ways of another world, theirs.

# 2. *Waiting*

Height for Melissa has been a trigger word, a seminal concept, as far back as memory takes her. The first thing she remembers is the awareness that she was taller than her sister Janice, almost two years her junior. The second thing she remembers is her mother's prophecy that she'd soon enough catch up with her brother Lemuel, a year and a half her senior. As for the youngest of her three sisters, Ruth and Sarah, they had no chance at all of pulling rank over her longitudinally, as she had eventually done with her brother: both were obviously going to be shorter than their siblings, so their mother knew early on, and so Melissa remembers knowing—hearing perhaps, or surmising on her own. In that last regard, she has given over much of her ruminative life to the question: whence her tallness? That is, who is her biological father, and where has he gone? Her first remembered question to her mother posed that matter, and at fifteen she could recall, word for word, her mother's reply, her gestures, the scene: "She was at the sink, washing the dishes. I was standing near her. She joked with me, 'The way you growing, you'll soon be able to peek over [the sink] and see this mess I clean every night.' That's when I asked her 'how come'—how did I get to be so big? She told me it was God, He made those choices, and we have to take what He gives us. I guess I must have known right then

and there my high school biology, even though I was, maybe, five or six. I said, 'Mummy, who's my daddy?' She stopped her washing; she turned off the faucet—I can see her doing that right now. She said, 'Your daddy's gone.' So, naturally, I wanted to know where to, where he's gone to; and she told me she didn't know. I was getting ready to ask her the next question: when will he be coming back?—and she just cut me off. She said he'll never come around, he's 'way away,' and I should forget him, because he never was my daddy in the first place. I knew different—he's the one who's tall, real tall, and that's why I'm tall. But I've never seen him, and my mother doesn't have a single picture of him, and she says his name was Jack, and she doesn't even remember his last name, and she's not sure he ever told her his true name, that's what she told me another time, when I tried to find out."

That story, relayed willingly, even with a certain pride, prompted Melissa to want to assert her stature: she would invariably stand up, as she talked of her father, on this or that excuse. She wanted something to eat or drink. She had forgotten to do something, and she'd better go quickly do it, lest she forget yet once more. She had a cut, and she needed to replace the Band-Aid on the finger. She was to return something to a store, and she wanted to make sure it was near her, in the kitchen, so that she'd right away take it with her after our conversation ended. Each time she stood up, under those circumstances, she stretched herself, almost to let herself know, never mind anyone else, that she was five foot eleven and a half, "headed for six, almost there," as she put it. For her, to be six feet tall was an important objective, and when she became pregnant, at fourteen years and seven months, she wondered whether she might stop growing "up," because she was growing "wide." What did I think? I told her the obvious (and what I told her she already knew)—but my assurances didn't quite settle the matter, because, of course, it was linked to other matters. "You never can tell what the body might decide to do," she told me after she'd heard my explanation. Yes, I acknowledged, but

I still felt her ultimate height wasn't going to be diminished by a pregnancy—certainly if she took good care of herself. She listened, and then let me know that her interest in this subject was profound, indeed: "It's the most important thing for me, to be way up there, to carry my head high! A lot of my friends say they're sure glad they're not as tall as I am—but they're looking up at me, and I'm looking down at them, and that's the way I like it! They think the boys won't go for someone who's tall, and that's true, if the boy is short, but if the boy is tall, then he's going to like being with you. 'That makes two of us,' Billy said [her boyfriend and the father of the child she is carrying]. He's six feet two, and he thinks he'll make three, because he's still growing, he says. [He is sixteen.] He'd like to be six-six, but I don't think he'll get that far up! If you do, you have a better chance of success! The taller you are, the easier to put those balls through the hoop. Billy plays good basketball, real good [on the high school team]. If I have a boy, he'll be big from the start—or a girl, too, she'll be big. The doctor said I'm built good, so I'll deliver easy!"

She stops suddenly, gets up abruptly, but this time for no apparent purpose. She approaches the refrigerator, and now I'm sure *that* is her reason for rising, but no, she veers away, walks toward a window, stands there—looking out for longer than a few seconds, to the point that she is clearly making a statement of sorts: silence, her back to me, the lengthening, concentrated stare in the direction of a row of tenement houses across the street. I sit quietly, but wonder how or whether to break the silence. Finally, she speaks, though without turning around: "My daddy could be walking down that street there; he could be someone who's living near here. When I see a real tall guy, I think to myself: is he the one?"

Now she is silent again; and now, she turns around—as if, perhaps, to confront her daydreams, her expectations with the reality of a conversation. I nod, and then feel I've made a mistake in doing so—encouraged

her, thereby, in a line of thought that bespeaks of loss and yearning rather than what is at all likely. She seems, suddenly, sad—a contrast with her usual upbeat manner. I hear myself breaking the silence, asking her if she's been thinking more about her daddy since she became pregnant. She is not readily forthcoming. She thinks things over. She says, "No"; then she changes her mind—to "maybe"; then she takes further stock, and says, "Maybe yes." Her terse successive replies tell me to go no further—unless I am prepared to pursue this question clinically, and even then, the success of such an inquiry would, of course, require her assent, and I am not sure she would offer it. I decide to let the matter drop, and I am thinking of another tack to take, when she matter-of-factly takes herself to task, acknowledges the extreme unlikelihood that her father is anywhere near us, and instead, speaks of her resignation—that she will never see him. When she has said that, she comes back to her chair, sits down, and looks at her enlarged belly. Soon she is talking of the child within her—the *two* children within her, actually: "I wonder if this one I'm carrying will look like me, or like Billy. I'm sure, either way, it'll be one big baby! As long as I can remember, I'd dream of having my own baby, and here it is, right there [she gently, briefly rubs her abdomen], and if I want, I could find out if it's a boy or a girl, but I don't want to know until I deliver the baby, and the doctor will let me know. People ask me: Melissa, what do you want, a boy or a girl? I say, I don't care, so long as it's a big healthy kid. They laugh—there you go again, talking about your baby being *big!* Well, it *will* be! Truth is, I think I'd prefer a boy. That way, Billy would pay more attention, I think. He *says* he'd like a girl, but I can tell, he's telling me what he thinks I'd like to hear—what I want. I told him—don't do that. I told him, I'd like a big, big boy, and he could grow up, and be the best basketball player *ever*. 'That's a tall order,' he says. OK, but he'll be a tall kid—is how I answer him!

"The other day, I was walking to the store, and this really tall man was

coming in the other direction, and he stared at me. All my life, when that has happened, I get curious, I get scared—I think to myself: it could be *him,* my daddy. I know it's not, but that's how I think. Since I been pregnant, that has happened more than ever to me. I don't know if it's just plain coincidence, or if it's me, thinking more about my daddy now than ever before. You be pregnant, and your mind changes, not just your body! You be more like you was when you were little!"

I nod fast, perhaps too vigorously. She takes note, smiles knowingly— ah yes, you would, indeed, welcome that remark. I decide, however, not to apologize for being overeager, for showing pleasure at hearing my own convictions upheld by someone else; rather, I seize the moment, ask her (risking banality) what "changes" she'd noticed in her mind these recent weeks. She is not loath to oblige: "It's not big changes I'm talking about. I mean, I'm still Melissa, the same person. I like the same food, only more of it—fries, shakes, cheeseburgers, pizza. I'm supposed to eat vegetables, for the baby, but it's no fun that. Mummy fries up some okra for me, and she puts cheese on tomatoes and cooks them, fries them—it's OK: I take my medicine! It's something else, I'm talking of: it's thinking of your baby, not just yourself, and it's thinking of yourself different— how you got here in the first place. See what I mean?"

I think I understand what she is trying to tell me, but I'm not completely sure I do, and I tell her so. She takes to my acknowledged uncertainty, tells me she herself isn't certain where she's headed in her thinking—but she wants to say more: "What if my daddy hadn't paid attention to Mummy? She's always told me that he was a 'no count man,' and I know he was—else I'd be seeing him. But he must have liked her. He slept with her: and that's me, that's my life—I came from what they did! Maybe he wasn't any different than Billy. Maybe he was a good guy, and something bad happened, and he had to leave town. Lots of guys, they've got to go someplace else—no work, no one to help them out, done something wrong and got in trouble with the law, those things happen. Billy's

doing all right now, but tomorrow or the next day he could have to 'move on.' Mummy says 'men move on'—that's what I worry about all the time these days!

"I told Billy—I said: 'You could be like my dad—you could leave, and I'd never see you again.' He got really, really upset with me. He said, 'Melissa, you're giving me a vote of no confidence, no confidence at all— and it's not right!' I apologized. I said, 'Look, I can't help what's crossing my mind.' He said he could see why, but I should laugh and be happy, and not be feeling down. He said it's no good for 'that kid,' me feeling down. Then, I felt even worse—I said, 'Billy, when you say "that kid," it don't sound very good to me.' 'Well,' he say, 'what you mean? You making something out of nothing!' I tell him, no—he could have said 'my kid,' or 'our kid,' that's the best. He just shakes his head, and I can see he's real angry; he wants to get up and go. I see his feet crossing and uncrossing, and he's pulling on his sweater, and he's thinking, I know he's thinking some excuse to tell me, and that's when I have to think fast, and head him off, so I do, I soothe him, I touch him, I tell him he looks good, real good, and then he quiets down, and we have fun, we make out. It's later, when he's gone, that I'm sitting here, and watching the television, and I should be happy, because I'm feeling all right, and I can feel that baby kicking, one kick, then another, that's good, but I remember what I just told you. I remember what he said to me; I remember what I said to him, and how he took a fit, a big one! That's when I just lose it: I'll be low, and I feel these tears coming. I'm not crying, but I feel these tears coming. I just lie down and try to forget it, forget everything. The more you can forget, the better!"

I am more than a little surprised to hear that psychological comment —such a contrast with what I learned while training to be a psychiatrist, a psychoanalyst. Here is suppression, repression all right—sought, embraced, even advocated as a general principle. I want to talk more with Melissa about this way of regarding mental life. I start to do so with a

supposedly innocent question: "Do you really think so?" Immediately she spots the pretense, the guile, cuts to the bone with this: "I know you folks don't." I am surprised—condescension at work, I fear. I am also speechless. How to get her talking about her notion of forgetting as a psychological virtue—how to hear more from her about the way she handles the press of memories, and too, the matter of a family's mysteries? I don't really consider those questions explicitly—rather, as I prepare to talk, I unselfconsciously draw on a general attitude, on all that I've learned to assume: how one ought to look at one's fellow human beings under circumstances such as these. When I open my mouth, though, I utter a disclaimer—and am somewhat surprised to hear it: "I'm not sure I can speak for all of my doctor friends, but I think a lot of us would say that we're for what works best for the person." She right away responds to that personal and metaphysical overture: "For me, it's best to put all my troubles out of the way, way out of the way." I decide to continue with an observation about others: "Some people just can't do that too well, so they get into a jam—their troubles take over." She is not at all uncomprehending: "That's right! I've been there: there'll be a day when all I can think of is the baby and what can go wrong—I mean [she sees me ready to ask, so she proceeds] the baby could be born sick, or something could be missing, you know. If Billy found out, he would—I don't know what he'd do. I used to wonder if my daddy left because of me—I wasn't up to what he wanted. My cousin, she once said she heard my daddy was light, and I took after my mom. That's why he could have all those girlfriends, maybe. Billy is lighter than me, you know—so he'll want the baby to be like him, I know. I never bring it up—I never talk about that with him, no [I had asked]. There are some things you know, but you don't mention them—it's no good to stir up a lot of trouble, when you're trying to find some peace for yourself, and your baby inside you! My mummy told us, many times, 'The less said the better,' that's the big rule!"

More psychology that differs drastically from the assumptions that inform my life, my kind. I am getting ready to mouth a piety, protest the notion of conversation as the proverbial prod at the hornet's nest. She, however, is right there, before I so much as think of what to say, let alone start to do so: "If saying what's on your mind will change things, that's something; but if saying, talking, will get you in even more of a mess than you're already in, then you're only throwing more of that bacon fat in the pan than you need to keep your cooking going, and you'll ruin it."

I now have two sayings to consider, and her version of one of them has me stymied. I want to insist that even if putting one's emotional cards on the table does create an uproar for a while, there can be beneficial consequences down the line, the received and commonplace wisdom of the world I inhabit. She seems to know what is inside me, requiring expression—and squelches my essentially psychological argument with one that has in it a mix of the biological, the social and cultural, so to speak: "Your color—you can say all you want, but there's no changing it, and no changing how you (how folks) will look at you!"

I feel a slump in my body—while, at the same time, I reflect with some admiration on this quite pointed and well-charged realism, offered with apparent casualness, but of course, a well-considered, shrewd earthiness. I look at her and notice her looking at her own skin, touching her right forearm with her left fingers. We get into a quite candid further talk about skin color, the kind of talk I've had, occasionally, with children and youth of African American background over the years. She lets me know, repeatedly and in several ways, that her mind as a pregnant teenager is quite preoccupied with that matter and its implications and ramifications—the baby in her and its relationship, as an aspect of its skin color, to a father she has never known, to its father, her boyfriend, and not least, to herself. She also lets me know about a tell-tale conversation she's had with her friends, also pregnant or already with a child: "The man, he wants his child, but he doesn't want to be there, caring for it—

that's what everyone says. A woman does this, a man does that—you hear. I'm for that—except a lot of the guys, they brag, they talk your head off about being the one who got the gal pregnant: macho, macho! But will they come and help you out? Will they hold the baby? I'm not talking [about] changing diapers! My friends tell me: Melissa, get ready, it's you and the kid, and don't think Billy will be hanging around a lot, trying to give you help!

"I think they're wrong: I think Billy is different. Of course, if I tell them that—well, when I do, they laugh; they say, 'Famous last words.' They say every girl is going to think like that, until she learns how it is! They say a lot depends on how the kid looks, you know. If it's a boy, the daddy might be more in favor. He might come around more. If it's a kid who looks like his daddy, you've got a better chance. My hope—if this child is light, rather than dark, and it's a boy: I think Billy will be here all the time, and he'll want to show off with his kid. It'll be *his!* My mummy says, the man will always look at the baby, and he'll quick as can be decide if he's going to stick with the kid, or he's going to talk about it, maybe brag, or just plain forget it. If you have a daddy who's light, then he'll want a kid to follow him."

On another occasion, Melissa is not feeling well, and notes that the family dog, a mongrel she describes as a "mixture of everything," also isn't feeling too well. The dog had vomited the day before, and Melissa, too, had been "sick to the stomach, real bad." She began to worry that she might be in danger of losing her baby, though she did not have abdominal cramps, and did not actually throw up any food. The nausea passed, but its implications (and its connections, in her mind, to her dog's travail) lingered in her thoughts for quite some time, prompted an intensity of reflection that she herself noted, commented upon as we talked: "I've been looking out the window more than ever—looking at people go by, and trying to figure out what they're up to. Lots of folks, they're in a big hurry. They have to be at work, or their kid has to make

the [school] bus. Lots of folks, they're not in any rush—that's the prob-lem: they've got nothing to do, so they're just hanging out. They're wait-ing for the Jug [The Brown Jug, a nearby bar] to open, so they can go in there and sit and watch the TV, and that's the whole day they'll spend, with a beer, and another beer, and talking about nothing, just any-thing they've picked up on the street. I wonder why God goes through all the trouble to put us here, and then you might have nothing to do, most of the day, but see those hours go down the drain!

"I guess being sick a little got me going—I said to myself: 'Melissa, do you really want this baby, or are you just carrying it because it happened and you couldn't think of anything better ahead, and so you just said OK I'll take this, I'll go with this! I tried to talk to Mum about it, but she told me: it's only because you're not feeling so hot that you're talking that way, and when you get better you'll put all those ideas out of your head! She's right, I guess—but I've had them up there in my head even when I've been all right, nothing wrong with me. I guess when you get sick, you think even more than you usually do; I guess that's it. But I sure hope I haven't made a big mistake, having this baby."

She not only stops speaking, she looks down, first at the floor, then at her tummy, which she touches only briefly with her right hand—then lets it come to rest on the arm of her chair. Her eye catches sight of a fly, a rather large one, a noisy one, cruising the ceiling above her. She laughs, then explains that her aunt is afraid of flies, admittedly an improbable re-action, but one Melissa can't forget—because once the aunt got on her chair, to kill a fly that had landed on the top part of a kitchen window that was located well above the kitchen sink. She swatted the fly with a folded newspaper, missed it, but put a crack in the window—and then fell down and got herself a big bump on her right elbow. Melissa tells the story with some bemusement, and then concludes with a touch of psy-chological and moral irony: "You see, you go looking for trouble, you find it. It's best to let things *be!* What's so good about killing a fly? What's

so bad about a fly? Better go about your own business, and not be poking in someone else's!"

She sees me both impressed yet somewhat unpersuaded. I don't have a passion for assaulting flies, but they do carry bacteria, I know—and, well, I was brought up to go after them. Melissa seems to realize that I am caught in that bind, impressed by her wry, philosophical comments, yet not able to be as indifferent to the question at hand (to kill, not to kill) as she seems to be. She lets me know more of her own thinking: "I know you can't let your place fill up with flies and mosquitoes—next thing you know, you've got bites, and you can't do a thing without brushing them all away. You'd have to carry a paper with you, around the clock, and be waving it every other second or so. I'll kill a fly, if it's within reach, and I don't have to take a chance of hurting myself! Now that I'm carrying this baby, I've really got to be careful! If I fell down, I could lose the child. What's more important, my kid or that fly?"

She is back to staring at the fly, which has landed securely on a bulb in the middle of the room's ceiling. The light is not on, and Melissa notes that fact, then offers some speculations that have occurred to her: "If I was to put the light on—do you think the fly would move? I guess so—it'd be scared. I was thinking to myself a few seconds ago: maybe that fly is so big, because it's pregnant, like me! Maybe it's trying to rest up there, where no one can bother it, and then it'll go deliver some-place." She stops, then acknowledges a certain ignorance about the re-productive life of flies—indeed, turns to me for a mini-lecture, of sorts, on the subject. But I am also ignorant with respect to this matter—had never before, actually, given any thought to it. I am beginning to won-der how and why we have gotten this far into a discussion about the lowly, not very attractive housefly, when I am given more to contemplate by Melissa—who has every intention, I will soon realize, of turning to good account this sequence of conversation. She ends her gazing at the still fly above, makes these remarks: "There be times I'd like to fly

away—just be gone! I don't know where [she knows me, sees me being curious!], anyplace. I'll be sitting here, and you know, something comes over me—it's as if I'm being pulled, and there's no point in crying for help; I don't even want to. I'm just on my way. Next thing, I'm on some island, like you see in those TV ads, Jamaica, maybe, and I'm sitting at this big table, and there are other people there, but I don't know any of them, and we're all laughing, and there's this huge spread on the table, it's everything I like: steak and fried chicken and spaghetti and lots of desserts, cake and pies, and we're all just eating up, and the more we eat, the more they bring, and I say to this waiter (he's serving me hashed browns and chicken, I think), I say: Lord, I'll put on weight being down here, and he laughs and he says this food is too good to resist, and be- sides, its got this secret thing in it—so you don't put on weight!"

She stops and smiles. I do, too. In fact, I am all caught up in her memory of her fantasy—a bit of stomach gurgle, a bit of drool in the mouth: I have pictured that table, laden with goodies. (Besides, I *am* hungry; I had missed lunch.) She can tell that I've traveled with her, so to speak. She now smiles even more broadly, and then she resumes her report of a departure: "When I'm down there, I know I'm not there. I think about how lucky I am to be eating all that food, while everyone I know is back here—but I know, I do really know in the back of my head, that I'm really in Boston, and there's nothing on our kitchen table but the salt and the pepper, and in the refrigerator, some milk, maybe, and cokes, and the pizza from yesterday to heat up, and eggs, we always have them, and bacon—like that. When I leave that place—when I 'wake up' (I haven't gone to sleep!) it's like I really did travel all that distance. I feel much better; I feel full—I don't want to eat my food, because I've al- ready eaten (you see what I mean?). My mum will think I'm in trouble, I'm sick—when I say: I just don't have an appetite now! Then she starts her worrying. She says I have to remember, I'm living for two people now, I have to eat for two people, and the way I'm going, two people will

be in real bad trouble! I try to laugh; I tell her I went out and ate me a ton of pizza, and a ton of fries, and I drank a quart of milk, so I got all my vitamins. She don't buy it, though. She says: 'Melissa, you look hungry. I'm your mother, and I know!' I say, 'Hey, mom, you're chasing a shadow, so stop!' She don't like me talking that way! She says, when I get fresh, she *knows* there's something fishy going on—so, I say, all right, all right, I'll eat anything, anything, just so we can end this, end all the talk of me and the baby, and how we could both be headed for trouble!"

She is clearly upset, relaying the above exchange to me. She marches forthrightly, defiantly to the refrigerator, as if to enact a compliance with her mother, who, in fact, is not home; she opens the door, looks at the shelves, mentions the contents, slams the door shut. In a moment she is back at her seat, looking a little ashamed of herself, but also a little pleased with herself. I want to ask her to tell me what the foregoing is meant to convey, but this is not a clinical office, it is her home, and I remind myself that she has a right, as a conversationalist, to make her point in her own way, and if I don't understand her point, it behooves me simply to say that. In fact, though, she *has* conveyed a message to me, so I settle for a brief recapitulation of it, declare that she clearly loves to let her mind wander to interesting and enjoyable places, where she can "dream" of delicious food and companionable people. She nods, but presses the matter: "I feel different after I take one of those trips. I mean, I know I've never left here, but, at the same time, I *have* left, because my mood, it's different."

I quickly, reflexively ask her, "How?"—one word meant to elicit from her a description of the changes she experiences. I sit there, poised—I am sure she will be telling me something important. She is silent, though. She seems to withdraw into herself. She looks away, toward the window, then up toward that ceiling. No flies are in sight, I notice, but she keeps staring for a few seconds, then brings her eyes way down to the floor—she looks at a spot in the middle of that floor. Then she points out

to me some crumbs which she claims have been there "a day or two." I wonder what to say; keep silent; wonder what to think; try to suspend judgment. She amplifies—says her mother is "good at telling people what to do, but not so good at living up to her own words." I think to myself—she and the rest of us. Melissa decides to include herself in the assembly I have just conjured in my head: "I should talk! It's easy for me, to give advice. It's hard for me to follow my own advice!"

She now sits back in her chair, looks at me, smiles, seems more relaxed. She decides to tell me a story—an amplification of what she has just offered in the way of self-criticism: "The other day, I met this girl in the superette; we were both buying frozen pizzas. She looked at me, and she said, 'You're showing now.' 'Yup,' I said. 'Do you like it?' she asked me. I told her: 'Hey, it's not something you like, it's something you're going through, and you want it to be over, fast, so you'll look like everyone else!' Well, she wasn't going to believe me! There she was, ten years old, I think, and she said she sure hoped she'd have 'something to show before long.' 'Hey,' I said—what are you talking about! You be ten, and that's what you're thinking! 'Why not?' (She said that, *'Why not?'*). I near took a fit. I just walked away. I said to myself: 'Melissa, there's more trouble out there than you can believe!' When I came home, I was going to tell my mom what happened. But I'm not sure she'd be so surprised. Nothing ever really surprises her! She works [as a nurse's assistant] in a hospital, so she sees everything, I guess."

With those words, Melissa gets up from her favorite chair, walks to the window, looks out, shakes her head, walks quickly back to the chair, sits down, closes her eyes, sighs, shakes her head once more, lowers it, her eyes still closed, and thereafter, for ten or so seconds remains immobile. I assume she has seen something (someone) outside, and on that account is upset. I interrupt the silence with a question meant to let me share in what she has witnessed. She tells me, however, that she saw "nothing" out there. I begin to realize that she is responding, still, to her

memories of that encounter with the ten-year-old girl. She surprises me with her eventual remarks on that girl, on her fate—which began, actually, with a question put to me: "What would you have said to her, if you'd been there, instead of me, talking with her—and she said to you what she said to me?" I beg off, reply that I'm fairly certain the girl wouldn't have talked with me as she did with Melissa. She understands, but presses the question: "True, true—but suppose you got to earn her confidence in you; suppose you became her doctor, if she *was* pregnant— what would you tell her?" I am overwhelmed by the many implications of that improbable set of circumstances. I try to explain my way of looking at this hypothetical medical and psychiatric scenario. I remind Melissa that if the girl were pregnant, and I were her gynecologist and future obstetrician, I'd certainly have an obligation to try to teach her, care for her, in such a way that she would get through her pregnancy successfully. Melissa interrupts me—after I have made that declaration, and just as I have begun to expand on it with specifics: "You mean, you'd let her go and have the baby, and she'd be only ten or eleven!" I backtrack, indicate my assumption that the girl whom we've been discussing is now a bit older, hence able to become pregnant. Melissa gets argumentative: "I know girls, they're twelve, and they're carrying! What would you say to them?"

I get annoyed—what's the difference, really, between a twelve-year-old and a fourteen-year-old, like Melissa; or, put differently, whence this not so hidden moral indignation that has found expression with respect to fellow adolescents a mere couple of years Melissa's junior? I begin to realize, of course, that this fourteen-year-old person sitting across the room from me is not without a considerable capacity of self-judgment, and that she is giving voice, loud and clear, to that inclination. As I sit there, contemplating such an awareness on my part, wondering whether to share it with her (and how to do so convincingly, but without condescension), I hear a monologue that lets me know of a speaker's own kind of self-

awareness: "I like to watch the world go by—my mum says I started it [doing so] when I was real little. She said I'd stare out the window, or when people came visiting, I'd be 'watching, watching.' I'm always trying to understand why folks do the things they do!" A very brief moment of hesitation, an intense look right at me, as if to remind me of who I am—or let me know that she both understands my kind of work and personally connects with its intentions. She continues with a return to the superette scene: "When I saw that girl looking me over, I could tell what she was thinking. I've been there—I've seen older girls go down the same road I'm now walking. My mum used to say, 'Watch out,' but you know, she's only fifteen years older than I am, and when I was ten, I think (the same age as that girl)—it was then that I first realized what that really and truly meant! You know what? I asked her [Melissa's mother] how come she was so *young*, when she had me. She said, 'Child, I wasn't as young as you think.' Then she wouldn't talk anymore, and she got real bossy with me about how I have to do this errand, and the other one—so I knew: I'd hit on something *big!*

"Today, she's worried that *I'm* so young, and she said I could go 'end it'—you know, it's legal. I guess it wasn't when she was [pregnant] with me. But I thought: if she'd gone and 'ended it,' then I'd never have been born—there'd be no me! So, I got the goose-pimples running up and down me, and I said to her—just what I just said now, that it's scary, thinking I might never have been born, and she started crying and crying, and so did I, and that's when I decided I'd go through with it. But you know, it's not going to be easy, I know—especially for me, because I'm a dreamer! I look out there at people, and I think of how I could copy this lady I'll see all dressed up, and she has a big car, and her boyfriend is rich, or I'll see someone who's going to college, and I know she's going to get out of here, and stay out, and I'll say, 'Melissa, you could live another way, if you put your mind to it, but now this baby, it's deciding a lot for you about the future, it's telling you to settle down and accept it,

what's going to happen.' That's why I close my eyes a lot—so I won't be seeing everything, and thinking I could be doing one thing, and another thing. You've got to realize you can't go everywhere at the same time, and be everyone you bump into; you've got yourself to be—I guess."

Those last two words, naturally, bespeak of a certain resignation to which, at her age, she is certainly entitled, I think, as I ponder all that she has said, a whole lot. She watches me, mulling over her words, listens intently as the street resounds with the noise of several cars being gunned. She speaks of what we have heard—laughs as she does so: "Those guys, they think they're going someplace, real fast! They be fooling themselves!" I am moved by the knowing, melancholy resignation of her two brief sentences, which have, actually, sentenced the youths described to a rather grim fate, one which she seems to comprehend rather more fully and subtly than I had hitherto estimated to be the case. She has been watching me, too, I realize—and with that last observation of hers, has let me know the extent of her psychological and social savvy, as it has developed in the fourteen years of her life.

On the other hand, she clearly did not intend for me to get a one-sided sense of her, as she let me know a few days later. She had bought herself a maternity dress, and she loved its bright green and red colors, its relaxed fit. She had spent a lot of time at the store, looking over various dresses, trying them on, feeling satisfaction or dissatisfaction with them, to the point that she realized fully how weary of her the saleslady was becoming. Finally, that woman was ready to call it quits, and told her so, at which moment Melissa made her choice, made her purchase, made a fast exit, the dress in hand. "I think that lady was ready to kill me," Melissa remembered, smiling—after which, this statement, with its touching, confessional slant: "I don't know why I did that—kept asking to try on all those dresses. I knew I liked this one [she nods toward the dress she is wearing] the best from the first second I was there and looked at what they had. I guess I was just being 'indecisive.' My aunt

says that's my biggest fault. Billy says so, too—he says I'm always going 'this way and that, back and forth.' Well, they can't say I didn't get 'decisive' a few months ago! Here I be with this baby kicking in me (*it's* 'decisive'!). When I put on this dress, I think I'm saying something to the world—anyone who cares to look. Some people, they never give anyone any notice, that's how they are. Maybe I look too much at folks. If I saw me, wearing this dress, walking down the street, I'd take one long look, and I'd think: she must be happy, because she's showing, and she's showing off, the two. They'd be right—most of the time, I'm in a good mood. I'm ready to go, like those boys with their cars. I fall back sometimes, and I'm likely then to want to take off this dress and wear any old thing, something worn down by time. But mostly, I try to be kicking, like the baby is. Mostly. I hope it stays mostly. I do."

# 3. *Welfare*

All four of the women are teenagers, all four recent mothers. The oldest is Margie, seventeen, the mother of a one-year-old son. Younger than her by only six months, at sixteen, is Sally Ann, who has a daughter who is almost one. Mary Alice is about to turn sixteen—a month short, actually—and she also has a daughter, who is ten months old. Finally, at fifteen and a half, Wilma has a son of six months. We have been talking individually, each of these women and I; now, we have started talking together, in Margie's kitchen. Margie is, in fact, proud to be our host, and proud to be the oldest of the four mothers, and proud to be furthest along as a parent. She has bought a coffee cake for us, has plenty of coffee to offer, and has filled a candy dish with small Hershey chocolate bars and small Milky Ways. We sit in the kitchen, begin right away talking about babies. Margie is very pleased to report that her boy, Nate, is up and about: "He's walking; he falls down, but then he gets himself up." Sally Ann, whose daughter is six weeks younger than Margie's son, is surprised: "My Louise isn't near standing—she won't be walking for a few months, my momma says. She crawls, but she doesn't like it. All she wants, is for me to hold her, and put her down. She is always hungry, and she's getting fat, and so am I! Her daddy, he came over and he told both of us, if we don't be careful, he'll stop visiting. He said he doesn't want two fat women on his hands!"

After she makes that statement, Sally Ann seems relaxed, smiling. But about ten seconds down the line, as we all smile and make small talk and eat and drink, she lowers her head, looks at her thighs, rubs them, one with one hand, the other with the other hand, simultaneously. Abruptly, she speaks out: "I guess I shouldn't be eating this coffee cake [in her hand], but it tastes good, and I don't care what he thinks." We are all wordless—the first time of such persistent, freighted silence. All three women, I notice, are looking at Sally Ann, even as she keeps looking down at the floor, picks up her piece of coffee cake, and devours it in a couple of big gulps. Finally, she breaks the stillness: "I miss my girl, I miss Lou." Her use of the child's nickname gets to her and she seems near tears. She is only five minutes away from the baby—and will be back with her, at the most, in two hours, and yet she seems almost disconsolate. I decide, of course, that something else is troubling her—what, in fact, she told us her boyfriend had said. I am sure the other women have the same thought crossing their minds. They are gentle and affectionate and tactful with Sally Ann, take care not to make her feel any more vulnerable than is already the case, state their own wish to be back with their babies, all of whom are being looked after by their grandmothers. That way, Sally Ann is brought back into this mothers' circle—her particular dejection, which prompted a desire to be with her child, subsumed under a general, shared sense of yearning. But Sally Ann is still struggling with her own, evident, quite particular pain, and suddenly she breaks down, not in tears, as I had thought would happen, but with a bold outburst: "I wish I had *two* babies, right now! Then, my Lou would have someone to grow up with, and not be an only child, and then I could say good-bye to all those men, every single one of them: not a one is any good. They all be out for themselves, and they take what they can get, and then they walk away, and they haven't got a single good word for you!"

Another spell of utter silence, broken by a fork that Wilma drops on

the floor, and hurriedly tries to retrieve. She is the youngest, the thinnest, the most conventionally attractive. Men are very much interested in her—not only the man of seventeen who fathered her son. Yet she is the one who speaks first, and with an unstinting embrace of Sally Ann, a sharply angry critique of men in general, and in particular, the "boys" she knows. She says that she even worried about her capacity to be a good mother to her son—and told *her* mother how she felt: "I wanted a girl real, real bad! Boys, they may be OK when they're little, but look what happens when they get bigger. All they want is a woman—for an hour or two: then she's trash to them, so they go looking for another one! My David's daddy, I hear he boasts he's got three children already—and I believe him! He tells me he's going to settle down, and I'll be the one, but I can barely keep from picking up a hot cup of coffee and throwing it right in his face when he gives me that jive talk! I want to scream: bullshit! I want to say worse! But, you know, I don't speak up. I listen and I smile. He brings me some dough when he's made some, and he's feeling big—and my momma says I should wait and see: he *could* settle down and stay with me and the baby. But she's a sucker for fast-talking men, and look where it's got her: nowhere!"

There was more, and with the outpouring, the women, including Sally Ann, all seemed entranced, convinced, their spirits obviously buoyed. I am surprised—I had pegged Wilma as the "happiest," the least embittered, the best "adjusted" of the four women, probably for reasons that tell a lot more about me than her: she is so "attractive"; she takes such good care of herself; dresses so tastefully, carefully; seems ready, always, with a warm smile. Whereas the others, I had noticed, appeared resigned, already, to the life of a single parent, everyone spoke of Wilma's good prospects with her boyfriend (the father of David), or if that relationship didn't work out, her capacity to attract, as Margie put it, "anyone she wanted, just by a snap of her fingers."

Finally, Wilma stops, and drinks down the rest of her coffee in one

prolonged gulp. She has accomplished something: Sally Ann has perked up, is smiling, takes a chocolate bar with no apparent self-recrimination, gobbles it down with evident pleasure, stretches herself on the hard-backed kitchen chair, and now tells her friends that she sure is glad to have some "time off" from her daughter! It is then that Mary Alice speaks up, announces that she is glad to be a mother, and is glad, too, that she has a daughter, and she agrees with what Wilma has declared—*but:* "These boys, I feel sorry for them. They're not going nowhere, and everyone knows it, especially them! I have four brothers, and every single day of my life, I thank God that He didn't make me a boy! That's the truth! You know why? I'll tell you: a boy, he's got to be out there on the streets, fighting to be someone big, or he's learned to tag along and be a slave to someone who *is* big, and what happens to a lot of them—they go to jail, or they end up with drugs or booze, like that. Maybe some do all right; maybe some stay in school, and all, and go get themselves jobs, and they're doing fine, but most guys—it's just pitiful, the way they be, and the way they turn out!"

No disagreement: rather, nods and more nods, and Wilma says "Amen," and Margie follows with "Yes, you said it," and Sally Ann passes her the bowl of chocolates, fast diminishing. I am listening, taking notes, even as my recorder spins away, when all of a sudden I feel all four of these young mothers staring at me. I am at a loss for words. Part of me wants to try self-mocking humor—a gibe at my kind (men—all of us, no matter our race) in the hopes that an admission, a confession will earn sympathy or a pardon; and then we can get back to what for me was the "subject": how these very young women are managing as mothers. Part of me wants to fall back on my profession, be as cool and collected, as monosyllabic as need be, while deflecting their attention from me through questions meant to give them a chance to talk about themselves. I think I must have realized, though, that these women, as hurt and fragile as they could sometimes appear and sound, were tough, knowing, all too

unwilling to put up with me as a "group therapist." Moreover, here was a white man, privileged as can be, relatively speaking—so what does he know, and what can he say! That is what I did settle for: "I don't know what to say—I'm from another world, I know. I'm trying to learn what I can, though."

Now the chocolates are sent my way—by Wilma, of all people! She speaks, too: "You mustn't believe everything we say—it's true, but we have other things to say, too!" I am surprised at such a reversal, or at least, modulation of sentiment, qualification of stated attitude. But the others are smiling and nodding, as if even when Wilma was at her loudest and most strident, they knew of this other side of things. Within moments, actually, I am hearing of the better, kinder, more appealing side of all four of the young men who fathered their children, two of whom have paid virtually no heed, after the fact, to their progeny (Margie's and Mary Alice's one-time boyfriends). The more I hear, unsurprisingly, the more skeptical I become, and the more psychoanalytic in my ruminations: they have decided to put a lid on their strong bitterness, resentment, and are working mighty hard to do so, probably in an effort to ease us all through this very tense morning meeting. Gradually, the women make clear that they haven't forgotten their collective animus, not at all—they simply are not ready, quite yet, to surrender to it. Margie is rather pointed (and telling and poignant) when she puts the matter this way: "Look, men are men, and that's how it is everywhere, I'll bet. [I'm selfishly relieved—"we" have been sprung a bit from the confines of race and class, all of us.] The way I see it—them—you have to realize what the difference is, between a girl (she wants to settle down and have her family), and a guy (he likes to roam all over the place). I don't like them for the way they act, but I try to remember—I guess I try to remember what I've just said, but I don't always."

Murmurs of agreement; smiles and knowing glances exchanged; a flurry of activity around the coffeepot; a settling down, again—and a

long time of stillness, to the point that I wonder whether we're about ready to break up, even as I notice Wilma eyeing her coat, across the room, draped over a chair. I am about to call it quits in my own way—to flip off the Sony, close my notebook, slip my pen back in my shirt pocket, slurp up the remains of the rather strong coffee, which now has me, actually, eager to stay and ask questions and learn, rather than fold up the tent and slip away with the relief that accompanies a tiredness one has to hide from others. Suddenly, however, Margie addresses us all: "It's not men that's our problem. It's ourselves—you've got to look yourself in the mirror and be honest and see what's there! I'm trying to stay in school, but it's hard, with the baby, and to tell the truth, I'm not sure I'll want to be working, even if I do graduate, and there was a job out there waiting for me. My momma helps me, and she'll take care of my son, but I don't want to hand him over to her and go out and work. I know these days women don't want to stay at home with their kids, and there will be times of the day, when I'm ready to scream, and I've just had it with being a mother, and I think to myself: what if you had a job in some department store, wouldn't you be happier? Maybe so—maybe I would; but I'd be thinking a lot about my kid, and worrying, and I'm not sure I'd be good, selling stuff or working in a restaurant, knowing my own kid isn't being fed by me, while I serve somebody else. Of course, I admit—I look at my momma: she's been with all of us, and she says she wishes she'd had a job when she was young and didn't have all of us kids so quick. Maybe she wishes she didn't have some of us at all! I'm glad she had me—but I can see where she got really tired of us, and she wanted to go to work, but there wasn't much she could do, other than trying to do cleaning somewhere, and she said she'd rather stay home and be on welfare."

With that word spoken, I quickly respond; I ask these four young mothers, each on welfare, what they think about the political arguments going on—as to whether, in fact, they should be entitled to receive

monthly financial support, once they have a child. There is no rush, by any means, to say yes. I can sense the mixed feelings in each of these individuals—hence the unwillingness of any of them to speak for a considerable span of time. Finally, I have to intervene—ask again the same question, phrased a bit differently. Wilma, always one to venture boldly into new territory, did not disappoint us: "I'm the youngest here, and maybe I've got the most to find out, but I'll say this: I want those checks, because I need them, but you know, I don't want them forever. If I could get free of them, I'd be glad. The thing is, I don't know what I could do that would be so good. I wasn't doing so hot in school. I was never excited there—I'd sit and think of places I'd like to go visit, instead of learning my lessons! I guess I started having boys on my mind a few years ago, and now I've got one to bring up! It wouldn't be good for my baby, if I wasn't with him. My momma, she wants to help, and she does, but she's sick a lot—she has bad arthritis, the rheumatic kind, that really swells up her hands and knees and feet: so painful. They give her a lot of medicine—I think they gave her 'gold' for a while [gold salts, one of several therapeutic approaches to that serious illness] and she would laugh, and tell us she was getting rich, for all her pain, and when she was through with the treatment, we could just go sell her, like they used to do with our people, and she'd be worth her weight in gold, maybe, by then! But then they stopped giving her the gold, because it didn't work, and they gave her some new drug, it helps—begins with 'm,' I believe, the name of it [methotrexate]. So we're not ever going to get rich!"

She stops; and we're all laughing. She clearly has more to say, so we take a sip of coffee, or munch on a piece of pastry, and wait for her to resume. In no time, she is continuing: "You see, it's got to be up to us—'Ain't no gold in them hills,' my uncle is always telling us. I'd ask him where there *is* gold. He'd say, 'you've got to find it in yourself, that's the only place where it is!' I just wish I could be better at school. I'm not interested in those subjects they teach, and you know, they'd deny it, but

looking at those teachers, being with them, you can see that they're not interested, either! They look down on you, and they scold you, and they tell you you're just wasting everybody's time! I feel I'll never be smart in school, but I know I can figure out people. I like the idea of going and getting a job, and doing good at it—working hard, real hard. The trouble is, now I've got my baby, and if I hand him over to other people to care for, while I try to work, it'd cost me all I make, to do that. I know, because my cousin tried, and then she lost her job, anyway, because the store couldn't make enough to stay open, so that was that, and now she's back on the welfare, and you look at TV, and everyone thinks we're just sitting here and being lazy, and we should be 'cut off.' Well, I wish I could get me a good job and hold it down and keep it, and I wish I could afford to have someone help with my momma and with my baby, the right person. But where do you find her, even if you could wave a magic wand, like in those fairy stories, and have your wish come true!"

Each of the women is nodding as Wilma comes to the end of her remarks. She has said it all for these four teenagers, who are high schoolers in a not very eager way, except for Margie, who has placed great store in the diploma she hopes to have by the time she is nineteen. Sally Ann has thought of dropping out—she frankly has admitted several times in conversation with one of my sons, with me, at her home, that she never did well in school, never liked going there, that she "always" wanted to be a mother, "from as far back" as she could possibly remember, and that she was "glad" to get the welfare checks, because that's her job, bringing up her daughter, and if she didn't receive any money for doing so, the two of them wouldn't be able to eat and help pay the rent. (She lives with her mother, who is also on welfare.) I remember all this when I see her, in this room, getting restless, and obviously, a bit upset. She tells us, abruptly, that she is glad to "have the welfare," though she agrees, "a job would be better." But then, she disagrees with herself, and challenges her friends, sitting around the table: "None of us is ever going

to get a real good job. They're not for us, those real good jobs! If you're real smart, maybe you could stay in school, and go to college, and then you could get yourself one of those 'plum jobs' I hear folks talking about. But none of them are out there, around here, for any of us. That's why there's welfare, so we can take care of our kids. The men, they up and leave—and they don't have good jobs, either, unless they're doing something wrong! The welfare lady comes here, and she says I've got to get ready for a big change, because there's not going to be welfare for me, like there's been for my momma, and my aunts, so I should stay in school, and then I can get a job someday. I tell her that's great, I'd like to, but where are they, and *what* are they, that's something I'd like to know; and besides, where will I take my kid, while I'm working, especially if my momma is supposed to be working—I mean, where will she put my little sister and brother?"

She says more, then suddenly stops. She is crying. She doesn't have a handkerchief. Margie gives her one. Mary Alice, ordinarily the quietest and the most self-effacing of the four, gets up, moves close to her, gives her a hug, asks her if she can refill her coffee cup, tells her she "spoke the truth," and then tells the rest of us that she doesn't know much about politics, but she is convinced that the entire public discussion of welfare is "unfair." No one wants to pursue the implications of that word —they all sit quietly, heads lowered, Sally Ann no longer crying, but her right hand clutching tightly at the handkerchief that has been given her. I decide to ask Mary Alice what she had in mind when she used the word "unfair." I hesitate, though: these women are visibly shaken, each of them in different ways, and we have been together for well over one hour, and I wonder whether we all haven't had enough for a day, maybe longer. But Wilma repeats the word, says, "Unfair, all right." I expect *her* to do whatever talking there will be on the subject, but she goes no further; sits still and glum in appearance, her head bent way down. Abruptly, Mary Alice gets up, and I figure: that's it, they'll all be leaving

soon. I am preparing to stand myself, when just as abruptly Mary Alice sits down—and then starts to explain herself: "I get so upset sometimes, I can't sit still. I want to scream!" The others seems to know what she is thinking; they say yes, and they nod, and they tell her she *should* scream. She laughs, then becomes quite serious, and then has this to say: "All you hear nowadays is this talk of welfare—welfare this and welfare that. You know what they mean, don't you—the niggers, that's what they're thinking! My aunt goes to work for these rich people, and she hears them, when they don't think she's listening: they say we're lazy, the colored are lazy! There's my aunt, slaving for them, on her hands and knees, scrubbing their floors and doing their laundry, and changing their beds, and cooking for them, too, and all they can talk about is how we're all on welfare! My mom told her to go and give them a piece of her mind—but that means she'd have to quit!

"She hears them talking about all their money, and the deals they make. I suppose they're one hundred percent honest—everything they do is good, and no one gives them anything they haven't worked for; it's just us 'colored folks' who are the crooks, because we're the ones who are on welfare. The government, it's being drained dry by us—no one else, no one else! It makes me sick, the way all the troubles in this country get put on to us: we're the cause of everything that's gone bad!"

She is as upset in the way she is presenting herself physically to us as she is in her words. She hits the palm of her left hand with a fist made by her right hand—does so twice. She crosses and uncrosses her legs, and she pulls at the stocking of her left leg, even though there is no sign at all that the stocking has dropped. She punctuates her talk with her forefinger, either pointing with it, or hitting the kitchen table with it. Her emphasis is so forceful that the women notice that forefinger, keep their eyes on it while they listen attentively to her. Just as she seems to be winding down—a surprise outburst, indeed—I realize that she has more to tell. She asks if we have to go—if not, she has something we

"should know" to relate. Everyone is quiet, even as we all have signaled our readiness to hear her out. She seems embarrassed by the accepting, respectful silence given her; she starts to apologize: "I'm not much of a talker. I like to listen—but if you all don't mind, I went to a meeting the other night and it was very important what we heard there."

We are all curious, I decide; later I realize that *I* was curious—the others knew what meeting she'd attended (though they had not gone to it) and had an idea of what she'd heard. She talks of the meeting with great emotion, in a loud, strong voice, as if there were people in many rooms beyond the one we occupied, whom she wanted to address: "My brother has been telling me for years, three or four, to go listen to the Muslims, because they've got the truth. I'd say to him, Harold, you and I, anyone can find the truth: just look for it, use your head, and think straight, and look for it! He says I'm right, but you can learn from others besides from yourself—and the other night, I sure did! I went with my neighbor to a meeting, especially for us women, in the mosque, and I heard the Muslim leaders talking, and I met the women, and they sure know a lot that's going on! I'm not sure I'll ever join with them. I think to do that, you have to have a real *conviction;* you have to be ready to 'set yourself apart,' they kept telling me, and I'm not ready: maybe I'll never be. I like to go shopping, and I like to dress up—that's my problem. I mean, I couldn't look like them, I don't think, ever. Maybe, sometime—but not now, I know that! But I thought to myself, listening: these people dare speak the truth, while the rest of us go running to hide!"

She is quite aroused, obviously, even as she tries to contain herself—and does so to the point that she stops herself, gets up to fill her cup with coffee, sees that the coffee container is empty, puts her cup in the sink, and seems at a loss: to return to her seat, to make some fresh coffee for herself, or to begin the motions of departure? The other women want to hear more—though I notice, for the first time, that they are discreetly eyeing me: how to talk about the Muslims in front of this guy? I

decide to take leave. I stand up, say I've got to go—I have an appointment elsewhere. No, they tell me, stay a little longer—Mary Alice among them. But I'm quite certain that the protest I've just heard is pro forma, that they really would be more comfortable at that moment (well, all the time!) without me sitting there. Still, they tell me that soon everyone will be leaving—and I should stay "at least for five minutes more." I wonder why—no revelations will be forthcoming, I think to myself all too confidently, if not smugly. It is Mary Alice, actually, who insists I stay: "I'll tell you what they said about welfare, and then you can write it up for people!" I sit down, more than a little uneasy by what I've just heard about my work—rather, by how I choose to interpret what I've heard: the scribbler who is an informer! She is tense now: "The Muslims think being on welfare is being a slave! They think you should stay off; you should be independent of the white man's folks, the welfare people, all of them. You should make yourself your own boss, and clean your life up, and join them, and not be someone holding your hand out, and waiting for some bossman (it could be the welfare people, you know) to come and give you a few bucks, so you'll smile and say yes, sir, yes, sir!"

She is not going any further, I can tell. She purses her lips in a determined silence. Margie thereupon says *she* has to go, and since it is her home where we now are, in no time we're all leaving. As we go, I hear much that is important to remember, though—I hear these four women both agreeing and disagreeing with the Muslims. Yes, welfare in some way does make them dependent, they acknowledge, yet what is the alternative, they all say, Mary Alice included. My tape recorder is in its case, and we are walking down steps, walking on the street, but when I am in my car, and have driven out of sight, I stop, to write notes to myself: to remind myself that more direct conversations on welfare would be helpful for all of us, not just this white male outsider—so each of those women, indirectly, seemed to be saying, because they lingered long, they talked hard, they separated reluctantly.

We are together again, three weeks later, this time quite pointedly intent on "hashing over the welfare business," Margie declares—again she is our host. I ask for "thoughts" on the subject, and Margie is quick to respond to *that* word, never mind the word "welfare." She challenges, it soon becomes apparent, my assumptions, if not presumptions. "I don't do any 'thinking' about welfare. It's not something you sit down and start having your thoughts about! It's there, it's what you apply for. I guess you're asking us if it's right or it's wrong—what we think. I don't know—is it right or is it wrong, the way a lot of things go in the world? Is it right the way some folks have everything, and others nothing? If Jesus came here, would He say the thing that's bad about America is welfare, or would He find something else to blame for our troubles? I don't know, and I don't know what I should think. I got a job before I got pregnant, working in a store, for Christmas, cleaning up and putting stock on the shelves—it was the new 'superette' we have near here. (We finally got one!) Then it got slow, and they said they were 'merging two positions,' and I got laid off. I tried to get another job, but no luck. My aunt said maybe I should come with her, when she does cleaning [across town, for a well-to-do white lawyer's family], and I could learn how to do that, but I'm in high school, and I kept thinking I could do better than clean somebody's house. My aunt said, 'Right,' but she said I was getting 'uppity' with her, so if I'm going to be like that, I'd better work hard in school, because you can't be uppity and have no work and no money, unless you want people to laugh at you! So, I tried doing the best I could at school, and I wasn't great, but I did pass everything. Then, my baby came to me. I'm trying to bring him up—that's what welfare is: it means you can buy food for your kid, and the Pampers, and all he needs. I'm trying to go to school, but I can't get there a lot. When my momma gets sick, I have to help with my brother and my sister, and then I've got my own to look after. You take welfare from us, we got nothing. If my momma and I could get jobs—and it's hard, I've tried—

who would mind the kids? I hear on television they're going to tell us to work, and send the kids to day care. Where's the day care around here? Where's the work? I guess I have those 'thoughts'—but not most of the time: most of the time I'm just trying to get from 'sunup to sundown,' like my momma says you've got to do, and welfare, it's what helps you get there.

"If they took it away [I ask about that, what would happen]—I don't know. I don't know how I can work and take care of my baby at the same time—nor my momma, and if there's no work you can find, then I don't know, I don't know. People say, the city would give you food, or the churches—I don't know. Maybe the city would give you a job, and they'd have places where you brought your baby. I'd be worrying, though—who's taking care of my baby!"

She starts scratching her right arm with her left hand, and at the same time she shakes her head. She tells us that she hates thinking about "all this"; then, she says, "It's hard to be black, it always is," and now she insists, "It's getting harder." All the others agree. Wilma speaks next, repeats what Margie has said almost word for word—on the particular difficulties African American people must confront daily. She expands on that subject, tells of moments of humiliation she has experienced in "white stores," on the streets with "white cops," in school, with the "white teachers" who, she tells us, "look at your skin first, and then decide what they think of you." She amplifies: "Even with us, they look at us to see if we're light or dark, that's always on their minds. We all know it; we all can see it—even the light ones, who become the favorites. The first day of school, we joke, before we even go into the homeroom: we can pick out who is going to be put in charge, and given all the nice things to do, like go on errands, and be told, 'You are doing well,' even if it's not true that person is doing any better than anyone else! They always hand out their compliments to the 'fair' ones!"

I ask about the black teachers—are they at all inclined toward a simi-

lar distinction? Margie doesn't answer with words. She waits a few seconds, then slowly shakes her head. But immediately thereafter, Sally Ann speaks, disagrees: "Our own, they can be the worst, worse than the whites! All they know is *color*, what shade you are! I remember this teacher in the fourth grade, she was pretty dark herself, and she had us all segregated, like a sheriff in Alabama would, my gramma said [who came north from Mobile during the early 1960s]. Everyone lighter than her, she favored. Everyone darker, she turned on, any chance she could find. I was somewhere in between—I now realize I was about her color. So, you know what, when she was in a good mood, she'd be nice to me, and to my friend Lill, who is the same as me; and when she was in a sour mood, feeling rotten, she'd turn on us and be real mean. Lill used to say: she's an old maid who never gets anything good! When she first said that, I wasn't sure of her meaning—but she taught me. She had one big mouth on her—and still does!"

There is an extended discussion on that subject, summarized by Wilma this way: "Color counts all the time—no way it doesn't. Even those welfare folks who come visit you, I'll bet they notice." At that, Mary Alice suggests we may have gone "too far"—she points out that "welfare is welfare," and adds, pointedly (in late 1994), "so far." But the others remind her of the discretionary authority of the social workers whom they see: some are tough, skeptical, demanding, legalistic; others are sympathetic, considerate, earnestly anxious to be helpful, and thoroughly aware of what flexibility the various laws and regulations allow. Indeed, these young women have often compared notes—who says what to whom, who grants what leeway to whom: the variations possible in a bureaucratic system become, for the individuals called "recipients," a matter of great significance. I am stunned, actually, at the direction the discussion takes: a coming together, surprising to me, of the matter of "color" *within* the black community, and that of "welfare," with Wilma the initial commentator to make the connection most explicitly and

forcefully: "You know, I compare what I hear with what my cousin hears —from the same [welfare] lady, and she's black, too! See what I mean?"

She stops long enough to get nods from everyone but me, who seem quite out of touch, so these women decide, as they look at me with a certain tolerance: the poor fellow sure *does* need an education, as he always tells us when he makes his pitch to us! More from Wilma, who looks right at me, and addresses me directly—a break with the routine of a conversation that has until then been shared by all: "You should know this, that because I'm lighter than Tricia, I'm always being encouraged! She comes a lot more times [than she does with Wilma's cousin] and she tells me that there's all these programs, and I can really get somewhere if I just *decide,* that's what she keeps telling me, *decide* that I'm going to 'break the cycle.' You know what she's saying? She's saying that I'm better, I'm a better person than my own cousin—even though her mom and mine are sisters and we have the same gramma, and she's never been partial to anyone, because she tries to be equal, with her love; and that's because she's a shade on the dark side, compared to me. It's *that;* it's nothing else that makes the difference."

My face registers both belief and doubt, I realize—I'm surprised (the doubt), but I'm no stranger to the various ways people respond to others on the basis of race, *and* while working in the South in the 1960s, my wife, Jane, and I often heard such stories, told us with sadness or anger or bemusement by black children, never mind their parents. But it's now thirty years later and I am in Boston, where admittedly, racism is no stranger, but where (among blacks) or in connection with welfare payments (seemingly an automatic matter) I would not have expected such clear and constant discrimination. Wilma sees my perplexity right away; she laughs, as if to signal me her comprehension, and she becomes, yet again, a teacher: "If you are white, you probably won't pick up on something like this. If you are black, everything gets tied to this—you just know you're one 'shade' or another, and it makes a difference. That's

what I heard my mom say when I was (I must have been) four or five: 'Wilma, honey, all the white blood in our family has come out in you, and so you're going to have Lady Luck smiling on you all your life!' I'm still waiting! But I sure know what she was telling me! Listen, when I was carrying my child, you know what I thought—this: if it's a girl, I sure hope she takes after me, and if it's a boy, it doesn't mean as much. See that?—the lighter you are, being a girl, the better your chances with the guys!"

I must still be in some way unconvinced or puzzled: yes, with boys, but with welfare workers?! She knows exactly my reluctance (as it appears to be to her) to go as far down a road as she has gone. She decides, first, to declare what she believes to be the reason for my skepticism, and only thereafter, to take it on argumentatively, or maybe narratively is the better word: "You think welfare has nothing to do with all this—that you register, and you get your worker, and she interviews you, and that's all. It's true, if you're eligible, you're eligible—but, there's all kinds of things that can happen. They can be nice to you. They can try to give you breaks, and get you into programs. They can give you extras, if they like you and want to help you; or, they can be tough, real tough, and put you through the third degree, and question you and question you, and visit you and visit you (I mean, check up on you and check up on you), and they can delay, and they can say they've got to *look into* something, and before you know it, you're not getting a check and you're not getting a check, and they're making you feel like you're the worst, the worst. I won't use the word how they make you feel [smiles from us all], and it's on account of your skin color, and I tell you, the welfare worker, she could be black, and this could happen to you—it *did* to my own cousin; and that's the world, how it is."

Now I get it: now I'm the one lowering my head, in an incredulity that has, at last, yielded to embarrassment—as well as the reflexive expression of moral sympathy that I utter. Now we all sit and look at a

plate of cookies and our coffee cups, full—no one drinking or eating: this topic, aired, has stopped us in our tracks, and will do so for the longest time in my research on the larger issue of "teenage pregnancy," a subject within a subject, alas. Finally, Wilma carries us on: "There's one worker I talked with, she's nice, she's a white lady, and she said everyone thinks of black people when they hear the word 'welfare,' but in the country, it's fifty-fifty. I wish none of us was getting welfare—if we could just get by without it. That's the big problem: getting by! I don't want to take what's not mine, but I have to feed my boy, and my mom, she has to feed us. She's tried to work, but she has anemia, and she can't last long on her feet. She has problems with her joints, blood in them, the hospital people say [she has sickle-cell anemia]. She can keep the house clean, but to go across the city and keep someone else's clean, with them breathing down your neck, and adding new things to do every week, and counting the dollars they give you each week—it would be too much for her. You know how I know that? She tried, and she got sick. My aunt, she keeps doing it—she's maid to a guy, he's a lawyer, and he has girlfriends. My aunt says she never knows which one she'll find there, from one week to the other. Some are nice; some are mean. But if you can't be a maid, and you can't last on your feet in a store, sweeping and dusting—there's nothing to do, and you can't eat with nothing coming in, and welfare is a lot better than nothing. That's how I see it."

General agreement, though Margie insists that all of them shouldn't "apologize" for what they're getting, because "it's for the kids, and they deserve it"—and since they might have to go fight a war, welfare is a way of paying them their due. She has heard that line of argument, actually, from two sources, her brother-in-law, who is in the army, and her welfare case worker, a black woman of strong political convictions who keeps insisting that "welfare is a right," that all sorts of other Americans are assisted in various and substantial ways by the government, and so poor people are also worthy of support. Margie dutifully echoes that

sentiment, but then voices some skepticism, which she attributes to her own nature: yes, the point of view may be correct, but she is always hesitant to "take from someone," because she feels a concomitant obligation to "pay back" what has been received, and she knows that she won't be able to do so with respect to her welfare checks. She astonishes everyone in the room with this description of a weekly habit that hasn't stopped since her son was born and she started getting checks from the city where she lives: "I got a big piece of paper, and I put down the amount of the first check, and then I added the second one, and after there was five there, I added them up, and got a number, a lot of money, that I owe the folks [at the welfare office, which she had visited]. Then, I did the same with five more checks—and I'll try to keep it up. My [older] sister, she thinks I've got some trouble in my head for doing that, but it's a way for me to remember what I've been getting, and if I could pay it all back, I would, but I'll never make that kind of money, I know."

Each of her friends in that room clearly wants to say something to her, wants to persuade her to stop doing what she is doing, yet none of them speaks to her, or says anything to the rest of us. Instead, there is much fidgeting, and exchanging of knowing looks—a sense of some unchallenged weirdness. Margie is far from unaware of all this, however —she waits, then surprises us a second time with her further reflection: "I know you girls think I've been hit over the head, and there's a big swelling there, and that's why I'm doing it. But I'm afraid that if I don't, I'll just get used to those checks coming in, and I'll never lift a finger to stop them! Maybe I won't be able to stop them—unless I get down on my knees and ask my mother to feed me and my son, and let us move in with her. But *she's* on welfare, too—so I wouldn't be *off* it, I'd just be *on* someone else's. If I can get through school, and go to beautician's school, learn that, I think I can do it: make enough money to pay my rent and buy us food. I get ten dollars sometimes from the baby's father, but it's not sure, from week to week, what he'll do—if he'll help us out.

He gambles a lot, in cards, and if he really wins big, he'll come over and give me a ten (twice a twenty), and he feels like a real big shot, then. He'll tell me I should change the kid's diaper, when I've just done it—that way, he can show he's a father who cares for his son! I never argue with him. I talk to myself. I say, this guy is more of a baby than my baby is! I say, go along so you can get along! I say, ten dollars is better than nothing, and he could make it a habit, maybe (who knows?). If he wants it [sex], I'll go and do it with him. I still like him. He says he wants to come and be with the two of us, when he's got himself plenty of cash. But no sooner he wins, he goes wild with his bets, and he loses. Then he borrows, to start in all over again, and so he's always behind. My gramma's brother, he says it's like it used to be down South with being on 'shares' [sharecropping]—you always owed something, and you never really got free, and that was just like the slavery they had before. I feel sorry for the man! For a few times, I was writing down how much he left me, too—but he never gave me that much, so I can keep it all in my head!"

She gives us all a shy, engaging smile—an acknowledgment on her part that yes, it is a bit odd, this accountant's zeal she can't seem to shake off. Still, the more she talks, the more she earns our respect and sympathy—the poignancy of her wish, in some way, to keep a record of what is happening, to balance things out, somehow and sometime. Indeed, Mary Alice quite unselfconsciously joins ranks with her, tells us that she doesn't write down sums on paper, but she does keep remembering the check, well after she has cashed it—and she has "a big dream," that one day she'll get a check like that from her boyfriend, the father of her daughter, or from a job she has secured (though she has scant hope that either of those two possibilities will materialize). Sally Ann nods, says she knows "about how much" she gets each year in welfare payments, and calls it "a weight you have to carry, not something nice that's happened to you," a distinction that obtains a vigorous chorus

of approval from all the others—though Wilma is quick to add her more political voice as a contextual afterthought: "We're always carrying weight, us folks." They all looked to me: do you get this racial reference? I nod, and we break for more coffee.

I begin to realize that in our meetings it is hard for the individual young women to talk about their more private thoughts. In a sense, after all, they drew strength from one another as they ate and drank and told their respective stories about their children—and they much enjoyed, actually, being away from them for those meetings: a morning "off," as it were, with their mothers or sisters standing in for them as baby-sitters. Nor did they feel free to be all that candid about their boyfriends, I began to realize, in the company of others. True, a general mood of cynicism about men prevailed—"they" and "them" constantly described as untrustworthy or unpredictable or, at best, unreliable. Yet, each of the four young mothers wanted so much for things to be different, in that regard, to the point that, one after the other, they rallied around those four men who had fathered their two sons, two daughters: excuses offered, explanations suggested, even justifications made—until a smile, a sigh, a shift of the body, a wince on the part of one of them turned things around from a dissent kept under wraps to a general confession, wherein "the true colors" of this or that one of the four got a quite vigorous, critical airing. When that had happened, when a man heretofore protected by rationalizations, exaggerations, even outright lies, was suddenly, for a brief moment, discussed with some candor, the four of them fell into a sustained, a tenacious silence, and I often felt that it was *then* that we all ought to probe the matter further, talk about how such reprobate behavior affected them, as young women and young mothers—but no, invariably we got side-tracked by someone (I began to realize) determined to table such a line of discussion. Once, I persisted; I tried to force the issue, kept asking that we talk about those men less as persons to admire or condemn, than as individuals who had made, after all, a big

difference in the lives of these four mothers in that room, and so, as individuals whose future is important to them and their children. No one wanted to pick up on that theme, on the men as of *continuing* significance to them, to their children.

When I talked with each of those four women separately, I heard, in contrast, a great deal about those men—and very important, about welfare as an alternative to them, a means of providing for women whom men had chosen to ignore all too consistently. So often provocative, Wilma was the most readily inclined to take off the gloves, have a blunt say about "more than just one man," as she put it, moving steadily toward the abstract: "You have to think of this—without welfare we'd be at the feet of those guys, begging them for coins, not bills! They're so tight. They're so stingy with you—and for their own kids, they still don't want to help out. No, not every single one [I had asked], but most, that's how I see them: no good, when it comes to supporting what they got going! Oh sure, they'll sweet-talk you. They'll spend on you 'before,' and they'll cry 'poor, poor,' boy will they, 'after,' that's what we all know; and that's where welfare comes in—it's not something you want to be on for the rest of your life, but it gets you through starting out, so that you're not running after some guy reminding him of what he's trying to forget."

She is especially angry at her son's father. He has more money, she knows, than he lets on. He hands that money over to his tough, demanding mother, and to his brother, who is the pride of the family, and headed for college. He spends freely on himself, yet rarely wants to give Wilma the money she'd like from him—not so much full support (which she knows he'll never offer, no matter how much he makes as a truck driver and, she suspects, part-time drug runner) as a gesture of loyalty and interest in her, in their son, who bears his name. For a while, she wasn't going to name the boy after his father, but he insisted, and she thought that if she consented, there would be a generous response. There

wasn't, however—and so Wilma bitterly turned to the welfare system, after having sworn, initially, to her friends, to herself, that she would find a way of not doing so: "I had my mother on my side: she'd try to feed the baby, the way she does everyone else, on *her* welfare money. (She said to me: 'Two of us on welfare, that's too much.') My aunt said she'd give me some money, from the pension she gets [her husband was killed in the Iraqi war in a fluke accident], and I was still holding on to my dream that this was one daddy who'd care about his kid, really care. Well, famous last words: no one had a thing to give me, except Momma, and all she had was in the refrigerator, and food doesn't pay rent, or for the baby's clothes, and I didn't want to stay in my old bedroom, with my sister there, too, and now the baby. So I turned to welfare, and that's how I live, now."

For Mary Alice welfare was, she did not hesitate to say, a part of her anticipated future. She is the daughter and granddaughter of women who have raised children without the continuing presence of their fathers and with the help of the monthly arrival of a welfare check. She is not in the least of a mind to feel ashamed or apologetic for receiving those checks. She is quite willing, actually, to describe how those checks have all along fitted into her sense of things: "When I was little I'd go with my momma to shop and to visit Nonna [Mary Alice's grandmother]. There was this store that cashed the checks. They got plenty for doing it, I can remember! I don't remember how much, no. [I had asked.] But I do remember Nonna saying that it's not just the white man who 'steals bloody murder' (that's what she said!) from 'us colored folks.' She could remember her grandfather talking about being on shares in Georgia, and by the time the owner of all that land was through, 'the colored people were lucky they were still breathing.' Same with that store where they cashed checks—if you got out of there with enough money to buy your food for the month, you were doing pretty good!

"What is welfare supposed to be for? [She is repeating my question.] I

haven't ever asked myself, but I could try to answer—I mean, I *know* what it's for: it's so my little baby and I can eat and have a roof over us, and she can have her clothes, since her daddy doesn't want to be her daddy, *yet* he says, but 'yet' means no, I sure know! That's how I see it —welfare prevents you from being out there on the street, with nothing to eat: that's what it would come to, without the help we get. I remember my momma telling us that this is what keeps us going, and she'd show us the check. We'd have drowned, otherwise!"

When she was nine and ten, she thought she might want to go into the army or navy—she'd seen television advertisements that promised good careers for women who enlisted. She was never an able or interested student, but she did love to look at maps and globes, and she let her mind wander to different places on this earth. Moreover, as she watched television and thought about herself, as a grown-up, she imagined herself walking down the streets of foreign cities with the heightened self-respect that Americans in uniform can get, can feel, or so she believed. She would sit in her chair and watch a movie or a news story that showed one of those distant locales, and put herself in the scene, think of herself as part of it, a soldier, a member of the air force or navy, on leave and exploring this or that world. But by the time she was "twelve or so," she was no longer "into thinking about that stuff." She had her first steady boyfriend; she felt an increasing disinterest in school; she was putting herself into different films and news stories—thinking of herself dressed like so-and-so, driving one or another kind of car, using a particular kind of perfume, owning particular tapes and compact discs: yet another "with it" American consumer. She was also beginning to think of herself as a mother: "It's only natural, I guess. I don't remember the first time [I had asked], but it was about the time I broke up with Andy [her first boyfriend] that I would think a lot about having a baby. My momma said to me, when I started with my period: you be careful, something can come of this—you can have a baby. I knew anyway, but

her saying so stuck in my mind. She said, 'Don't you have a child until you're good and ready,' that was what she kept telling me. When I got pregnant, I told her. I said, it may be early for me, but to tell you the truth, I'm 'good and ready.' Then, I told her why: because I wasn't getting anyplace any other way, and so this was the way for me. You see, it was—"

She stopped right there and was loath to continue. She turned her head away from me, looked at the refrigerator long and hard. She got up, went to it, got herself a Diet Coke, asked me if I wanted one, brought with the drink some potato chips, both of which she set down on the kitchen table. She munched away on the chips, and said nothing. I decided that I ought to leave—we'd been talking for almost an hour, a long time, given the subject matter and her shyness, her ordinarily taciturn nature, which had already been abandoned quite enough, I began to realize with some tardy gratitude, a sentiment I now tried to put into words. I told her that she'd been a great help to me, that she'd helped me understand not only her thinking, but that of others, so I believed. She smiled, nodded, and kept working on the pile of potato chips and at the Coke. She asked me if I was "sure" I didn't want either. No, I replied— and I suppose, if I had been asked to put on the record what I *did* want, it would have been a continuation of the discussion we'd just been having, which I had begun to realize was carrying us close to important psychological matters: a youth's decisive moments, when she turned in a particular direction—or maybe, decided she couldn't walk down certain paths, and so let herself drift toward one path whose destination she knew well, knew in her bones out of a family's experience.

But I got up to go, exchanged pleasantries, and was about to be on my way, when Mary Alice decided to say this: "Soon the baby will wake up and need to be fed—so I guess I'm getting my own feeding in first!" She stopped there, and we both laughed. I was tampering with my Sony machine, and getting ready to pack it up, when she joked with me that

the machine seemed to be "settling down." She remembered previous troublesome incidents, of various kinds, often the result of my mechanical incompetence, a trait that has gone unmodified by over thirty years of on-the-job training. I told her that at last I had figured out how to work this new gadget, and now was able to take it for granted, more or less. In the past, a tape recorder that didn't always work had turned into a big presence, indeed, in that room, maybe a presence that had a considerable influence on the direction of conversation: a heightened self-consciousness that dampens spontaneity, creates an awkwardness, a hesitancy in everyone. She smiled knowingly as I alluded to the phenomenon—and then told me that "when something doesn't work, and you want it to, then you're real, real frustrated." Yes, indeed—and now an analogy in her own life: "I had a lot of trouble, at first, with the baby: my milk was coming too fast, and she wasn't sucking good, and we were in real trouble. My momma tried to help, but it still wasn't right. Then Nonna came, and she showed me how to hold the baby, and somehow she got her doing better, and me, too. She should have been one of those doctors: there's nothing, it seems, that she can't fix right!"

A moment of silence, while I digest what I've heard, connect that story to mine—the tape recorder and its owner as parent and child! Mary Alice takes one more swig of that Coke, and finishes our educational meeting with a strongly emotional declaration: "Now that all is going real good with the baby and me, I feel I've got my life working the best it can, and I'll just hope this baby will grow up and be healthy. You've got to have something to keep you busy—my momma always says that, and now I do, so I'm glad!"

She had found a way of life that fits into the customs and habits of a neighborhood. "Me and my friends," she'd often say to me—referring to other young mothers with whom she spent time in a nearby park, exchanging news and stories that had to do with pregnancies, child rearing. As I heard more and more from her, and from Margie and Sally Ann as

well, during visits with them, I began to understand how *natural* all this seemed—not quite the "problem" it most certainly struck me as being. Again and again, these "adolescent mothers," as I often thought of them, were letting me know, in a variety of ways, that even as I had found my vocation, learned how to lug around a tape recorder, feed *it* with voices (theirs!), get a sense of fulfillment from so doing, they had found in early motherhood their own vocational direction. Moreover, the more I took issue with that way of thinking, challenged it directly and indirectly (with some tact, I hope), the more impatient or sullen or defiant (depending upon the person, the time of day, the remark I'd made) the rejoinder I'd hear. When, for instance, I pushed Sally Ann, once, on her "reasons" for becoming pregnant "so young" (she and her boyfriend had practiced "safe sex," as she put it, "sometimes," so certainly knew how that is done) she told me at some length that she was "glad" she could be a mother, "because that's my job, you see." I fear I didn't quite "see," *don't,* still. I wondered out loud, as tactfully as I could, about welfare as a kind of "job subsidy." Is that what the government intended? Sally Ann took me by surprise with this blunt rejoinder: "Hey, I saw on television that the government is giving these loans to college students, money so they can go to school. That's good! The more people getting an education, the better! I wish I could have stayed in school, but I was never very good there. Maybe I could have been, I don't know. I was sick with bad trouble in my lungs for the longest time, pneumonia, you know, and I missed a lot of going [to school], and so I had to repeat, and just never did catch up. But I'll hope I can get my girl to do better! Isn't that doing something for the country—to be able to take care of your baby right, so maybe she'll want to go further than you? I'm trying to learn, too [in a parenting class], like the folks in school—how you raise your kid right, so you'll get an A plus as a mother, and the kid will get good grades, too, when it's time to go to school."

She has constructed an analogy, posed it to me—all done casually, in

a tentative conversation interrupted by a phone call and a baby's call for food. She is not prepared to tell me that she is the troubled youth that she more than senses I hold her to be—nor is this current life of hers the choice of last resort I keep deeming it, as she also guesses to be the case. As for her political (and sociological) suggestion, that the country regard *her* and others like her as "students"—welfare, in a sense, as an educational subsidy of sorts: I let that one go by, when I am with her, and later, in another sense of the phrase, I also let the notion "go by" as unrealistic, and too, as morally and psychologically flawed. Still, I have been pressing her for her views about the situation, and specifically, about welfare—what she thinks of it, what she thinks of herself as a recipient of it—and she has given me that, her considered views.

# 4. *Fast-Time*

Words pour out of her mouth, so her mother says, trying hard to figure out her daughter, understand what crosses her mind. The mother herself is an easy talker, but she does stop and think every once in a while; and she precedes or punctuates her sentences with an "oh," a "hmm," a "yes, but," a "no, not really," that are allowed to stand on their own for a second or two, as if to tell the listener that she is thinking hard, or wondering about something, or has gone off to consider the matter, and will be back soon with a sentence or two. As for Marie, the daughter, she talks nonstop—a torrent of language that has her mother puzzled as well as angry: "We're Irish, and we're supposed to have the gift of gab, but when that girl starts in with her talk, I want to hold my hands to my ears! When she's not talking a mile a minute, she's running someplace. She's always in a hurry. If I tell her to slow down, please, and let the rest of us catch up, she gives me a look that says: poor you, I can't be bothered living that way! I've learned to bite my lip and say very little—anytime I ask a question or just suggest something, I get shot down. I talk with our priest, and he says it's 'adolescence.' But I was young once, myself, and Lord, we respected our parents. *They* were the ones who did the talking; we did the listening. It's just the reverse here in this house!"

That house is located in a comfortable working-class neighborhood just within the city limits of Boston. Marie's father is an electrician; her mother is an elementary school teacher (the third grade). Marie is one of five children, "the third down," her mother puts it: an older sister, an older brother, two younger brothers. Her older brother has graduated from high school, has gone to college, wants to be a lawyer. Her older sister is a senior in high school, is headed for the arduous training required of those who want to be nurses. Marie was sixteen, a sophomore, when I first met her. She had become pregnant, and though her parents are devout Catholics, they urged her to have an abortion. She defied them, said no—she would carry the baby, give it up for adoption. But that intention was soon enough abandoned, much to the chagrin of her mother, especially. Marie's father, who is quiet to the point of being taciturn, kept telling the mother to mute her objections—he shrewdly sensed that they weighed heavily on whatever Marie decided: the desire to confront, to take issue with her mother. He had told Marie "good," when she told him "maybe" she'd keep the baby, after all—and he saw her face fall, a telltale disappointment. Yet, when he told his wife to follow suit—the best way to get the daughter to come around to their way of seeing things—there was only the cold silence of anger, spoken later in this fashion: "I don't understand this child; I think I never have. I may have 'lost' her when she was very young—she's in the middle, right in the middle, and maybe I never had the time for her that she needed. My husband says I should sit down and talk with her, and not argue with her, and then we'll be reconciled; but I've tried, and it never works. Now, he says to go along with her—and if I do, then she'll be more sensible, and give the baby up, but I'm not so sure, and anyway, she can 'read' me, she knows me. I'm her mother. I can't pretend, it would be foolish, and she'd turn angrier than she already is. Of course, when you talk with her, she won't admit to being angry. She says she loves life, and

loves to be part of it—and she's going, going, all the time, she and her friends."

I am introduced to Marie (as I was to her parents) by her parish priest, whom she respects, but keeps at a distance. I meet her and two other young women, one seventeen, one almost exactly Marie's age, in a room in the basement of the parish meeting hall, next door to the imposing Catholic church, which all three girls have called their own since their first years of childhood. Marie is at the time five months pregnant; her older friend, Jean, is seven months along; her friend Maggie, like her, five months "into it," as she puts it, "with four months to end it." That cavalier, brusque tone, with its provocative ambiguity, unsettles Jean, but not Marie, who calls Maggie her "sister," because they are a week apart in birthdays and their children are due within a week of each other. As I sit with these three women, I remember what Marie's mother has said about her daughter's gift of gab—she is, indeed, a talker, as is her close friend, Maggie. Thank God for Jean, I think—who has the other two flanking her, Marie to the right, Maggie to the left, with the priest and me across the room. He has been meeting with them every week, "just to talk." They like him—find him much less judgmental and overbearing, the three tell me in different ways, than their parents, who are all solid, working people of the so-called lower middle class: Maggie's dad is a city employee, her mother a nurse; Jean's dad is a physical education instructor in a high school, her mother a secretary in a neighborhood law firm.

As I am learning the above, I notice how impatient Marie, especially, is with me. She laughs at one point, tells me she would have *written out* all the "family info" I've been requesting, had she only known. Then, she has a suggestion—I should go and talk with her mother: she loves to "analyze people." I am annoyed enough (there have been, from the start, displays of boredom, indifference, sarcasm) to throw the recommenda-

tion back at her: "And you, do you talk much with your mother?" I regret what I've said as soon as I hear it, feel stupid for saying it—why shouldn't these young women feel wary of me, upset with the priest who sprung me on them, without asking their permission beforehand! I can see him fidgeting, and I'm almost ready to say something, anything, to set us on another track, when Marie laughs and says: "I don't spend a lot of time with my mother, no. But I'm like her; I try to size people up, yes, I do. I'm quicker than my mother, though. She takes her time at everything! She says you have to have patience—and I guess if you're teaching third-grade kids, you do. I'll never do that, never!"

Her friend Maggie speaks up, tells her with friendly sarcasm that she'd be a "disaster" as a schoolteacher, no matter the grade. Marie gets surprisingly upset, angry—now blasts her mother in a tirade that lasts long enough to prompt the priest to intervene, ask her where such an outburst had "come from." Marie does not answer: she is dejected, morose, visibly shaken. She is tapping away with her right foot; she is chewing on her left hand's nails. Maggie puts her arm around Marie—who has teared up. The priest decides to apologize, tells all three of the young women that he is sorry he spoke up—but reminds them that he is a priest, and he can't help responding as one at certain times. Jean speaks up with poignant reassurance, reminds him that it is *because* he is a priest that they are there. Maggie nods, but not Marie. Eventually, Marie lifts her downward glance, looks at the priest, stops tapping the floor, speaks: "I sometimes wish I'd had an abortion. I know that's what my folks want. They won't admit that to you, Father, but they let me know! My boyfriend [the baby's father] feels the same way. He'll never want to really stay with me and that kid; I know it. Even now, he comes to see me once a week, and the look on his face—it's as if he's walking into a prison, and he's got a death sentence to serve!

"Why *am* I carrying this kid? I've heard all your reasons, Father, but soon you'll be advising some other kids, and meanwhile the three of us

will be having the kids, and we'll be on our own with them, and it won't be fun, the life we'll have. That's why I'm supposed to give this baby up [for adoption], but I don't know if I'll be able to, when the time comes. I don't know."

She is looking right at the priest, who eventually looks away, at one, then the other of her two girlfriends. Maggie is crying. Jean talks: "No one should decide this now. You need time. [She looks at Marie.] I feel as you do. One minute I want *out;* I mean, well—for a doctor to do something so I won't be pregnant. The next minute, I'm wondering what the baby will be looking like, and I'm wondering if I'd be a good enough mother for it. I don't know if I'm ready to stay home a lot and be with a baby all the time—feeding it, changing the diapers, holding it, so it can burp, giving it a bath: I'm just getting old enough to go out and have fun, and here I'll be, back at home again, looking out the window, seeing others going to have a good time, and not being able to join them! My mom goes to church a lot, but I think she wanted me to 'do something,' too. (She'd never use that word [abortion]—I can't use it, either, especially in front of you, Father.) I don't know what will happen—I do, actually: I'll have my baby, and I'll go back home with it, and I'll be there, bringing it up. That guy who got me into this—he's in Georgia, in the army. Do you think he cares what's going on now? He told me he'd pay for me to have that procedure—and he's a Catholic, too."

Marie has been listening carefully, and seems again agitated, and unable to keep her body still. She scratches herself. She runs her fingers through her hair. She crosses and uncrosses her legs. Finally, she talks, in a loud voice, indeed, looking right at the priest, mostly, and occasionally, my way: "I can't believe I got myself into this—let this happen! When I was little I dreamed of growing up and clearing out of this city. I wanted to go to New York. I wanted to go to California. I read in the paper about these writers—they crossed the country, and they had a

great time. I can remember the story, how they were going, going, and I thought that's what I'd like to do!"

She stops, though she obviously has more to say. She looks at the priest. He is trying to be sympathetic, encouraging, but she scans him in quite another light, as becomes evident by the bitterness implicit in what she now discloses, and the harsh delivery that conveys it: "My mother is always saying we've got no choice but to be 'good'—otherwise we'll be punished after we die; and besides, she says we'll get into plenty of trouble right here, while we're alive. My dad, he says you get what you deserve out of life—then, an hour later, he's telling us he's being gypped by this guy, and someone else is a crook, and he's 'living the life of Riley' in a big house in a fancy town someplace. My problem with listening to him, it's that I remember what he's said, all of it! My problem listening to my mother—I remember what she's told me, everything! She was crying once, in her bedroom, and I came in by accident; I must have been eight or nine, I think. She told me to leave, please, but I wouldn't, and then she cried more, and I came nearer to her, and she told me this story, of my dad, and a girlfriend he had, she was sure of it, and she was told that the girlfriend was going to have a baby, and Dad was giving her some money, but he didn't have enough, so he'd been—he'd started gambling, to make more money. But he didn't. I don't remember the rest: it was a long story, but I do remember that she'd gone to see the priest, and he told her he'd pray, and she wanted him to meet with her and Dad, so it all would 'come out,' but he said he'd rather talk to my dad first by himself. Afterwards, a day or two, I asked my mother what was happening and—would you believe it?—she said I should forget what she'd said, she was just 'upset,' and 'imagining things,' and everything was 'all right.' I must have looked as if I didn't believe her, because she got real 'cross' with me: that's what she'll do, she'll say she's 'cross,' and you're supposed to run for your life! She told me I was to forget what I'd heard her say, and never mention it to anyone. So, I

did—for a while. But then, when I got older, she started telling me I was doing everything wrong (she'll get that look on her face, that says I know what's right and you don't, so listen to me!)—that's when I told Maggie, and she told me stuff, like that her uncle just got married, and his wife had a baby four months later, or five, and her mother said that happens a lot. We started learning about 'life' early, Maggie and me—we were in the sixth grade, I think, so we were eleven, maybe [I had asked]."

She lets herself be stopped by my interruption—a foolish one, I realized too late: this urge for details that can sidetrack an important narrative flow. She clams up; her face displays a sullenness. Her eyes dart back and forth from the priest to me. Suddenly, an outburst—almost as if she has been waiting for a long time to put on the line what has more than crossed her mind: "In church once the priest talked about 'hypocrites.' I was a little kid then, a few years ago. I was sitting there, and he used the word, so I asked my mother: what does it mean? She said I should be quiet, and she'll tell me later. She thought I'd forget! She's always hoping I'll forget something! Well, I didn't. I waited, and when we were home, and she was cooking supper, I asked her again. This time, she told me she had to get the spaghetti going, and the vegetables, and the hamburg meat to go in the sauce, and she had a pie in the oven, and bread to heat up: I remember the whole meal! OK; OK, I said. 'Later?' I asked her. She said sure, sure—but I could tell, she wanted me off her case!

"But I wouldn't walk away from it! I was waiting for the right time, and a week or so later—guess what? She was out in the backyard lying on one of the beach-chairs, taking a sun-bath! I came out and asked her if I could catch some of that stuff, too. She said sure—but I shouldn't call the sun 'stuff.' I let that one pass! I just plunked myself down, and started staring up toward the sky, like her. I did this chit-chat thing with her; we talked about nothing for five or ten minutes—and then I got serious, and I said, 'Mum, I'd still like to know something.' 'What?' I

said I'd like to know about 'hypocrite,' what it means. She said 'Oh,' and she said, 'it's saying one thing, but practicing something else; it's pretending—to be something you're not.' So, I asked her if she knew any, any hypocrites. She didn't answer for a long time. Then, I came up with one—her sister, who walks into church like she *owns* the place, and she's best friends with God, and there she is, with this boyfriend, besides her husband, and her second son, my father once said (he didn't know I was listening from the bathroom), doesn't look like his father (he looks like that guy, he's the owner of a drugstore, and he owns a tavern next door to it). Oh, wow! She sprung up from that chair, and she just gave it to me! She read the riot act. 'How dare you? Your aunt! Who are you? Why are you talking like that?' 'Ma, Ma, cool down!' But she wouldn't stop. She was telling me I've always had a 'fresh mouth,' and if I didn't watch out, I'd be in real big trouble. I shut up. I didn't say anything, not one word! But she couldn't stop me from thinking! You can't stop a kid from using her mind, even if she holds her tongue in her check! You know what I thought? [A hard, long glare at the priest.] I thought this: I guess I struck an oil well, and it's shooting a mile high! We'd been studying Texas in the geography class, and I remembered the picture in the book of the oil well, and then the teacher showed us a picture [a documentary film], and then she said, when you hear the expression, someone has struck oil, that means they've hit upon a big 'vein of truth,' and I remembered that!

"Later, I told Maggie. (That was the start of her and me 'telling secrets.') She said, Marie, what the hell, what's the big deal: you've found out what 'hypocrite' means, and you've found out there are some in your own backyard! You want to hear about my backyard? She told me all this—everything she wasn't supposed to tell me, and everything she wasn't supposed to know. By the time the two of us were finished, we were sitting there without anything to say. I remember: she and I each had two glasses of ginger ale, and then we went to Brigham's [a Boston

ice cream parlor chain] and got chocolate sodas. That was the first time I've ever talked about sex with anyone, and since then, she and I trust each other, we really do, and we say what's on our minds."

She seems ready to proceed with more, but she doesn't; she leans over and talks with her friend Maggie. Jean instinctively moves her body first, then her chair, a bit away. They tell her no, to stay put; but they are obviously speaking in purposeful privacy, and all of us look away. Finally, Marie resumes: "We could tell you more, but we won't. When all these 'grown-ups' (they call themselves) say that 'the younger generation' is 'going to hell'—well, I think it's *hypocrites* talking! Anything we've done, it's nothing new! Where do they all get the idea that we're *starting* something—when we have a drink or we have our boyfriends? All right, I didn't want to have a baby until I'm older, but it happened. Does that mean I've started something *new?* I know two people in my family who have had abortions, and no one says anything bad about them!"

She looks at the priest, who only returns her look for a second, then directs his eyes downward. I expect him to rally, to respond to this pointed criticism of more than two individuals—of a whole community, really, of which he is a part. He says nothing, however—and Marie is by no means through: "I know one of them shows up here all the time [in church]. That's great! But I was told abortion is murder, so why is she allowed here?"

The priest waits three or four seconds, speaks only a few words: "My dear child, this is a complicated subject, and I'll be glad to discuss it with you sometime, privately." Marie reddens, takes in air, is ready to run down the field in full attack, but Maggie is quick to intervene: "No, Marie, later—let's talk first, you and me."

Marie doesn't like the advice she's been given, says so, agrees, however, to go along, turns to Jean, suggests *she* say something. But Jean doesn't easily open her mind and heart to others, and the stillness in the room unnerves Marie rather soon: "They always ask us to explain our-

selves and apologize; they're 'grown-ups,' so no one is looking over at them and letting them know *they've* made a mistake. My parents tell me I'm on the wrong track; I don't say it, but what I think is: I'm following *your* track, the one you've been on. My mother says she used to listen to Elvis right through the night, instead of doing her homework and going to bed early, because there was school the next day. My dad, he drank a lot, and he went to clubs and stayed to close them down, and he had so many girlfriends my grandmother couldn't keep their names straight, and now they want me to be—like they weren't!

"'You're always in a rush,' my mother says. Why not? I'd rather race than crawl along. That's why I don't know if I could be a good mother—ever! I lose my temper; I'm impatient. I want to do something that's scheduled for tomorrow yesterday! I can't believe it takes nine long months to have a baby! I talk to the kid, and say, come on, you can do this faster!"

A brief pause, a smile; she is just kidding, she lets us all know, but a glance at the priest satisfies her that she has drawn blood. He is sitting at the edge of his chair, frowning. He won't speak, but he obviously has plenty to say—and she knows the thrust of it. They have had a "rocky time," she has several times said, and now her talk about racing through life, her jokes about her baby's slow pace in the womb, have very much worried and hurt him. Still, he has spoken on her behalf to her parents, urged them to stop arguing with her, and to stop pushing her so hard—lest she act on her threat to leave, to go live in a "rented room." Suddenly, she turns to this middle-aged priest, now in a more friendly approach: "Father, I'm sorry if I've offended you. I don't blame you or the church for anything I've heard at home. My parents go to church, and I'm glad they do. But, when they worry about my 'reputation'—that's the worst. I get mad; I'm ready to blow sky-high. My reputation! Who's to decide that? Their neighbors? You got time to hear some stories? I wouldn't want to tell them—but if people are going to start talk-

ing about me, I'm ready to join in: I'll match anything I hear with what I've already heard!"

The priest smiles, and so do I—and, of course, her two friends. A certain play on words, a symmetry to a sentence manages to stop all of us in our tracks: a member of one generation serving precise notice on those of another. She is herself struck by what has come out of her—the fiery advocate and polemicist who won't bow to pressures or threats from on high. She decides to go further, to make a good case for herself and her friends Maggie and Jean: "My mother once told me her 'philosophy'—that was before I started giving her 'trouble'! She said you should live each day as if it's God's last gift to you, and there might not be another one coming. Now, that's the best of her—I can still see her making an apple pie, while she talked. I'd asked her if we were going to the beach, I think. It was the summer, and the weather man said it might rain. She said you can't always be running scared! She said you have to make your own decisions, not just sit and worry, all because other people are worrying, and they're worrying you about what they're worrying about—you're trying to figure it out! As long as I live, I'll hear her telling me that.

"I guess now she wants to forget—she's so worried about what everyone will think and say [about Marie's pregnancy] that she doesn't even remember what she once said! Well, I do; and I always will, I hope. 'You'll change,' my [great] aunt always says to us kids, but my dad says *she's* always been the way she is now—he calls her a 'nervous Nellie,' and a 'worrywart.' But, when she says something he likes, then he says she's 'the wisest person in the family'! He doesn't give us kids credit for listening to all his words and comparing them! Anyway, my aunt says I'm in some kind of a 'race,' and if I don't watch out, I'll 'crash,' just like cars do, when they're going too fast. All right, I could 'crash'—but I could sit still and go nowhere, and that way, you might as well be dead. My mother was right, each day should really count! Time goes fast,

whether you realize it or not—that's why I think I may keep the baby, after all: I could be a mother while I'm real young, and then when the kid is my age, I'd still be young, and I'd have plenty of years to watch what happens, and I wouldn't be some old nag, worrying myself sick, and trying to worry everyone else sick, too. If I had a girl, we could be buddies; and if I had a boy, I could give him the freedom to test himself, and not be locking him into the house when the sun starts going down, for fear he'll go someplace I can't see from the kitchen window!

"I know, I've got to decide soon. I know the plusses and minuses, the good part and the bad: I want to have this baby be mine, but I'm afraid that my family is so spooked at me not being married, and bringing up the baby on my own—that the kid will be 'marked.' (Do you see what I mean?) That's where the church comes into all this—you want this baby to go to some couple you've got on a list; I know! I've got to figure this out soon—I've got to decide if I'm strong enough to be with this kid, even if everyone doesn't like the idea, at least in the beginning."

She is looking at the priest, but not with the harsh, truculent glare she sent his way earlier—she is more plaintively reflective than she, perhaps, realizes. He becomes openly responsive to her, tells her he is not quite the 'enemy' she sometimes has him be—tells her, actually, that his heart goes out to her, that he isn't sure what he'd feel, were he by some mysterious chemistry standing in her shoes. She wants to hear more; she is incredulous, and politely lets him know that. He delivers quite a speech, tells her that he can understand why she has, on occasion, wanted to have an abortion, that he can understand why she (or others) would want the baby put up for adoption, and he can also understand why she might decide to keep the child. To be sure, those are contradictory decisions, but that is the point he wants to make about her situation, and about all of us: we move from choice to choice, depending upon how we feel at particular moments.

None of what he says is all that surprising to the three youths, never

mind me—and yet, Marie is obviously grateful for what she is hearing, as are her two friends. They relax, spread themselves more comfortably on their respective chairs. Marie stays quiet now, while Jean and Maggie talk with animation (for the first time) to the priest, become openly friendly with him. He moves his chair closer to them, claiming an inability to catch all their words. Marie watches him closely, lets her eyes rest, finally, on her hands, which are placed, palm down, on her knees. When a moment of silence arrives, she speaks with great force and passion: "I feel the baby kicking, and with each kick, I get more connected. I want to cry sometimes. I do. I would never have an abortion now—but I never did want an abortion. I figured, I'd got pregnant, and I didn't want to—but why take it out on the baby! The baby is the baby—and my life is mine. If I don't want our lives to come together, then let someone else be the kid's mother—that was my way of seeing this. Not my mother's or my father's—they'll smile and bow before the priest, and take Communion, but they worried most that the neighbors and their friends would *see* me: that was the reason for the panic! If they could have locked me up in a closet or down their basement, and when I delivered, sneak the baby to some adoption agency, then they'd have been opposed to an abortion, but only then. Of course, they wouldn't level with the priests—but they don't level with themselves a lot of the time."

She feels herself getting wound up, again—an all-too-familiar line of thinking, arguing. She switches direction, tells her girlfriends that she never expected what has now happened: "I feel like a woman in a different way! I don't want to talk too much about all this, but I won't ever be the same after this, I'm sure of it! Either way, my life has changed: I bring up the kid, and that means I don't live like I do now, always on the go, fast; or I give the kid up, and for the rest of my life I keep wondering and wondering about all sorts of things—where the child is, what the child is like, who is taking care of the kid, all of that. In the middle of the night I wake up, *bang*, and my mind is racing, racing. People said *I*

was the one who used to 'race,' but now it's only my head: all the thoughts, all of them! Being pregnant (no matter what happens, what I decide) is being different; so, once you're different for nine months, maybe you've *become* different, you *are* different—you don't go back (you can't) to being what you were."

As we listen, we all get caught in the existentialist reveries she is prompting. Her friends tell her outright that she is making them "think about life"; the priest tells her she is "dealing with big questions," and I drift in my mind to university classrooms, discussions of "being," what gives it shape, what modifies its nature. She continues, occasionally interrupted by her friends; she tells us that carrying a child has made her wonder what distinguishes an adult from a boy or a girl—reflect upon the rock-bottom responsibilities that make for a grown-up life. At a point Marie memorably drifts toward this angle of introspection: "If you carry a child inside of yourself or outside, you've got to think of two people, not just one, and that means you're slowing down, because if you don't, you won't do your thinking. I've got some big choices facing me, and so my mind is torn—I can't just *do* something, like before; I have to talk it over. With myself [I had asked]—but you know, it's with the baby that I'm having the big pow-wow, even if it isn't here to open its mouth and speak, it's *here,* all right! That's what I've discovered—that I'm carrying someone around, and I hear the kid in my head, saying things to me. Used to be, I'd hear only me, thinking of me; now it's me thinking of someone else who isn't me, even if it's someone who's inside of me."

She apologizes for saying the obvious, for talking too much, for being confused and confusing. Her friends reassure her, so does the priest—and she, thereupon, for the first time, mentions her fear: "I hope I'll deliver a normal baby, and it won't hurt too much." We all rush to reassure her on that score, too, whereupon she warns us against (of all ironies) being "too fast" with our hopefulness with respect to her—she who even a scant few minutes earlier had been extolling the considerable

virtues of a kind of unreflecting, youthful self-centeredness that is ener-
gized by a haste which has been turned into a guiding light. We, of
course, agree—we're not being rash, only reassuring. Well, fine—she
will accept our declared conviction that things will go well for her when
the time comes to have her child. But she insists, one last time, that (as
she puts it, unforgettably) this baby is inside her in several ways, so the
issue is not just how the delivery goes: "It's in my stomach, everyone
will be seeing soon; but it's inside my head, too, day and night—I think
of it, the kid, and dream of what's ahead, and that's what I didn't know
would happen until it just did, and maybe because of all this I'll never
be the same."

# 5. *Hit and Run*

The hospital clinic's waiting room is filled with teenage women whose bellies are getting larger month by month. The doctors examine these young women and the babies they are carrying. I sit with another doctor (a pediatrician) in a room, and with us are seven of those clinic patients, each of them over six months along on a first pregnancy, none of them older than seventeen, the youngest fourteen. We hear the usual questions, the usual medical concerns. At a certain point, I try to move us from physiology and obstetrics, from a discussion of the medical details of a child's birth (what happens, what might happen), of postpartum care, of infant care, to matters of the mind (if not heart): what does each of them think about the future ahead, and what would they like to discuss with the two of us, or indeed, someone else? Again and again, these women, all white (the hospital is located in an all-white neighborhood), tell us to go talk to others—first of all, the young men *also* responsible for their pregnancies. Amidst the truisms, bitterly stated ("It takes two to do this," "We are going to have their children as well as ours"), I hear a determined, concerted wish: please tap into the subjectivity of men as much as ours, so that we can learn something, and you with us, about the origin of this "subject" you are studying. The great mysteries of pregnancy are confronting these soon-to-be youngest

of mothers—but another mystery keeps plaguing them: what to make of the desire so many men have to create babies, along with the fear they have of being fathers to those babies!

At one point an outspoken woman of fifteen tries to get around my agenda (to talk with *them!*) by announcing that she has desperately tried to bring the father of her soon-to-be-born child to these "rap times," but ("naturally") he would have no part of that plan, that overture of hers. The moral of the story: the ones who made it all happen simply move on, wander to other bedrooms, disconnect themselves definitively from the progress of a pregnancy which is, really, *theirs* as well as that of a particular woman. In a desperate effort to remedy my own continuing reluctance, and maybe, my ignorance (what will I find out—that many teenage men have unprotected sex with various women, and soon enough, get them pregnant, only to leave the scene swiftly, with scant subtlety, even without the pretense, the protestation of further interest in the *two* lives being firmly put out of sight, out of mind?), one woman tries to hook me through a psychologically suggestive language: "The boys are pregnant, too—they'll let you know that, if you talk with them." She won't go any further, amplify a provocatively put assertion. I promise, then, to comply.

Two weeks later the priest who knows Marie as much as she will allow has arranged for me to meet Marie's one-time boyfriend, Eddie, and three of his friends, Hank, Jack, Fred—all of them seventeen years old, born within eight months of one another. They have agreed to come to the very room where I'd been meeting with Marie and her girlfriends, though they emphatically refused to do so in the presence of the priest, whom they knew well: all of their parents had attended his church since childhood. These were youths in the junior year of high school. None of them was interested in college, at least immediately, though one (Fred) talked of taking courses at a community college in a distant future. On their minds were "getting out of high school," a quite possible stint in the military, cars that had "juice," rock music, haircuts (their shifting

styles), and very important, though stated only indirectly, hanging out together—that is, playing basketball or football, browsing in shopping malls ("checking them out"), or drinking beer, which was not hard for them to obtain, no matter the law that forbids them access to liquor in a bar or store.

Our meeting seemed like one long stretch of silence, interrupted by my apparently tireless, sometimes desperate effort to prompt conversation. In response to the words I uttered, the questions I posed, these young men offered shrugs, looks at one another, the most fleeting glances directed at me, an occasional summons of yes, or no, bodies that kept shifting in chairs that were thereby made to squeak, and every once in a while, a sentence of, say, five or ten words. After forty-five minutes of this painful exercise, the youths began to smoke, and I thought we would eventually relax with one another. But as the smoke enveloped them, they became even more remote—as if enclosed in a separate world enabled by their strenuous inhalations, exhalations. When I caught myself thinking of the lung cancer they were courting, I knew that I was contributing my fair share to the distrust, if not hostility, that had taken over all of us.

Finally, Eddie announced that he had to leave, that he had to meet someone, and of course all four of them were up and out within seconds, leaving me to contemplate the absurdity of a tape recorder which had essentially memorialized a silence, broken in fits and starts by the most unrevealing of human sounds. Not that I didn't try to make something of that—the revelation that failed communication tenders: here were youths unattracted to talk, even with one another, as they had made eminently clear. Yet, they were living active, outgoing lives, each of them working as well as going to high school, and each of them with a girlfriend, or as Eddie did volunteer, "several" with whom they "kept in touch." I had at least obtained for myself the possibility of another go of it. Eddie had given me his phone number, a maneuver meant, I was sure, to facilitate a final, fast good-bye, for all time—a veneer of polite compliance that

masked thoughts which, given expression, might go like this: "Hell no, I won't go—to meet you anywhere, anytime." Nevertheless, I called, and called, and eventually spoke to Eddie, because he happened to answer the phone, and after more silences, managed to arrange a time for a meeting in a shopping mall at a restaurant: he then had a job in a store there as a "stock boy." I gave us a 50 percent chance, at best, of actually meeting —my thought, as I drove there, was that I'd have a futile half-hour wait, and then be on my way back home. But when I came there, Eddie was waiting for me; he'd ordered himself coffee, and asked me if I wanted some. I was ready to go and get myself a cup, but decided I'd let him do so. We sat and chatted about the mall, about his job, about his plans to see a hockey game that evening, about the movies he liked and didn't like (and why), about the kinds of clothes people wore (and why). In that last regard, I found him to be more forthcoming, more shrewd about and appraising of people than I, in my parochial stinginess and ignorance and unfriendliness, had expected. I found myself wishing I could have recorded what he'd told me—a sure sign that I was becoming respectful of him, rather than dutifully going through a round or so in some research project (and rather than, to boot, enduring with condescension a brief interlude with someone whom I had no real desire to try to regard with any broadness of mind).

In my head, I still can hear him talking about the various people he observed during his working time, or while taking a lunch or coffee break —I can hear him, I believe, better (the words he used, their significance, too) than I can hear others whose every statement I have on a tape recorder's cassette. I hear him, that is, because his remarks made their way into my mind in such a way that they keep coming back to me, sometimes, when I'm in a shopping mall myself, rather than in pursuit of an "interview" with someone whom social scientists might describe as a "subject." I especially hear, remember quite distinctly, and word for word, Eddie's description of his first meeting with Marie. He had known her

before; they lived in the same neighborhood, had gone to the same schools—but this was a chance encounter that turned into something more. She had gone with her mother to Sears to do an errand for her dad. The two had agreed to separate, meet in an hour. She had gone browsing, only to meet him—he was, as he kept putting it, "looking the scene over," by which he meant a bit more than cruising in search of a girl to pick up, though he was not a novice at so doing. "I'm always looking at people and figuring out what they're like," he told me—and he spelled out tersely his methodological mode of such social and psychological inquiry: "I notice what they're wearing, and that will tell you plenty about them."

In that regard, he can still remember Marie's attire—she was looking "sexy," whereupon he quickly and knowingly assumes the role of the psychological observer: "She didn't know it, why she was dressing that way." I am now interested; I think to myself, how does he presume to have known what Marie didn't know (and thereby, maybe, how does he presume to usurp my "right" to be the one who can assume such things about others)? I ask him for "data," for the particulars. He lets me know: "She had too much lipstick on, and her dress was a 'come-on.'" I want to know more about that latter variable. He obliges with a disquisition, the longest spell of talking I'd heard from him, and by the end of it I realize that I am in the presence of a young man who carefully and wittingly takes the measure of what young women wear, and claims thereby never to have failed to be correct in his surmises—his success rate a function, so he claims, of the follow-up interviews he has pursued. Put differently (put by him), he "went up to her," told her "you look as if you're looking for someone"; he received back a smile—and in no time they were sipping coffee, talking about one or another "lousy teacher," and making plans for a next and more leisurely encounter.

Soon enough, Marie's tight-fitting dress was no longer a "come-on," but an obstacle to Eddie, as he made clear: "The first time we met (I

mean the first time we went out on a date), I knew we were going to get real serious—she was looking for that." He talked at great length and easily about Marie—her search, as he saw it, for an alternative to her parents, who kept too close an eye on her. He was glad to keep his eyes on her, and she was quite interested in doing so with respect to him. They were sleeping together (in his bedroom) within two weeks. Both his parents had weekend jobs, so he had the run of the house. He knew when his two sisters were going to be out, and he had the use of an older brother's car, occasionally, even though he hadn't, then, an automobile license. They made out a lot in a parking lot near a beach, in the winter: "You don't stay cold when you're with a girl, even though you are taking your clothes off and you've put the motor off."

He enjoyed talking about such times—was matter-of-fact in his presentations. We met several times more; and I heard more—and more. Marie, to his mind, "wanted that baby from the very start." How did he decide that? "She was looking for someone to get her away from her family—I just know." Did she actually say so? "No—I just knew." Did he and she take any preventative measures to head off a pregnancy? "No." How come? "Well, I don't like condoms, though I've used them." Did Marie suggest that he use them? "Are you kidding? She would have been embarrassed, way embarrassed: big time embarrassed!" Did he worry that she would become pregnant? "I thought of it—but I figured she was just starting out in this game, and I guess I figured it took time. I figured this wasn't going to be a long one." Did he know that from the start? "No—but I knew myself how it goes with girls." How does it? "Oh, you could call me a menace on the roam!" He laughs; I smile. I don't ask for a clarification—I think I've got the message. Besides, he can be quite touchy, prickly with questions. He likes to be the one to pose them for himself, then to answer them: "I was looking at this woman, she must have been thirty or more, and I was asking myself, why is she hanging around here? Then I got my answer!" He tells me not only of that thir-

tyish woman, but others. Marie is but a mark, so to speak, on a continuum that is in no danger of coming to an end. "I'm a hit-and-run artist, I guess"—whereupon he smiles, and looks closely at my eyes: what will they say to him? Am I a covert policeman, judge, priest, high school guidance counselor who runs a sex education program? I stare back with the feigned impassivity or neutrality of the researcher, but I feel I am failing in that regard, and I can tell by his suddenly fidgety movements in the booth opposite me that he has either figured that out (my psychology), *or* that he is turning on himself, struggling to fend off self-critical judgments which he may have wanted to come his way through me, and now, unsure of success in that respect, feels rising directly within himself, hence the need to shake them off, as if he were a dog, more than annoyed by twigs and thorns that have clung, that have begun to hurt. When we say good-bye this time it crosses my mind that we may not ever meet again—though I quickly toss out that notion. Aren't we getting to know each other better and better, talking more readily with one another? But we would never again meet. First, he was evasive; then he agreed to a time, a place. I came there and he never showed up. I tried calling later, and never got through. Perhaps he felt he had taught me quite enough.

# 6. *Ups and Downs*

So often, sitting with these youngest of mothers, or with young women soon to be mothers, I hear about the oscillations of mood that fall on them out of nowhere. A young woman, Henrietta, uses vivid lyrical images to tell me what happens as she, at fifteen, sits in the same room as her one-year-old daughter. "I feel fine, I'm doing fine; and then, all of a sudden, I'm not doing fine anymore! I'm doing bad, real bad—I'm in trouble. A big cloud from the sky has come down through the window and surrounded me. I'm in the middle of it. I'm trying to find the sun. Where are you, sun? (I'm asking.) Then, no telling when and why, the cloud decides to move on (to someone else, I guess) and there I am, in broad daylight again, the warm sun making me feel good again."

Her moods only *seem* to come and go without explanation or cause, as she herself sometimes understands. Often she "gets going" (her way of describing the descent into moodiness) because something hasn't worked right as she is taking care of her baby girl: a feeding problem; a diaper rash; crying that bears no observable connection to the child's ongoing life. Indeed, this mother is quite willing to see her baby as utterly responsible for her psychological difficulties, to the point that she becomes in her own mind a mere extension of the child: if the baby is in trouble,

the mother "falls apart," the phrase she uses when talking of her down times.

Yet she was given to bouts of tearfulness, glumness during her pregnancy, when, of course, there were none of the incidents that now set her off—as she remembers: "I'd be fine, fine, and then, suddenly, I wouldn't be. I never knew why there was the change. My mom said it happens to everyone who is pregnant, but I had two friends who were pregnant the same time I was, and they said they were upbeat all the time. Of course, maybe they weren't trusting me with the truth!"

The more I talk with her, the more I comprehend some of the sources of her plunges into the blues. She is one more single parent, very much alone in ways, at just the time when her situation as a mother places great demands on her. The man who got her pregnant walked away from her as she began to become "big." He told her he lost his interest in her —and thereupon, she felt unattractive as well as bereft. He had promised to "stick" with her, eventually to marry her—before he knew she was pregnant. She really loved him, she keeps saying. She doubts anyone will want to "be" with her now—she isn't as "pretty" as she once regarded herself. Her mother, several times a grandmother in her mid-thirties, gives her all to another family as its maid and occasional custodian of its children. She has little time for her daughter or her granddaughter. "I'm on my own with my daughter," Henrietta keeps saying—a loneliness that is very much a part of her life. Moreover, she has not exactly been helped to feel confident and knowing about child care: what is best to feed her baby, how to understand the child's requirements, and yes, *the child's* moods. She walks away from the baby for long stretches of time, because she doesn't feel "up" to being with her, then is puzzled when the child is cranky, tearful, even howling upon her return. She gives the child pacifiers, or sugared water, to keep her quiet—and again, is surprised that her own efforts, finally, to cuddle the girl aren't immediately welcomed. Diapering bothers her—so she doesn't change the baby's

clothing as quickly as she might (and she doesn't realize that a baby will cry when wet).

At first I take it upon myself to become a "health educator" of sorts, but I soon find out that the issue is not primarily cognitive: Henrietta has been told and told what I want to tell her, have told her (have just mentioned). She is, I begin to understand, more chronically dispirited than she herself can say, or in fact, realizes. Nor is she alone, at least in that regard. I persuade her to go to a hospital clinic, to sign up there for a "discussion meeting," held biweekly for young single mothers such as herself, high school dropouts from poor neighborhoods: women with relatively few resources (social, economic, familial, psychological) to lend them the strength they need to be strong and capable parents. She would eventually, in such a setting, be able to acknowledge not only the downside of her emotional life in general, but the downside of her maternal life—how, at times, she wishes she weren't a mother, how at times she wishes her baby "would somehow go away." Not that such thoughts don't race across the minds of many solid, reasonably happy mothers during transient moments of irritability or apprehension or dejection. But she has no husband to whom she can turn; nor really, an available, an interested mother; nor a truly close friend, willing to offer an ear when the need is great. Nor does she have the educational background that might stand her in good stead, emotionally as well as with respect to a future job—give her some knowledge about the world, some perspective on it.

"I had to go from second to second," she reminisces one day about the first year of motherhood. Now, the social worker at the hospital who has been conversing with her (and running the "young mothers' group" to which she belongs) has persuaded her to be "matched" with another teenager, a year her junior, who has just become pregnant. Henrietta, wryly, wonders whether she can be of any help to that youth: "I'm just learning all this myself, so how can I be a teacher to someone else?" But she also has come to realize, shrewdly, that in talking with another per-

son, telling her what she knows, she is herself learning a lot, not to mention obtaining the human satisfaction that goes with sharing ideas or attitudes. Moreover, she is beginning to see motherhood (indeed, life in general) as something more than a day-to-day kind of experience: "I think I let myself get pregnant—that's what I now have discovered. I could have prevented it from happening, but I had nothing else to look forward to doing, and so this baby of mine was my one and only hope. The trouble is, if you're not becoming anyone yourself, then you're not going to be much of a mother—I mean, you'll rise and fall with every little good or bad moment, because there's no life you have, other than waiting on the baby, and that's not good for either of you. Of course, I say this, but I don't know if I'm any different now than I was, except for the fact that I know there are others in the same boat I'm in, and I can come home and remember I've got that company!"

She worries about her "up times," too—they prompt in her a kind of frantic buoyancy and hopefulness that is wildly disproportionate to the observable reality of her everyday life: "I'll suddenly switch into high gear in that head of mine, and I'm thinking that this baby of mine will grow up to be the world's greatest—she'll be a singer, she'll be a beautiful actress, she'll be the first woman to join some basketball team, she'll be a knockout who marries a millionaire! I'll rise with her, I'll be there with her; that way, I'll be far away from this place!" A brief pause—and then the acknowledgment of the inevitable plunge: "It doesn't take long for me to come crashing down—my baby and I are here, and we're going to stay here, and I'd better go change that diaper!"

Up and down she goes, even as she talks: one moment, her face full of excitement and hope, her eyes opened wide, her mouth mobile and also welcoming to the world, her hands expressively at work; the next moment, her eyelashes shut out her vision, her lips purse tightly, her arms fall limp to her side, and her head, heretofore extended upward, now turns toward the floor. Once flowing sentences trickle to a word here

or there. She takes a sip of water, as if to let it be known how parched things are. I try to get us through this dry spell, inch us toward more promising territory; but the very nerve of me, taking on such a task, does not totally escape her notice. In an apparently "irrelevant" remark (I could escalate the matter, call the remark telling, or use the high-and-mighty word "revealing," with its clinical overtones) she declares, out of nowhere, that she has been thinking about her father, who left her mother and her years ago, but occasionally returns. He had done so once during her pregnancy, and she had not been feeling well that day—the prover-bial nausea of the early child-bearing weeks had beset her. The father had tried to be "nice" to her. He had gone to get some ginger ale. He had recommended dry toast and dry cereal, with a little milk and tea, and too, some vitamin pills. She had been taken by surprise—the apparent authority of his advice. She tersely posed the inevitable question: "How come you know so much—down to the last detail—about all of this?" The father smiled, asserted his credentials: an experiential learning curve, as it were, that had risen and risen over the years. Moreover, he went further, moving from internal medicine to psychiatry, told his daughter that she was "only going through something," and that soon, very soon, she'd be feeling much better—so she should hold on to that expectation and thereby maintain a proper perspective.

I dress up his assurances, but they were, indeed, delivered from on high: "He started playing big with me, giving me the rap about preg-nancy, that it goes to your head, as well as your tummy, and you should remember, if you're on your knees, sweating, this week, that the next week you'll be up and about and wanting to catch some kite in the sky and go with it!" Her reply: "Yes, Daddy, yes, Daddy, I know you know." Now, a year and a half later, the clever sarcasm of that statement of hers, its adroit surface acknowledgment, its bitter underlying accusation, still hits home for her, as she recalls this brief encounter for me, the listener, the white man, the occasional visitor, the "doctor" who claims to know

a lot. Lest I have any doubts about all of this, Henrietta scratches her left arm, then her right, and in a voice itself fragile, scratchy, cowed almost, announces: "There are days I be down below down; someone telling me to snap out of it, he can't see where I am." Her polite indirection aside, she has taken the measure of men as she has known them all her life. Later, feeling better, but not forgetful of a certain truth that despair can sometimes offer, she observed: "When I'm so low I can't go lower, I feel myself hitting up with the truth—you know, I'm here, on my own, completely, and this girl, she's the *proof* of that." Her child not as someone whose life is a representation of possibility, at least, if not hope, but as someone who is an enduring witness to a bleakly inescapable loneliness and vulnerability.

# 7. *No Caution to Throw to the Winds*

So often as certain young women, now mothers, or soon-to-be mothers, remember their earlier years, the ones that preceded their pregnancies, I hear of "mistakes" made, of "surprises" that have happened—the common explanations of how those babies were conceived: "I don't know"; "We took this one chance"; "The condom must have been no good"; "I'd just had my period, so I didn't think I could become pregnant"; "He told me not to worry"; "I hadn't really had sex before, so I didn't think it could happen to me so soon"; "I was surprised, I really was." I have dozens of variations on those comments, avowals: in their sum a "record" that constitutes yet another late-twentieth-century research project. No wonder the young would-be physician son of mine who was helping me with this effort perked up when he heard this: "I really wanted to become pregnant. The first guy I slept with, I told him that. He thought I was nuts. The second guy— he said: 'Baby, you're looking for deep trouble, at fourteen.' The third guy—he became my kid's daddy." My son's observation: "She knew what she wanted, and so there wasn't even any caution to throw to the winds."

I have long contemplated that remark—a way of evoking a young woman's strong, unconcealed desire, one that would not be contained by social or cultural customs, by family beliefs, wishes. In fact, this young

person had wanted to be a mother, so she has said many times, ever since she realized that she was a girl and would one day become a woman, and could then become a mother: the sooner the better. As for those who had, indeed, urged caution on her—why, for what possible reasons? She knew, of course, *their* reasons, but she had a mind of her own, she insisted, and it was a mind she had been at pains to examine: "The nurse [at the hospital where she visited an ob/gyn clinic] asked me right away if I wanted an abortion. 'What!' That was my answer, one word! I must have scared her! She thought I was scared! She sent this shrink-type in to see me, and he wanted to know how I felt about being pregnant. 'Great!' He wanted me to talk more. He kept trying, but I wouldn't; I just sat there. So, he asked me if I was 'feeling depressed.' 'Hell, no'—that's what I said. I was *glad*, I told him. He shook his head, just like the nurse. I knew what they were thinking: she's too young!

"I'll tell you, now that I've got the child with me—he's great! I love taking care of him. I have something to do all the time that I love to do! Go back to school, everyone says that—people around here, and you see those ads on TV. Well, fine—if you want to do that: I have nothing against anyone going back to school, or staying in school, I don't care how long, until they die, for all I care. But why should I do something I don't want to do? I've hated school from day one! My mom says the first day I came home I told her I didn't like it—and she said I'd change my mind, but I never did. She gave up trying to win me over. She said I should be the kind of person I want to be. She confided in me: she hated school. She dropped out when—when I was born. Before that, actually—she dropped out a little after she became pregnant with me. She was sixteen. [I had asked.] I guess I beat her by a year."

She shows every sign of loving to be with her son, Sean. She sings to him, coos to him, changes him, dresses him with gusto and obvious delight. She loves cooking for him, and loves tasting his food first, then feeding it to him. She holds him with unselfconscious affection and with

continuing interest. She has no interest in attending a "group" for "young, single mothers"—she was told by the nurse at the hospital she ought to do so. She can figure things out on her own, she insists. She doesn't need "counseling." She doesn't need others, "sitting around in a circle." She doesn't need "some book." She avoids the "advice to mothers" columns in the newspapers and magazines. She will talk to her own mother, though, and between the two of them, they "figure something out." She is not lonely, nor does she now "date." Her son, she says, is her life—and will be until he's on his feet. How long will that be? Until he's ready to go to school. Then? "Then will take care of then," she says with some boldness. She can tell that I'm vaguely disbelieving or unconvinced, more skeptically curious than the facts, as she states them, would justify. She tells me that I must be having a "very bad time" while doing my documentary work. Why? She can "sense" that I'm talking with women who got pregnant, but aren't now truly happy as mothers. I avoid answering directly—say that I'd like to know whether *she* is as contented and pleased with her life as she keeps saying is the case. Without question, yes—and she repeats what I've already heard several times: a recitation of her daily joys, which begin with the first sounds her son makes, and end with her looking at him as he is asleep, leaning over to kiss him as he keeps sleeping.

Finally, ready to be a convert to her asserted truth about herself, I throw up my last battery of questions, meant to find out from her whether she doesn't, every once in a while, have the slightest concern about her son's lack of a father. After all, the man who enabled his life has never seen him, and apparently never will. She is quick to reply: "I never had a father, but I had an uncle, and two older cousins [boys]. My mom never had a father, but she had a brother, and an uncle, and one older cousin [a boy]. I have some friends, not boyfriends, but friends. There will be men around—in school: the coaches. I can take myself and my son to church; we can meet men there."

She stops and looks at me with impatience, annoyance, I sense. I begin to wonder why I'm prodding her with these downbeat questions when she seems so relentlessly upbeat—probably because for me an upbeat young single mother of modest social and economic background *has* to be (with respect to her "location" on that elusive psychological terrain people like me explore) most assuredly downbeat. I believe she suspects the nature of my line of thinking—a disbelief in her assertions as worth attending on their face, on their merits as she declares them.

Eventually, she turns the tables on me, starts questioning me—and, of course, I immediately summon the adverb "aggressively" to characterize the manner in which she does so. (When I question *her*, of course, I am only being careful, thorough, painstaking—oh, maybe, persistent.) How old am I? How old is my oldest son? How old was I when I got married? How old was my wife? Was my father around a lot when I was growing up? Were there other men in my life who meant a lot to me, guided me in, say, sports, or as a Boy Scout? Did certain men teachers—or neighbors, or relatives—come to my assistance, help me figure out how to grow up and be reasonably strong and sensible? As these questions come my way, I realize they are all ones I've posed to her. I also realize that in response to her assertiveness I am becoming smug. I think to myself: my parents were in their late twenties when I was born, and that is how old my wife and I were when we were married, and my parents never got divorced, nor did my wife and me—two solid families of a quite conventional kind. She sees, she *feels* something of that in me, the pride, the self-importance, that are connected to that family history. She stops with her questions; she looks at the kitchen table, and nearby, her baby's high chair. He is asleep in the bedroom, but he will soon be up and ready (eager) to be fed: her favorite time, the feeding of the little fellow. She decides, impressively (wondrously, actually) to be kind and merciful—she tells me this: "I can see you like being a father as much as I like being a mother." I am struck; I am moved—truly taken by her willingness and

capacity to brush aside all the clutter I have kept putting before her, before myself, and too, brush aside her own retaliatory instinct, in favor of this quite touching rapprochement, this large gesture of sympathy that extends toward me from someone who has not ever been led to believe that she can look at others from on high, but who also has no reason to feel apologetic in the least about her life, its satisfactions and its passions.

I wonder, though, about other passions: how long will she be able or willing to confine her love life, as it were, to this child—and more obviously, at what consequence? She needs no prodding from me to bring the matter up. Her mother has told her that she "never did trust the men" in her life—that real trust is what takes place between a mother and a child during the first two or three years of life, and that afterward, when a boy or girl starts keeping company with others, on the street, a "distance" develops. Such a time seems far off, now, but not so distant as to be beyond imagining: "I do wonder what will happen. Will I meet a man I really want to live with—and will he want to stay with me? So many men want to keep moving! If I did find that man, would he want to take over this child, be his daddy? You never know the answers to these questions, I guess, until you find the person who will answer them—if he will!"

She is ready to continue, and I am eager to hear more, but I am so impressed by a certain wisdom she has offered (her willingness to tie speculation to an individual, rather than let it feed on itself, as so often happens in theoretical discussions in university seminar rooms) that my face registers a grateful smile, which she notices, and alas, misinterprets: "You think I'm kidding myself—that I won't find a real good man, so I'm just whistling Dixie with my questions?"

I say a quick no, and am prepared to go further, explain my facial response, but *she* wants to go further: "Maybe you're right. Maybe I should have waited for Mr. Right, and not gone and had my baby. But there aren't a lot of Mr. Rights I can see walking down the street, and I don't want to spend my life dreaming. Now that I've got a son, I hope I can

teach him to be better than a lot of boys—you can see where they're headed even when they're little ones: they lord it over the girls. I watch at the playground [where she goes with her baby in his carriage]."

I decide to ask her this: "Would you want more children?" I am aware that I'm pushing our conversation a great deal, but her lively candor, her unaffected psychological intelligence, have stirred me to admiration and curiosity, both. "Oh, yes," she immediately replies, showing no sign that I've by implication been provocative. Without ado, she gets to the heart of my uneasiness: "I see on television these people saying a woman who has a child, and the man has left them—she'll keep on having children, it's most likely, but she'll still be a single parent, and they say it's for welfare that we do it, to get the check. Not true, not for me—that's not why I wanted my baby, and I sure don't want more babies just for a check!"

I'm wanting to be tough, to ask her whether she'd have had her baby, were there no welfare; whether she would have another child, if she sensed that the father wouldn't stay, wouldn't contribute, and were there, again, no prospects of welfare support. I hesitate, decide I can't pose that kind of inquiry. Then I reverse myself, ask her this question: "Do you think young women like yourself will think twice before having a baby, if the laws change and the city or the state won't give you and the child much money, or any money, or if they do, only for a year or two—because the idea will be that you should go to work?"

She is by no means ready to be glibly responsive. She sits and thinks. She looks over at the baby's high chair, as if he were in it, a reminder in the flesh of this "idea" we are discussing. (He is still sleeping in the next room.) She evades the question in an honorable way—and so doing, yet again, lets me know of her preference for the concrete over the abstract: "My baby is here, and I'd give my life for him. I'd work at any job to get the money to feed him. I can't imagine my life now without him. I'm sure happy he came to me."

Once more, I realize that I am trying to move her into the land of conjecture and surmise, while she stays firmly tethered to her ongoing experiences. As I think back, actually, to what she has already told me, and as I observe her maternal fulfillment, I am left with my own hunches and guesses—that she'd have found a way to have that baby somehow with someone, even if there had been no welfare check forthcoming upon the child's arrival. As for any future children, she had by then taught me enough to stay my hypothesizing hand, ever ready to grasp at the lives of people (and at straws, whenever they can be conjured up). Yes, I had my "thoughts"—that she would eventually want another baby, because she clearly enjoyed being a mother, at least (all she yet knew) of an infant, a very young child; and that were she to lose her welfare check, she and her mother and others in the family would hunker down, pool their energies and capabilities, find the necessary work, and find time, as well, to offer a new son or daughter plenty of devotion.

I put all that aside, though; I wonder now, about men—the way this quite young and not unattractive woman regards them: it's almost as if they are necessary biological progenitors, but otherwise, a deeply suspect species of humanity, quite "other" to her and her kind (women, mothers, children). I want to get *that* subject aired, want to hear her talk more openly about men in general, as she has already learned to think of them. I even wonder whether her earthy and (to me) quite welcome insistence on staying away from generalizations isn't a "defense" on her part, a way, ironically, of not bringing to light some very definite conclusions she has reached at her young age—some strongly felt ideas about men. I plunge forward, ask about her hopes—whether she does ever picture herself as getting married, and if so, to what kind of man. We have covered this territory before, I know, so I say to her, but it is worth looking at again, so I also say to her, with an associated apology for my "one-track" mind.

We circle around the subject, as so often happens when people talk about matters of complexity and importance both. She lets me know

quite directly that she is not a "man-hater," and that she yearns for a solid marriage someday. But she is a realist, she also lets me know, without using that word: "I keep my eyes open—I'm looking. I mean, I'm looking for a good guy; I'm looking over the whole scene, you know, and I don't like what I see, I have to admit. I wish there was better news out there for me. I wish so; but I don't want to be the person who lets her wishes go to her head, so I'm fooled by myself. It's bad enough, when you're fooled by someone else; but to be fooled by your own self, your own head, that's not good, that's terrible. You know what my grandma would say: she'd say, 'That's the pits.' She means, you can't do much worse than you've just gone and done—tricked yourself into believing something that isn't true."

A year later she is going out with a man who is thirty-three, twice her age. He has two children by an earlier relationship, not a marriage. He contributes to their support, a commitment which she very much respects, admires. She clearly has hopes for herself and this man—she loves his interests in music (jazz) and in politics. He is a carpenter, a self-educated man whose many experiences in life (he traveled across America for two years "to see the place") impress her, have helped educate her. The two of them have *talked* about having a child, done so repeatedly. As she pointed out to me, that is something new to her: "I've never done this, sat with a guy to discuss whether I should have a baby or not with him, 'the good side and the bad side,' he says. There's no 'bad side,' I told him. But he convinced me—what if he got sick or died or got into trouble and took off! He tells me I'm too 'independent of men,' and I would have laughed if anyone had told me that before, laughed at them. But you know, I'd have been laughing at the truth! I had an answer for him; I said, look here, if you can be saying that to me—well, I'm not so 'independent' of you! He laughed. He said, 'I'll give you that'! I said, 'Thanks!' "

She has more to tell of this friendship, but she stops to muse. She

stops relaying such unfolding developments in her own life to comment upon a more general aspect of human affairs (for her, an unusual, a conceptual angle of vision)—she talks of the loneliness lots of her young friends feel, many of them single mothers. Like her, they are seeking men on whom they can count—and she emphasizes the point, "men who work for a living and will bring their checks home to pay for things." That is what she wants for herself, for them—so she makes clear, even as, of course, I am quick to wonder silently when such a day will come for so many of these young women.

# 8. *Second Chance*

Again and again in the North Carolina clinic's conference room these four unmarried couples, these eight teenagers, these two African American mothers, two African American fathers, two white mothers, two white fathers, these residents of a small-town America rather than its urban precincts, declare themselves side-tracked from life, curbed or frustrated by it—yet they range in age from fourteen to eighteen, and I am moved (maybe, provoked) to say, at one point in our discussions, as I hear of the futility they feel in various respects: "Already!" I am instantly more than annoyed with myself. I am not there to be passing judgment, however indirectly, but to be taught, to learn from those whose experiences I presumably want to document rather than observe with dismay. I had intended that one word to indicate surprise: so little in the way of hope among Americans so young, and to my eye, physically strong, mentally sound and solid. But the way I uttered that one word spoke of something else—a disguised reprimand: come on, you eight, you can do better in this country at this time; you can find lives far less bleak and forbidding than you are describing as you speak of your prospects.

The young parents are as quick as I am to pick up on my unacknowledged intent. One of them, Dorothy, a white mother, fifteen years old,

tells me that she was "born into trouble," that she sees little likelihood that she'll ever get out of it—and adds: "I know this is hard for you to see." I am not surprised, not taken aback—but I do feel bad, feel criticized, perhaps as put down as she felt when she heard my exclamation! I decide to respond directly—ask her why it can be so hard for me, for others, to comprehend her present and future difficulties in this life. She is not slow to reply: "I could tell you all that's happened to me—I've already said a lot; but it's not what's happened that you need to know, it's how it's made me feel. I don't know how to tell you that, because it's not something I know how to say. It's not words that will do the job. I don't know what will, I don't."

I should know that distinction she has just made—between factuality and the subjectivity of a person's mental life; it is a distinction I supposedly learned a long time ago when I was learning to do the kind of work I do. But Dorothy felt (again, there's no explicit evidence in the sense of words used) that I wasn't responding to all the turmoil she had experienced in the first decade of her life, never mind the teenage years she was then going through, and she wanted to put that judgment on the record, however cautiously and respectfully.

Sitting beside Dorothy, on her right, was her boyfriend, Ted, who had said nothing at that point in our conversation. Sitting on Dorothy's left was Beth, sixteen and the daughter of a black man, a truck driver, who had died of a heart attack when she was eight. (She was the last of his four children.) It was Beth who spoke up: "People look on us as doing bad—because we're mothers so soon, but we're not married yet, and a lot of us, we might not be marrying the guy who's the father of our kid. I can see why that is—it's best to admit it if you haven't done as you should. I used to dream of this big wedding, and I'd be walking down the aisle in the church, to meet my dream man. Trouble is, I don't have a daddy to walk me. He's gone. Even when he was alive he cheated on my momma. Since he died, my momma has had some boyfriends and I have

my half-sister on account of one of them. Lots of trouble for us, men can give."

Abruptly, she stops. She takes out a handkerchief from a pocket in her dress and holds it, but doesn't use it. She is not crying. She casts a quick glance at her boyfriend. He moves about in his chair, reaches for a cigarette, offers her one (she declines), lights it. She waves away his smoke. As I sit and watch, I remember what I read of her life in a clinic chart, the sexual abuse at the hands of her half-sister's father, her mother's "drinking problem," her use, too, of cocaine on occasion. I also remember a school report with its details of Beth's "poor adjustment," her withdrawn, sulky, irritable nature, her repeated bouts of illness: a host of "pains" in the stomach, the knees, the back, and constant upper respiratory infections, "more than average," warranting an evaluation for possible asthma that was never done. "She is depressed," the school nurse wrote, that and no more, when Beth was nine and in the fourth grade—a "poor student," who seems "locked up," and "indifferent to what the class is doing." By thirteen, she was still indifferent to her schoolwork, but not to boys, who began to seek her out because she was a "looker," so Beth had told the doctor when she learned she was pregnant. Did she want an abortion? No. An entry in that chart: "Patient wants to carry the fetus to term. Says it's all she's got."

I recall those words, recall writing them down in my notebook, as we all sit there in silence. I recall the chart I once constructed for myself, lines going from words and phrases to other words and phrases; lines meant to indicate the "relationship" between "teenage pregnancy" and other variables, such as the experience of sexual abuse, membership in a "single-parent family," clinical evidence of "depression," the onset of "learning problems" at school before the arrival of adolescence. Meanwhile, we are enveloped by a stillness in the room, as the young men and women stare straight ahead, except for Beth, who is looking at the floor. When she does talk, she refers to the preceding quiet in the room: "We

each of us know what's caused us to hurt badly, so we don't need to mention it all. I'm hoping my child will have it different. I have a boy, and I'll tell you what my purpose in life is: to bring up this boy, so he'll be different than the men I've known. That's my purpose! I told his daddy [she looks right into his eyes; he averts his eyes] that he can help me, if he wants, and if he doesn't, then that's all right, too. My grandma said: 'Better to be alone than to be with someone who's going to do you harm.' "

Everyone nods to that quoted remark, including Beth's boyfriend, Raymond, who now does look at her, and then speaks: "There's a lot of reasons to see her side, I agree. I'm with her—I mean, I'm her friend. I don't want to argue. I'm *here*. I could have stayed away. If a man does the wrong thing, he should be blamed. Lots of guys, they'd like to do right, but they're not sure what it's best to do—what is right and what isn't. I mean, should you get married, if a kid comes along? I asked Beth, I said: 'What do you want, what do you think?' She said, 'Well, I want to get married, but I don't think this is the right time.' That's *her* speaking! I said, 'All right.' We never did talk any more about it, though my mom said I shouldn't be with women if I don't know how to take care of myself [use condoms], and she's 100 percent right, I admit it. Of course, Beth—she's glad she's got the baby; she's told me so a hundred times, at least, so does that make me wrong, for letting it happen? I'll tell you—I don't like mentioning it: if you ask me, it was Beth wanting the baby all the time, that's why I wasn't so careful. I am most of the time. A man— he leads; but he's taking his cues, too. Do you see what I'm getting at?"

While he is talking, Beth is looking at him. When he stops, she's right there with her response: "I don't argue with a word he's said. I don't argue with you, Raymond. [She turns to him.] You've said the truth. I should admit it—like I told that doctor, when he said I'm pregnant: I do want this child, yes I do. No way I was going to get me one of those abortions. 'Are you sure?' he asked me—and I said, 'Positive,' and I was,

and I thank God for the baby, every morning when I look at him, because he's all I've got, and he's a good baby. With him, I can try to do things right, so he'll be different from others: he can grow up to be somebody, and not be hurting people, doing them in. You raise a child—and you have a second chance, you know."

That last observation is greeted with considerable attention, approval. Dorothy, who has been paying close attention to Beth, begins talking, declares that she is "with her in all she said"; urges everyone else to speak up, and when the others nod, but don't resort to language, she offers a monologue: "I don't like to say anything about all this—because people are ready to criticize you, and not look at what you're trying to do that is good. So, it's best to hold your tongue and keep going along. But when you said 'second chance,' it sure struck me: that's *right* (I thought). My boyfriend says he wants to marry me now, and I hope we'll get married. If people thought it was wrong, what we did, they might change their minds then (or they might not, I know). But I don't care—'Pay attention to everything people say,' my aunt said to me, 'and you won't be doing anything else in your whole life.' She's a wise one, and I thank the good Lord that she is around to tell me something wise every once in a while!

"Let me tell you all, when I look at my baby girl and see her looking back, I get my spirits back. A lot of the time, when I was a little kid, I wondered if I'd ever get to the age when I was a grown person. My mother got tuberculosis, and she had to go to a hospital; and then they said it was something else—breathing in the stuff there in the factory [where she worked, a textile mill]. My daddy wasn't any good at all. He'd take the strap to anyone who didn't agree with him, and even if you did, he'd take the strap to you, and he could hit you so hard and so long, you ached for days: he drew blood, all the time he did, and that's what we all knew—be careful or he'll give it to you real bad, and you'll be recovering from it the rest of one week and into the next one!

"We've agreed, he and I [she looks at her boyfriend], never, ever (not

once!) to hit this child of ours. Of course, I realize you can punish a kid without laying your hands on her, by being neglectful. We'd like to have two, or maybe three kids, and we'll prove something, that's what: we'll show the world that you can be just 'kids,' they call us, and still, you can be good to your own kids, so they grow up good. It *is* a second chance, you get, and if the first time around hasn't been OK (if it's been bad) then you can remember that, and what you remember can help you when you're with the baby, and too much is happening at once, and you're afraid you're going to start crying, or throw a fit! When I'm with my girl, I talk with her. She doesn't understand what I'm saying—but she knows it's important. How? She knows by the look that's crossing over from me to her: it's like electricity; I'm all charged up, and it crosses over to her, through the eyes."

Her eyes move to her boyfriend, to Beth, to others in the room, who are clearly in agreement with what she has said—except for Al, the boyfriend of the African American young mother who has maintained complete silence, though she has registered her occasional approval of what both Dorothy and Beth have said. Al looks at her—Donna is her name—and then whispers something. She tells him to tell me what he has told her. He shakes his head. "Go on," she urges. He shakes his head. She threatens to speak on his behalf. He shrug his shoulders as if to indicate indifference—but is soon letting us know what has occurred to him: "I think you are all giving yourselves a bad rap. We shouldn't give up on ourselves. We're just starting out! We're young, you know! I told Donna: 'It's great we've got this kid,' and I'll stand by her, and I'll acknowledge the baby [boy, as his own], but you can't turn your whole life down, for the sake of the baby. You've got to have your *own* chance, not just be saying all the time: there's the 'second chance,' through the *baby!* You see what I'm saying?"

Donna is quick to rise to his support. She says she agrees with him—but she also agrees with Beth. She thinks a mother owes it to her child to

have "some life" for herself, or else the baby will think the mother is a "slave." On the other hand, a baby "gives you something that's different from anything else—a life has been made, and you're the one who has done it, and you're the one who can teach the child." She seems, mostly, to be saying the obvious; and to be equivocating; and to be afraid, actually, to say anything controversial—she keeps checking things out with Al, who nods as she talks. But she explores original and important territory in that room when she describes herself and the others as teachers. In her hands, the obvious turns into the original, the provocative: "I figure, I can try to show my kid how it's right to behave, and how it's wrong. Maybe my mother didn't do the best by me. She was sick a lot. She got beaten up a lot [by the man who fathered one of Donna's two half-sisters]. So, it's true, I can try to do better. I can remember the mistakes, and try to improve on them. I hope I will—I hope Al will be there to help: two is better than one, my mother told him. But if you don't have your own life—then what can you teach your child about life? You've got to think about that! You can be a slave to your man, and that's no good; but you can be a slave to your kid, and that's just as bad. The kid will get the picture; the kid will see that you've been defeated, real through and through, in your own life (and here you are, so young!) and you've gone and surrendered, and you're just holding on because you want this 'second chance,' you all were saying. But what's the lesson you're giving: that you don't have anything going for yourself, and you've totally given up on yourself, your life, and that's what happened to you—so why shouldn't the kid think it'll happen a second time around. You get me?"

She stops and searches the faces around her for evidence that she has been understood. No nods, no comments. She resumes, drives her point home: "If all you want is a second chance through your kid, you'll be telling your kid you've got nothing to show for yourself, only that you had him, or you had her; and the result—when the kid is grown, it'll be a 'second chance' come home to roost, I'm thinking, because you never

did have the most important thing to give your kid: your life that you've been living, what's good in it that can be copied."

She has now begun to be understood. She forgoes any claim to originality, tells us of conversations she has been having with her great-grandmother who is "real old," who is "almost touching seventy." The wisdom of that elderly lady, Donna insists, is earned—a long, eventful life, whose travail, but also achievements, we hear chronicled by a young woman who holds on tenaciously to that story, its eventful moments and its reflective breakthroughs. As I look around me I realize how hungry these young men and women are, how eager to learn from any elders who care to pay them heed. These are young men and women both burdened and challenged. None of them comes from a world of privilege or power. They are the first to remind me that "others" like them, who have become the potential parents of a child, have chosen with few second thoughts to have an abortion. They are the first, also, to renounce self-righteousness—they chose to become parents out of their own preferences and needs, freely admitted. They are the first, on that score, to worry that perhaps they have made more than one mistake—to have allowed a pregnancy to take place at all, and to have let it come to term. The men among them say that they will stick by their girlfriends, their children, for the long haul of it—but none has actually suggested a wedding date. The women among them are glad to be mothers, but have their times of doubt and apprehension, their decided second thoughts, their worry that the disappointments and jeopardy, the mistakes of their lives, will now become an inheritance for their babies, even as they obviously hope (hope against hope) for another kind of outcome, that "second chance" which one of them espoused as so important.

"I wonder what it'll be like for my daughter," Donna told us once—and then her specific point of interest, of speculation: "I wonder how she'll be when she gets older, how her life will turn out, but I also wonder how mine will turn out, being her mother." With that remark she

makes clear a conviction that a pregnancy allowed to continue has to do, eventually, not only with a future person's life, but with a future mother's life—no big intellectual triumph there, but a statement too commonly ignored by some of us who concentrate on the subject "teenage pregnancy," while forgetting those who are living particular lives: individuals hard-pressed, caught in this or that undertow, even, but also trying mightily, on occasion, to find a "second chance," a new beginning of sorts for themselves, even as they watch a child also make a start of things, and so doing, bring possibility to what often seems like the impossible.

*Suggested Reading*

Thand his book belongs to the tradition of collaborative documentary inquiry. Two photographers, one a pediatrician, and a child psychiatrist, with the help of three young men in various stages of medical training, we took it upon ourselves to try to get to know a range of individuals about to be or already parents. The result is a series of narrative presentations, some enabled by words, others by pictures. Joelle Sanders's *Before Their Time* (1991) is close kin to this effort—the reader is offered four generations of teenage mothers, all from the same family, a carefully rendered series of portraits, of personal stories. Needless to say, there are other ways for writers and readers, scholars and students to approach this aspect of humanity. Documentary work tries to bring certain lives to the attention of others—tries to attend closely to the words, the appearance of particular individuals (who may, of course, share certain experiences, hail from a given place, do this or that kind of work) in the hope that those who read books and view photographs will feel themselves instructively, suggestively connected to people or places otherwise unfamiliar, if not misunderstood. But lives can also be fitted into those various "contexts," "frames of reference," that sociologists or political scientists or psychologists properly summon—and of course, a thoughtful, sensible journalist or essayist, given leeway to explore a world

and write about it, can shed a good deal of light in a language blessedly accessible, even arresting.

Here, I'd like to recommend books that have helped my sons and me to understand the young men and women with whom we were spending our time—books that connected us, it can be said, to worlds other than the immediate ones (the specific homes, neighborhoods) we were visiting. These were, after all, "adolescents"; and there have been wonderfully subtle and knowing efforts to comprehend that time of life, fit it into certain larger "perspectives"—social, cultural, historical, political, economic, racial: the life of the mind (felt experience and everyday awareness and personal memory, for example), as linked to the time of one's existence, the place where one lives, and the kind of family to which one belongs. In that regard, Erik H. Erikson's *Childhood and Society* (1950) is still a major milestone—psychoanalytic knowledge enlarged by a discreet and wise (and lucidly presented) resort to social and historic analysis. Not that psychoanalytic knowledge, in its conventional, clinical form, doesn't help us see more clearly, pointedly, what it is that prompts various young people to speak as they do, act as they do. I have in mind Anna Freud's *The Ego and The Mechanisms of Defense* (1936), its last chapter, especially, some of it with thinly disguised evocations of Miss Freud's own adolescence. Aaron H. Esman's *Adolescence and Culture* (1990) extends and updates the kind of broad psychoanalytic inquiry Erikson initiated, and John Neubauer's *The Fin-de-Siècle Culture of Adolescence* (1992) offers an exquisitely sensitive and subtle integration of literary and psychological interpretations of a particular era and locale. Judith Musick's *Young, Poor, and Pregnant: The Psychology of Teenage Motherhood* (1993) is an extraordinarily comprehensive, erudite and balanced attempt to connect psychological analysis to social understanding—and its references (over twenty-five pages of them) offer a major bibliographical contribution to an interested reader.

To move from psychology and cultural analysis to the sociological, and

to political analysis, I recommend *Adolescence and Poverty*, edited by Peter Edelman and Joyce Ladner (1991)—a collection of essays that convey what it means to be young and poor, vulnerable in mind as well as with respect to one's social or racial background. Another slant, in that regard, is offered in *The Uptown Kids: Struggle and Hope in the Projects*, by Kerry Williams and William Kornblum (1994).

Unsurprisingly, teenage pregnancy has become a major political issue in our late-twentieth-century American life, hence books such as *The Politics of Pregnancy: Adolescent Sexuality and Public Policy*, edited by Annette Lawson and Deborah Rhode (1993), *Losing Ground: American Social Policy, 1950–1980*, by Charles Murray (1994), *Dangerous Passage: The Social Context of Sexuality in Women's Adolescence*, by Constance Nathanson (1991), and *Early Parenthood and Coming of Age in the 1990's*, by Margaret Rosenheim and Mark F. Testa (1992). These books will give the reader plenty to consider, plenty of pause: adolescent sexuality (and parenthood) become, inevitably, a matter of anxiety, alarm, argument. All the more reason, then, to call upon history, as John Neubauer does in the book mentioned above, or as Rickie Solinger does in *Wake Up Little Susie: Single Pregnancy and Race before* Roe v. Wade (1992), with its reminder of what obtained in the mid-century America of the immediate post–World War II years. All the more reason, also, to ask for help from our most skilled and patient and persistent and balanced journalists—and one of the best of them, surely, is Leon Dash, whose extensive reports for the *Washington Post* have been fortunately gathered together as *When Children Want Children: An Inside Look at the Crisis of Teenage Parenthood* (1989).

Finally, I suggest some helpful articles: "Defining the Teen Pregnancy Problem," by Ellen Freeman, in *Readings* (June 1994); "Association of Young Maternal Age with Adverse Reproductive Outcomes," by A. M. Fraser et al., and "Adolescent Pregnancy—Another Look," by R. L. Goldenberg and L. V. Klerman, both in the *New England Journal of Medicine*

(April 27, 1995); "Adolescent Health: A Generation at Risk," *Carnegie Quarterly* (Fall 1992); "A Look at the Sexual Behavior of Today's Adolescents," *Community of Caring* (July 1993)—these articles remind us of the jeopardy some youths must constantly endure, as documented by physicians and social scientists.

A last word: a lingering, attentive look at the painter Edvard Munch's "Puberty" and a slow, solemn reading of Tillie Olsen's story "I Stand Here Ironing" offer a kind of heightened sense of the nature of adolescence and young motherhood. Munch's telling, unnerving portrait conveys a time's confusion, fragility, and vulnerability without any mediation of words (their sometimes prolix futility!), and Olsen's short story relates a young mother's desperate but defiant struggle on behalf of herself and her first child—a short narrative that, one suspects, calls upon some of the author's firsthand experiences, albeit transformed into compelling, powerful fiction.

PHOTOGRAPHS BY *Jocelyn Lee* AND *John Moses*

*Photographs by Jocelyn Lee*

I began photographing teen mothers in 1990. I was interested in exploring how these girls negotiated their way through adolescence, developing unique identities while adjusting to the strains of maternal responsibility. As I moved from graduate school in New York City to Austin, Texas, and finally to a teaching job in Portland, Maine, I continued to photograph teen mothers, who, to my surprise, were never difficult to find wherever I went.

Eventually I expanded my work to include the fathers of the children as well. What I discovered over my five-odd years of photographing young families is that teenage pregnancy is a complicated phenomenon. It develops from many layers of influence and need, and there are no simple relationships between its causes and effects. Teenage pregnancy and parenthood are filled with contradictions: there is childlike optimism confronting adult responsibility; there is tremendous love joined with personal sacrifice; there is unrestrained anger and quiet acquiescence; there is healthy nurturing—and unhealthy nurturing, when the young mother looks to her child for the love she might expect from a parent.

While the families I photographed had varied cultural, personal, and social backgrounds, there was always one constant: child rearing, even in the best situations, is extremely challenging. For mothers of any age,

waking up at three-hour intervals in order to feed a hungry infant is difficult. When a teenage girl is trying to finish high school simultaneously, this becomes a monumental feat. The sacrifices of motherhood demand that something be given up. Because the baby is an unavoidable fact—which they acknowledge with all their capacity for maternal love—most young mothers choose to put their own schooling and self-development on hold.

As a woman, I was particularly interested in viewing the way motherhood affected the lives and futures of girls. I remember clearly what it was like to be a teenage girl. I was awkwardly fascinated by boys, deeply dependent on my friendships with other girls, and naturally obsessed with my developing identity. Everything I did, from the friends I chose to the books I read to the clothes I wore, was evidence of my struggle to figure out who and what I was in the world. For me, adolescence was a period of experimentation, and no decision I made was so permanent that it fixed my course in life.

A teenager's decision to have a child, however, does fix her course in life, in such a way that she loses the typical teenager's chance to focus mainly on herself. One fifteen-year-old mother I photographed lived in a shelter for teen parents with her boyfriend, also fifteen, and their infant son. In addition to caring for the baby, she went to school each day and worked every afternoon and evening at a fast-food restaurant. During the day the baby was in day care at the shelter. When she arrived home at 7 P.M., he was returned to her care. Her own mother, who was in her mid-thirties, had a night job and often left her other two children (the girl's sister and half-brother) and her boyfriend's child for her daughter to baby-sit until midnight. One evening I watched this girl of fifteen act as though she were a woman of thirty. She bathed, dressed, cooked for, fed, and loved her own baby; she comforted and fed her toddler half-brother; she provided a home and a place to watch color TV for the nine-year-old stepbrother; and she made dinner and snacks for her boyfriend, the father of

her child. Her thirteen-year-old sister struggled to do homework while helping to care for the two babies. The fifteen-year-old father/boyfriend alternately played with his son and watched cartoons alongside the nine-year-old. When I left, well after midnight, the adults had not yet arrived; the young mother was trying to calm her own child, give him his asthma medicine, and get him to sleep; her sister had fallen asleep fully clothed on a loveseat half her size; the nine-year-old was watching TV with glazed eyes; and the other toddler had just woken up and was crying to be held. Except for the babies, all of the children in the house had to go to school the next day. Homework and sleep were luxuries hardly available to them.

I also discovered that many young girls choose to have a child well before they get pregnant. In other words, they plan. For a variety of reasons, some teenage girls believe that having a child will enhance their lives. One thirteen-year-old girl I met told me that within the year she would be pregnant, and when I saw her again a year later, she had accomplished her goal. Parenting for her represented an early and desired entrance into the adult world. In her Hispanic family there were generations of teen mothers: closest to her, her own mother and her older sister each had two children by the age of nineteen. Her sister's boyfriend was a father at the age of fourteen. While their mother was not happy that both her daughters had had children at such young ages, she was not judgmental, and never suggested alternatives such as abortion or adoption. It was a familiar situation with a familiar, acceptable solution. This family of women lived together and supported one another, sharing cooking, cleaning, and the care of the children. And, for the most part, from my perspective, they did so very well. They loved their children immensely and raised them with all the attention and nurturing one could ask for. For the fathers, however, history repeated itself in a destructive way: the boyfriends of both the girl's mother and her sister were in jail and unable to help raise their children.

Most of the young fathers I met were not involved with the child care. If some started out with good intentions, the strain of the family situation often overwhelmed them, and most became absent or neglectful fathers. The young mothers complained to me that the young fathers had sex with other girls, hung out with other boys, and did drugs. They failed to show up on scheduled days or contribute to child support. By and large teen pregnancy is a girl's struggle, one that affects girls' lives most deeply.

There are success stories. Occassionally a family is so intact, so supportive, that the young mother does not stop her own education, and does not come to question her own self-worth or ability to choose a future in keeping with her potential. But for the vast majority of teen mothers this is an unlikely goal, and all of their attention turns toward raising their children. I've seen their education interrupted at such a young age that it is awkward and difficult for them to return to school years later. Most of these girls have had to make do with less than a high school education, with restricted job opportunities, and with long-term dependency on social services.

For these young women and their families success comes when the children are fed, loved, and clothed, when they have a warm and secure home, when the young mother learns to control her frustration and develops good child-rearing skills. Most of the young mothers I met were very intelligent and responsible. They sincerely loved their children, and cared for them to the best of their ability. In some instances the parents remained together and made a home in the form of a nuclear family. They had financial plans, owned a car, and at least one of the parents had a job. In another instance, two young mothers lived together with five children between them, supporting each other with child care, domestic chores, financial responsibilities, and friendship. These are achievements I would not have been capable of at the age of fifteen.

Naturally it is through the lens of my own life that I saw these girls

and their families. I can never fully understand the experience of early motherhood, or attempt to document it in its entirety. It is a complex phenomenon, as varied and unpredicatable as the personalities of the girls themselves. At best my photographs can serve as particular frames through which to view young mothers and their families. And it is from the position of both admiration for each girl's love for her child, and hope for her own future, that I made these images.

I want to thank all of the teen parents with whom I worked for their generous gift of trust and for welcoming me into their homes. I honor their hard work and endurance as young mothers: Christine Adams (age 21), with three children; Rachel Adams (16), with one child; Kelly Shepherd (17), with one child; Lisa Moralis (15), with one child; Angela Williams (18), with one child; Reyna Garcia (16), with one child; Heidi Hebert (16), with one child; Julie Villarreal (20), and Jesse Barron (16), with two children; Dashinika Scott (16), with one child;

Rosa Thompson (15), who was pregnant; Page [last name unknown] (16), with one child; Diane Felan (18), with one child; Nicole Feindell (17), with one child; Noy Charaworth (18), with three children; and finally deep thanks to Halona Forest (17), with two children, and Tina Bruns (21), with three children.

I also would like to thank Alex Harris for his editorial counsel and long-term support of this project; Lauren Lee for her sensitive insights and feedback on the subjects of young girls' development and teen parenting; and Ray Sapirstein for his continual deep encouragement, intelligent guidance, and love of photography.

Austin, Texas, 1993

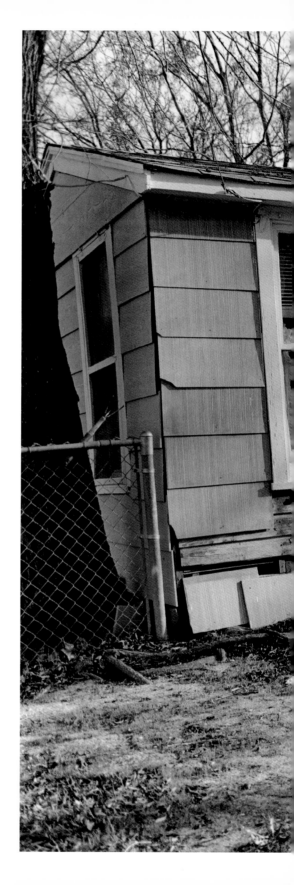

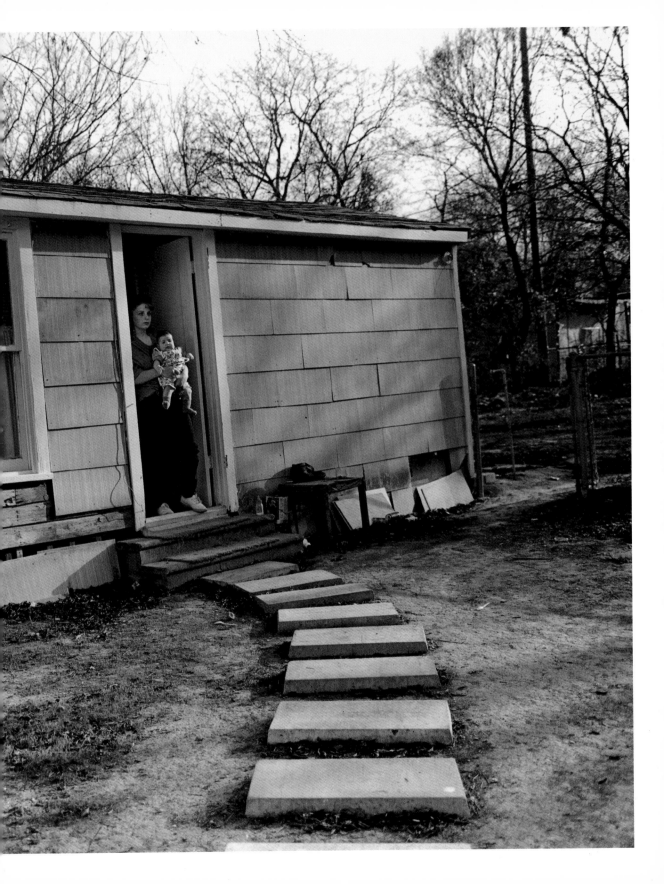

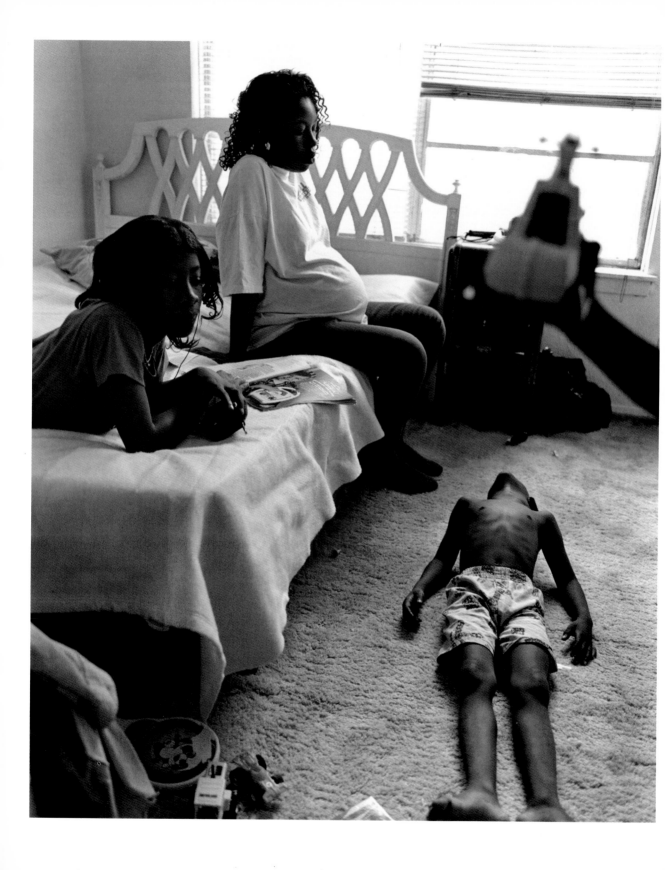

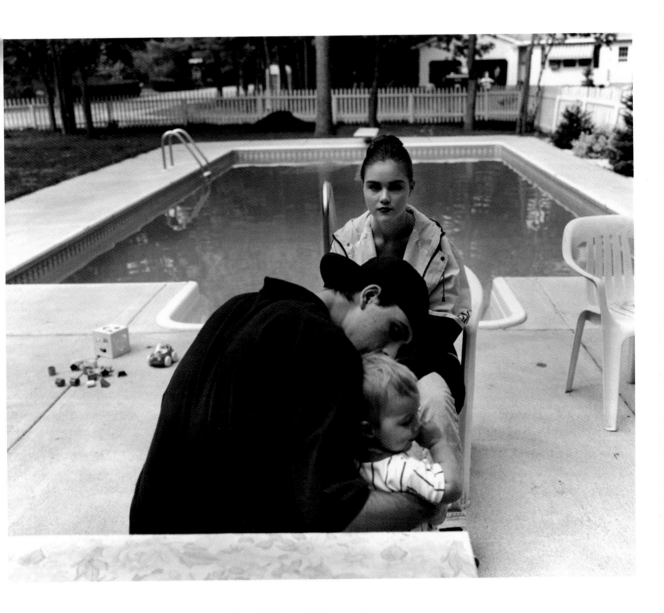

*Opposite:* Austin, Texas, 1993  *Above:* Gorham, Maine, 1996

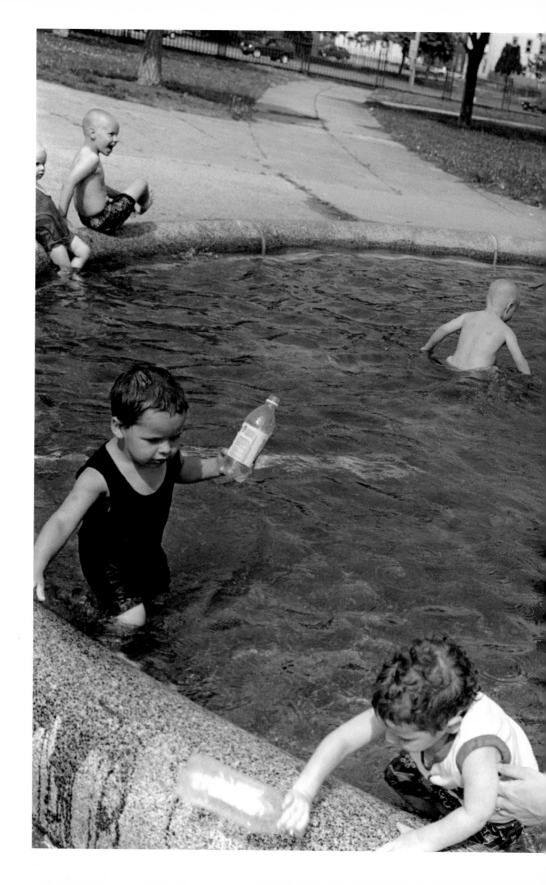

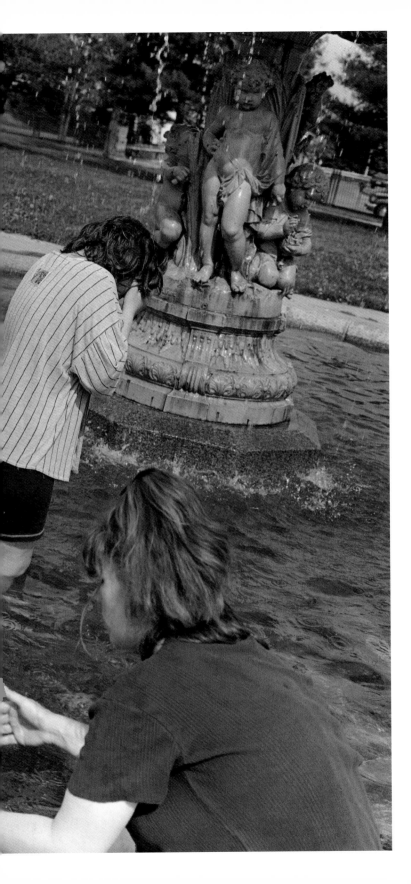

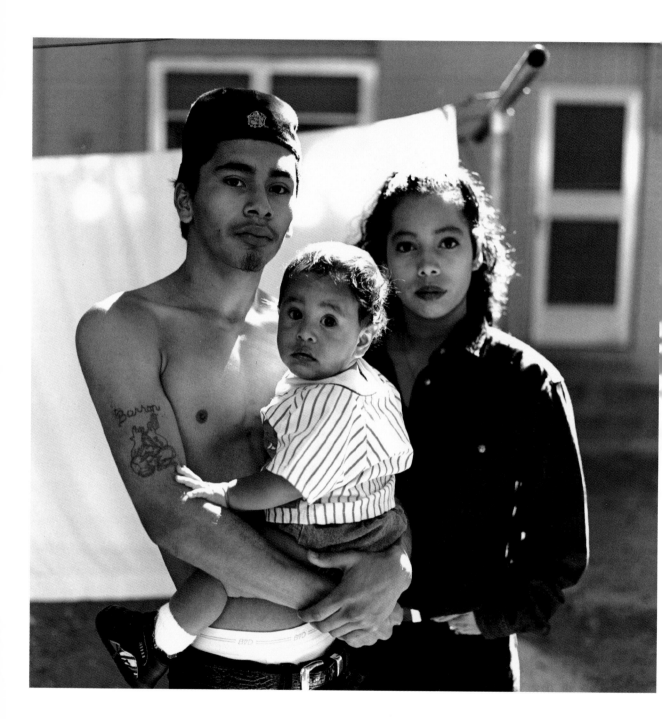

Austin, Texas, 1992

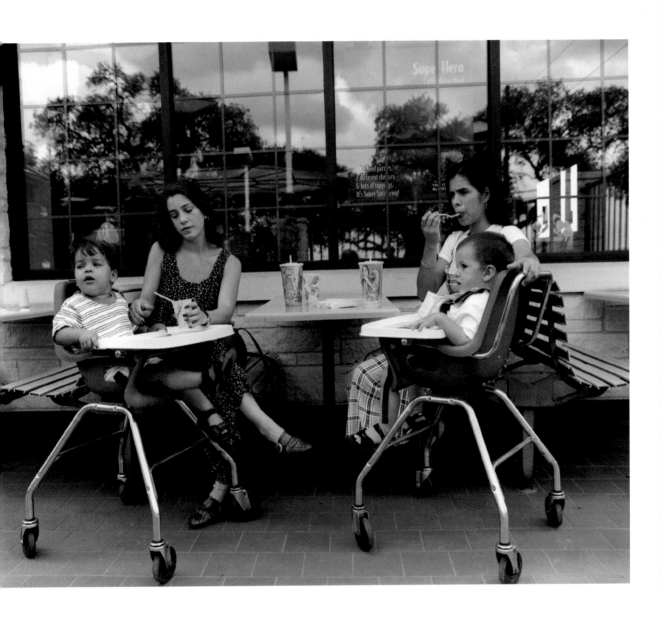

Cedar Park, Texas, 1995

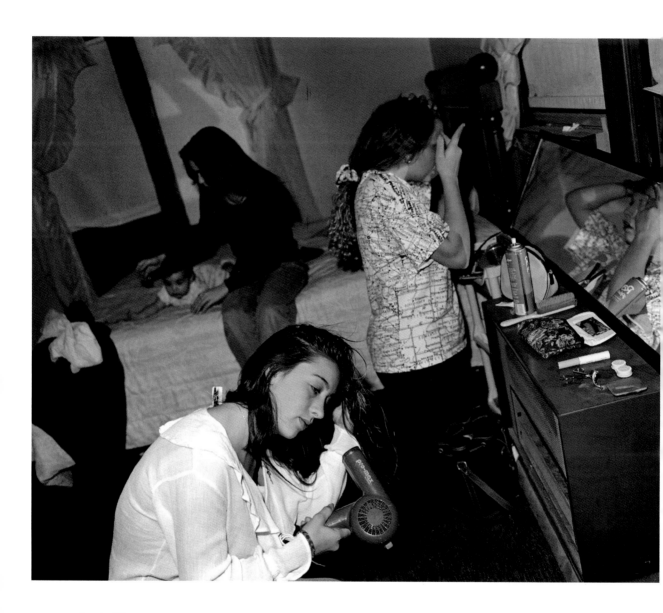

Austin, Texas, 1993

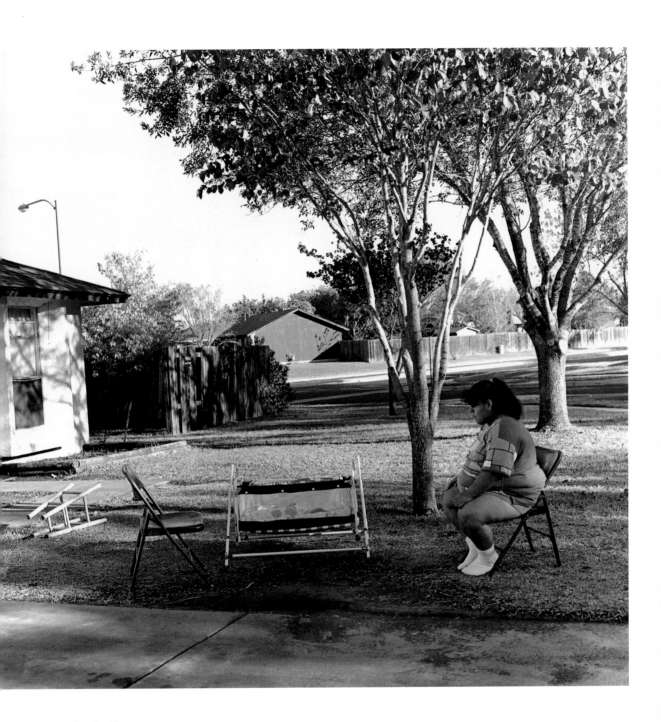

Austin, Texas, 1994

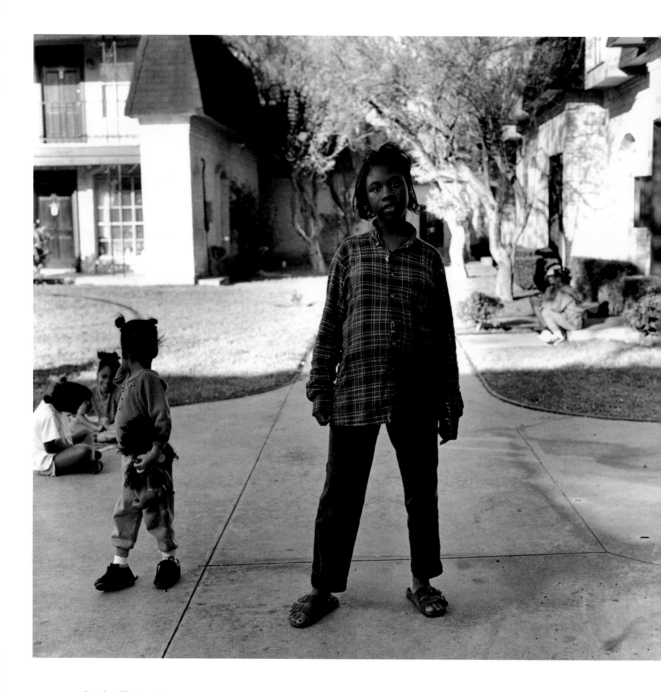

Austin, Texas, 1993

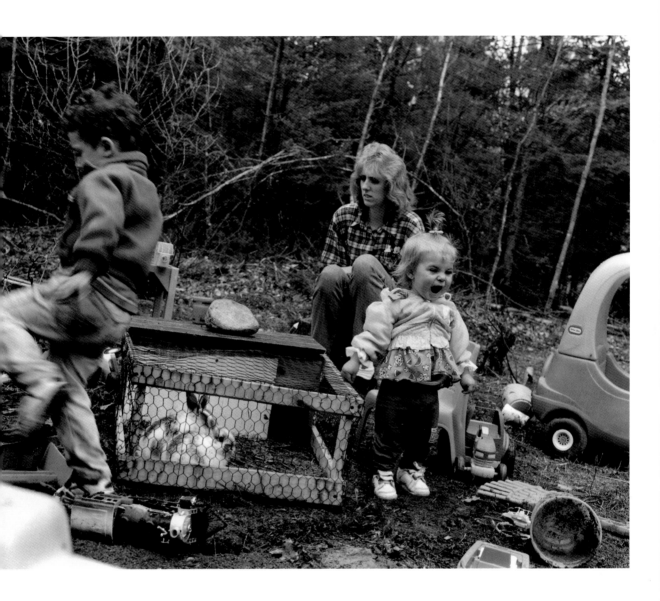

East Livermore Falls, Maine, 1995

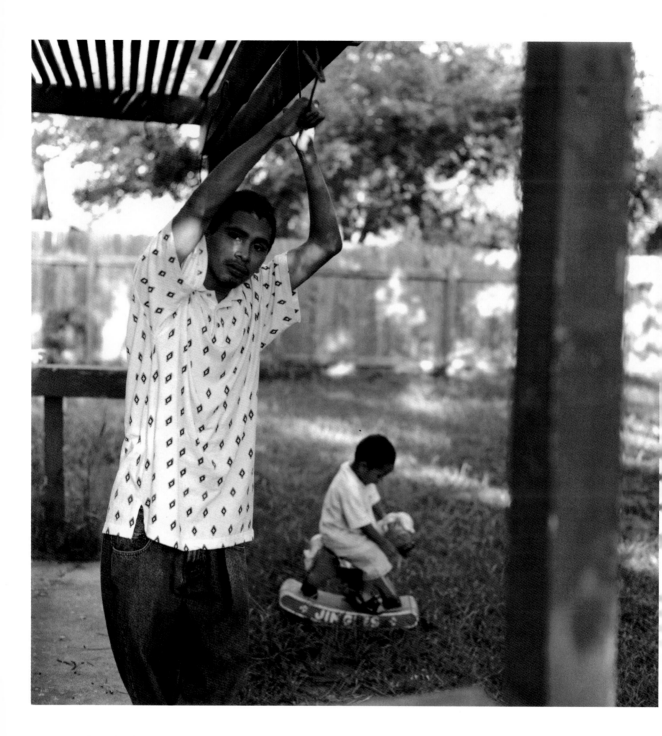

*Above:* Austin, Texas, 1996  *Opposite:* Portland, Maine, 1996

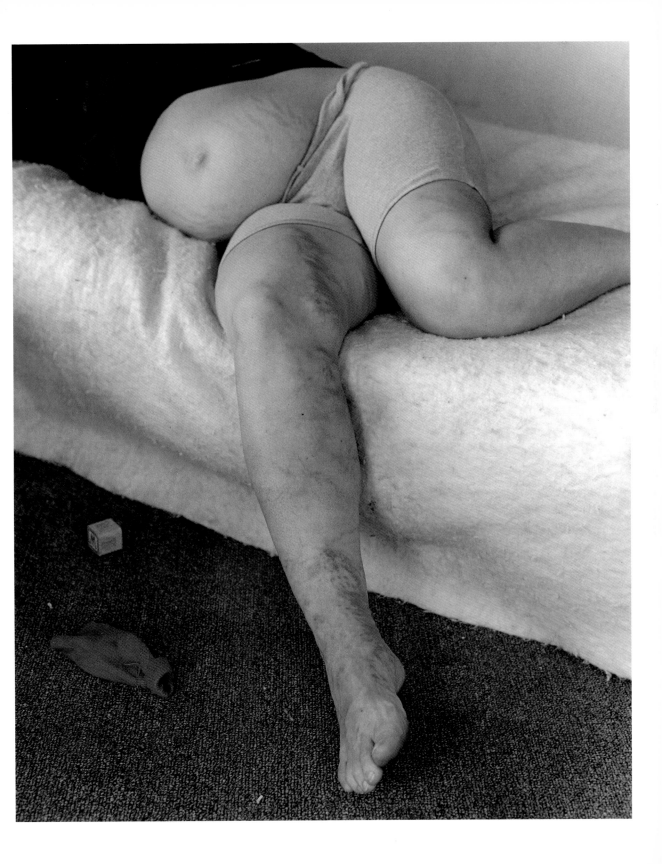

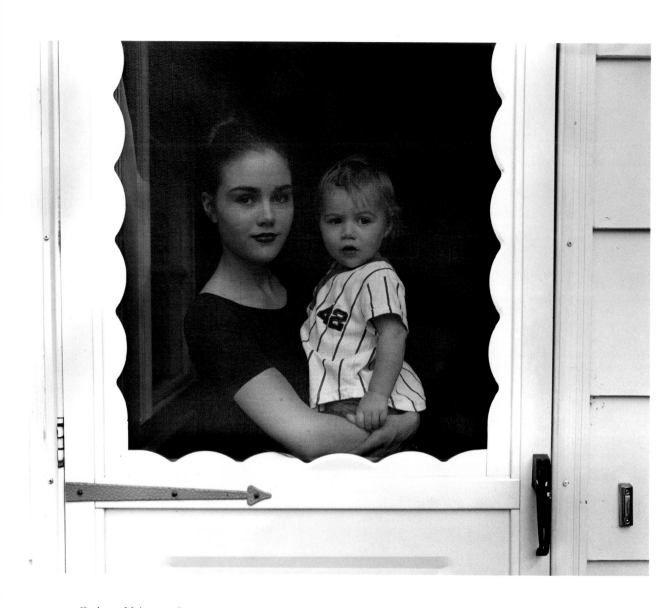

Gorham, Maine, 1996

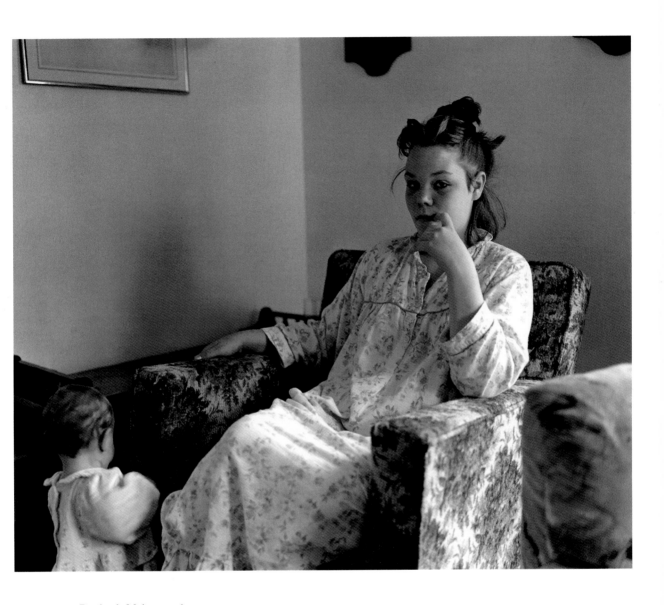

Portland, Maine, 1996

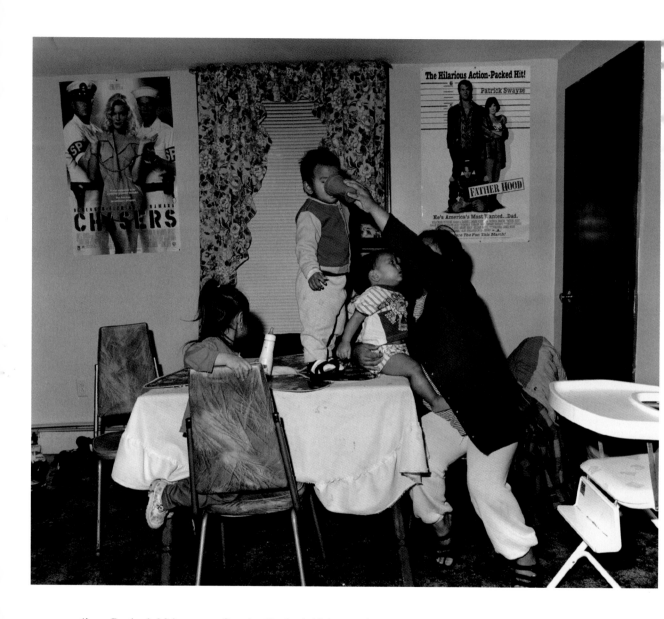

*Above:* Portland, Maine, 1995  *Opposite:* Portland, Maine, 1996

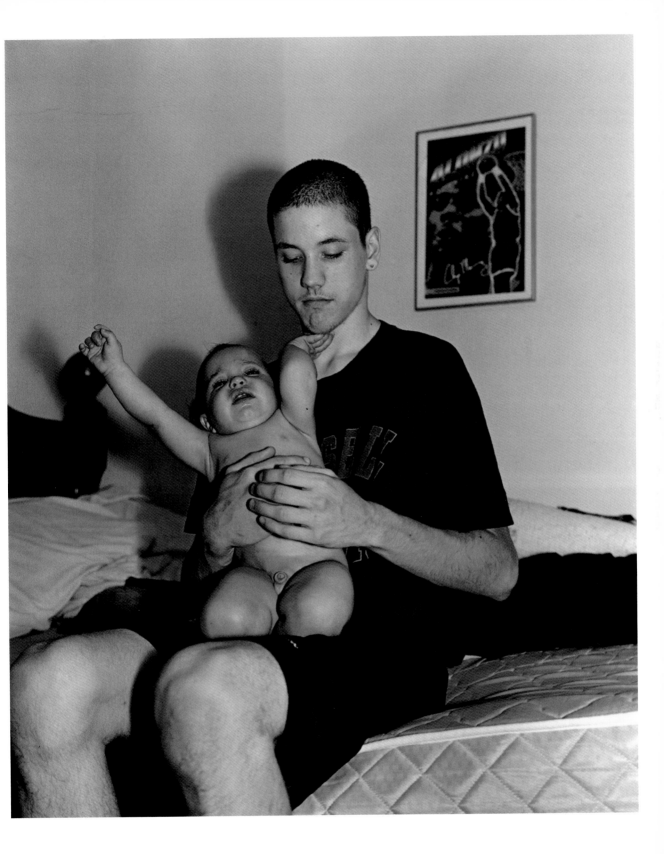

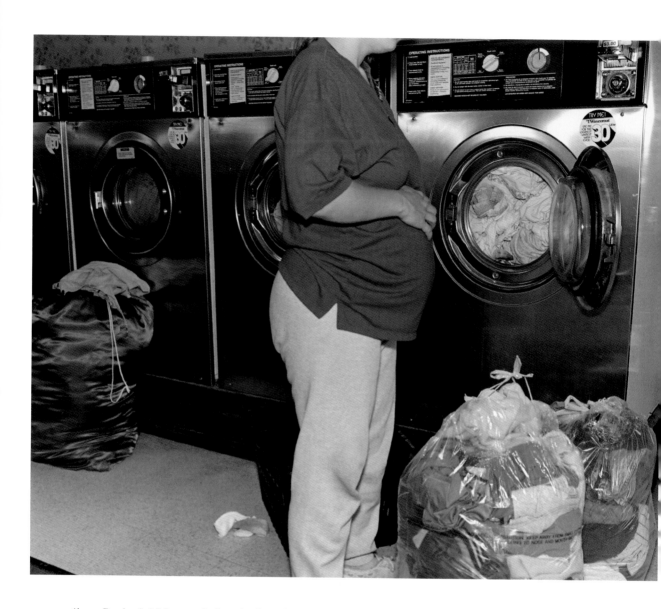

*Above:* Portland, Maine, 1996 *Opposite:* Leander, Texas, 1992

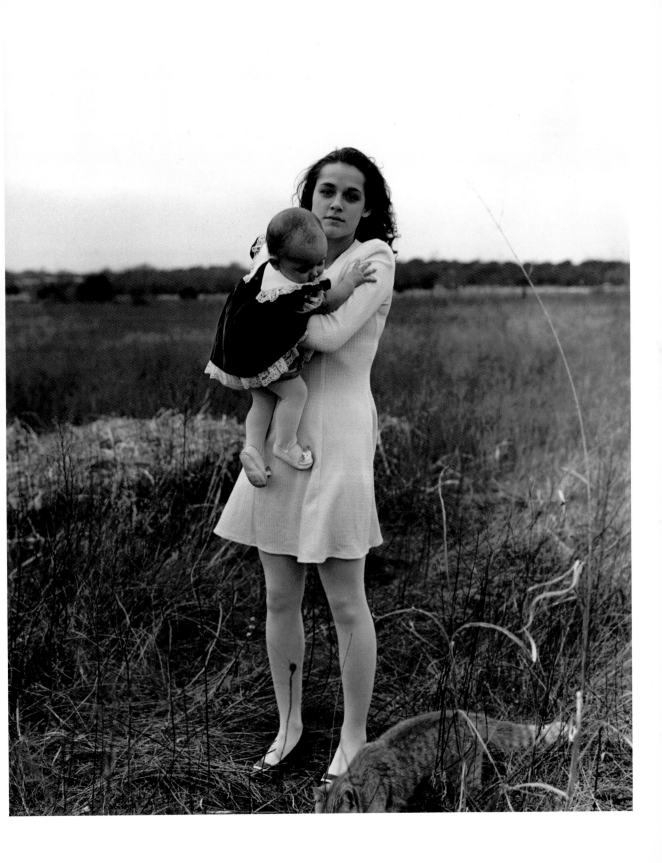

Austin, Texas, 1993

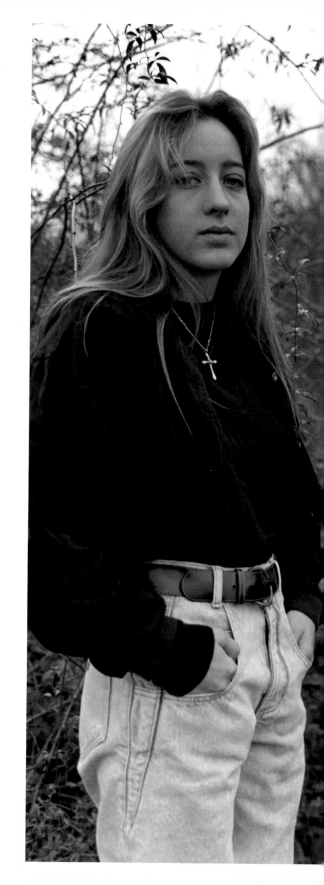

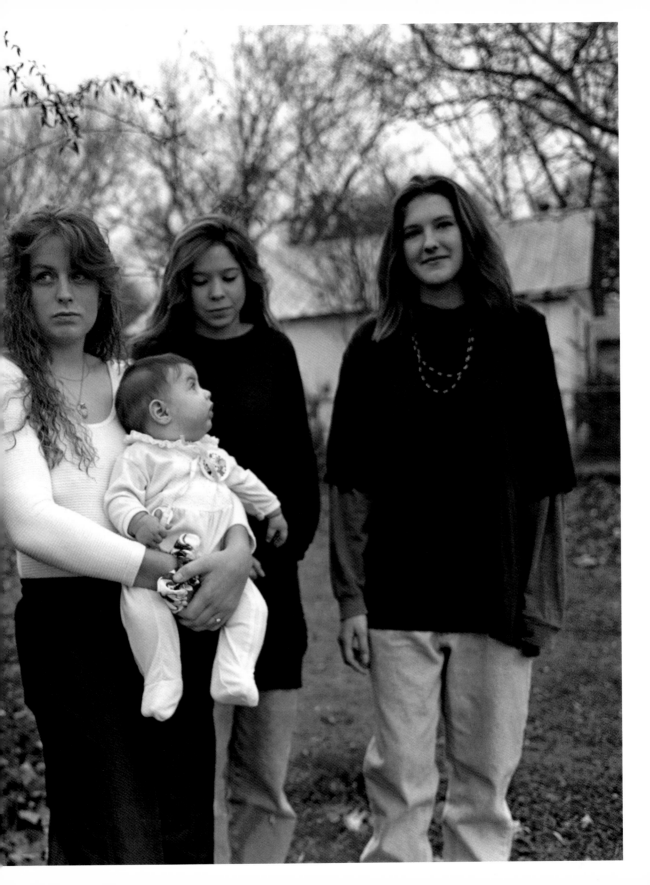

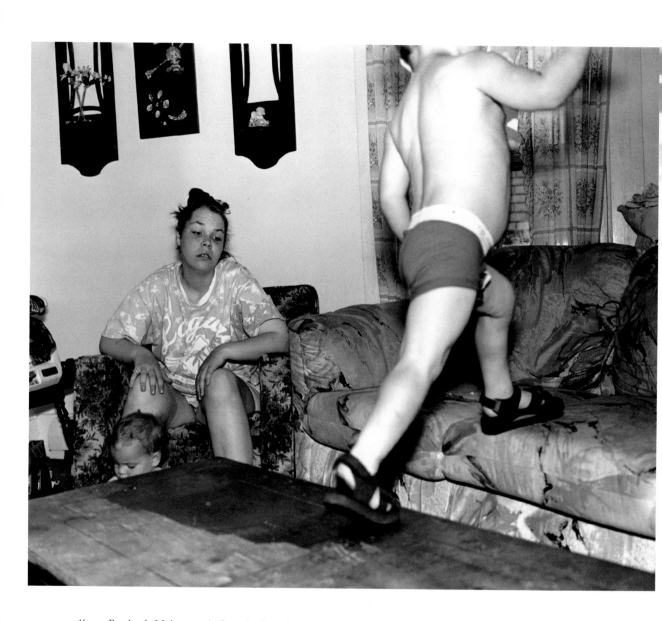

*Above:* Portland, Maine, 1996 *Opposite:* Leander, Texas, 1994

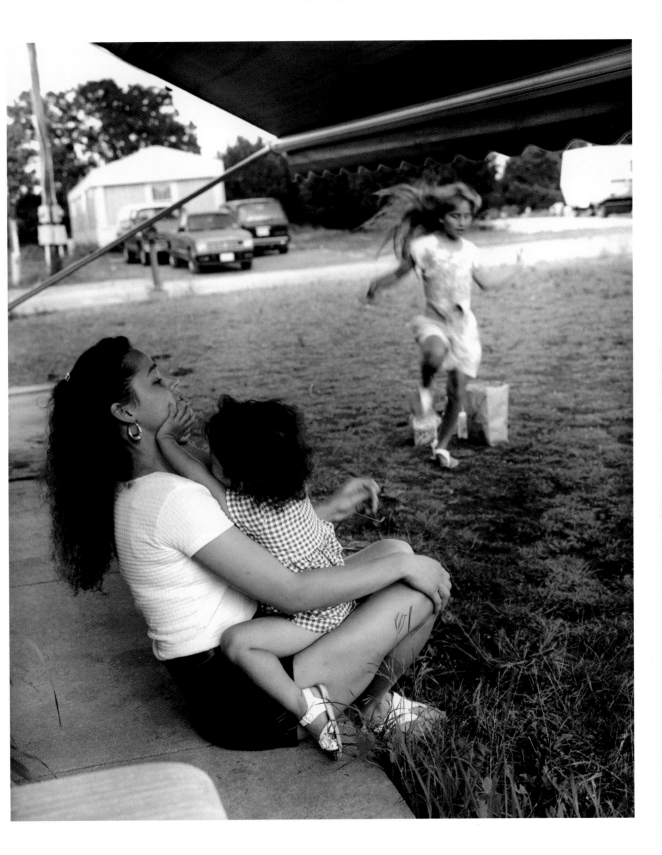

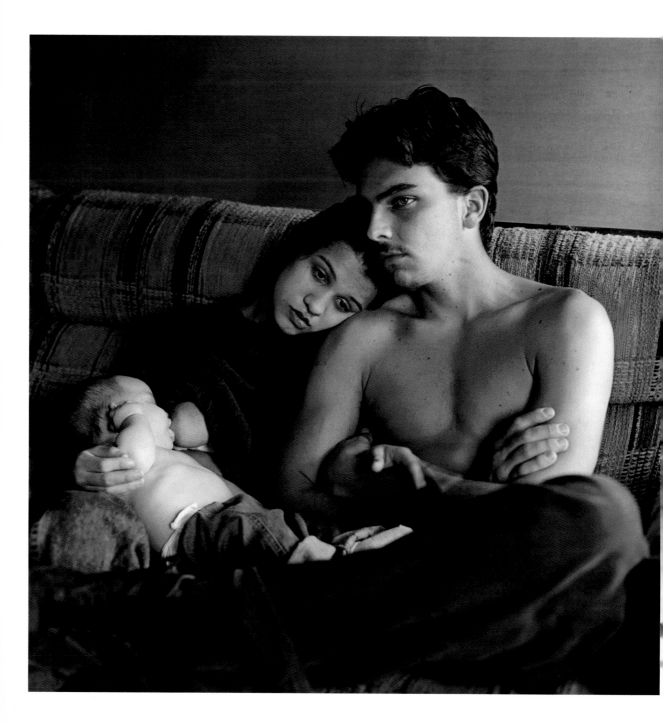

Cedar Park, Texas, 1992

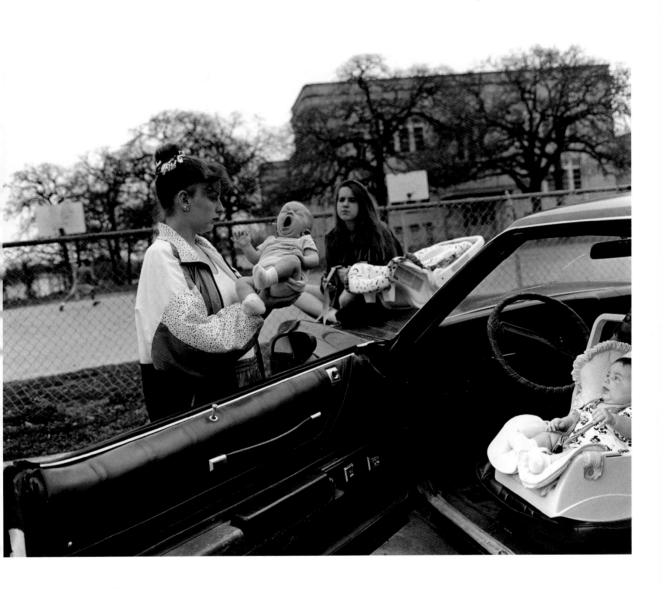

Austin, Texas, 1993

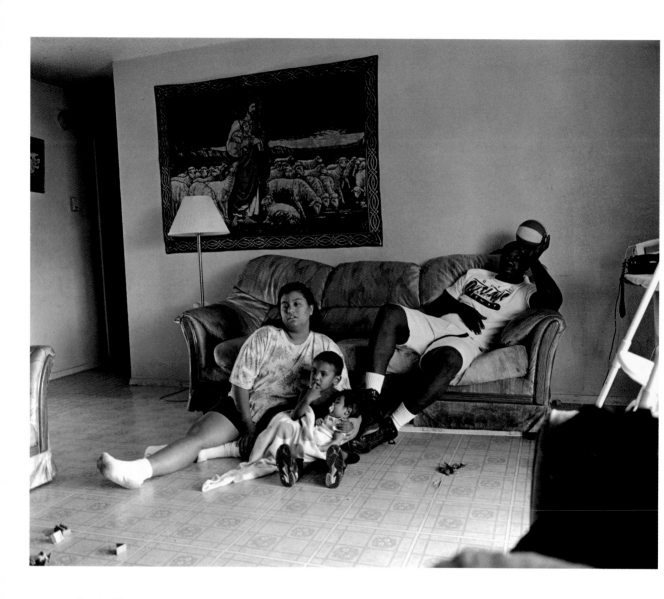

Austin, Texas, 1995

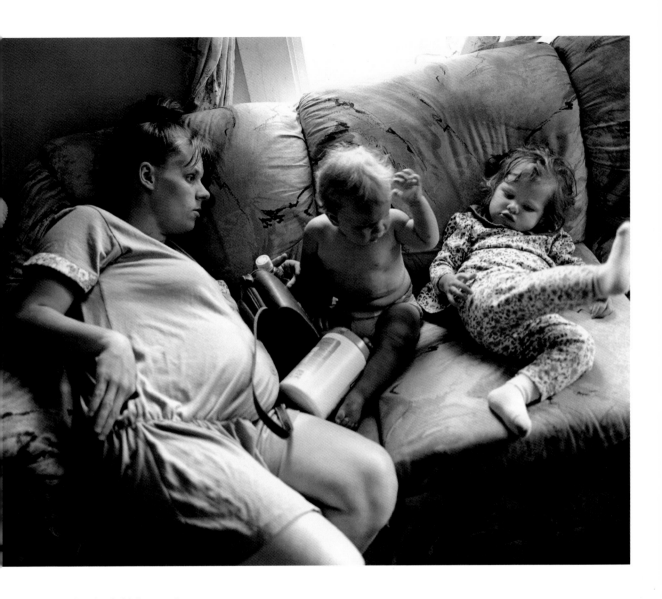

Portland, Maine, 1996

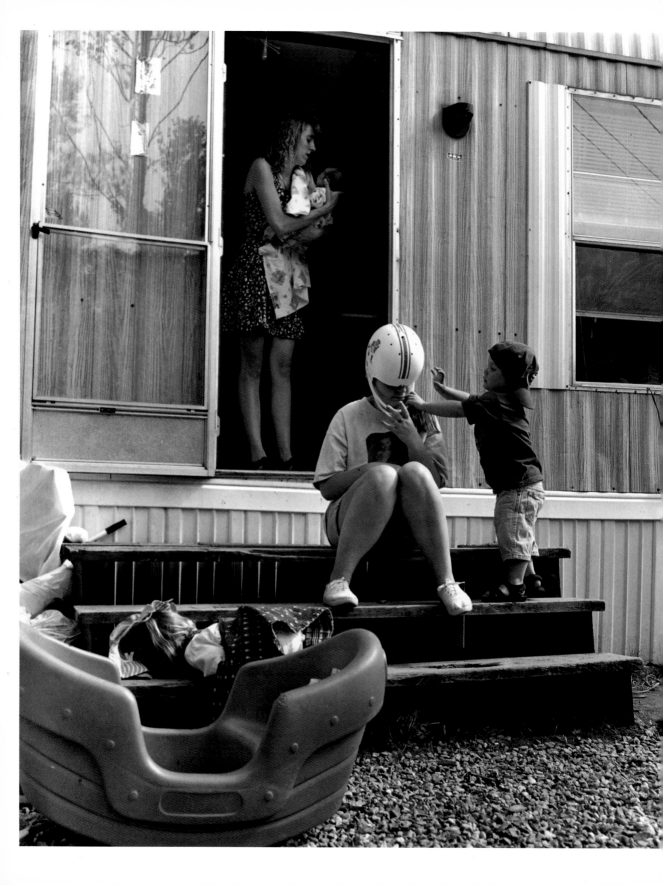

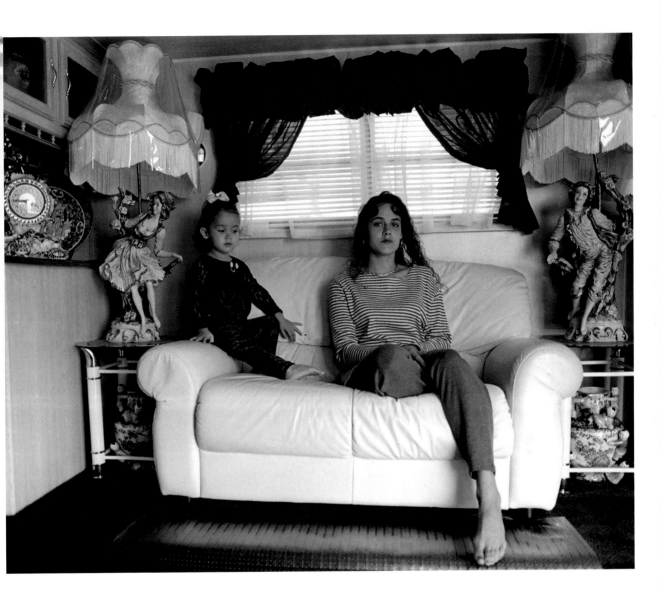

*Opposite:* East Livermore Falls, Maine, 1996 *Above:* Leander, Texas, 1995

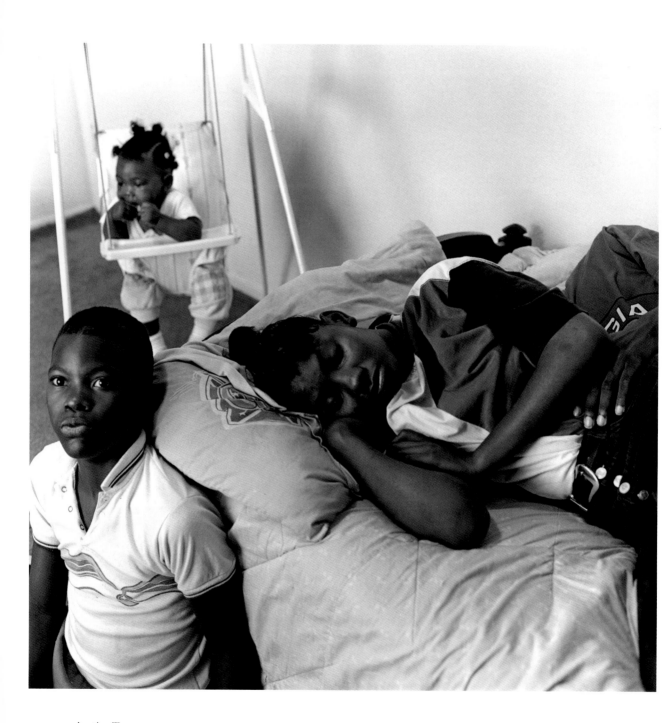

Austin, Texas, 1993

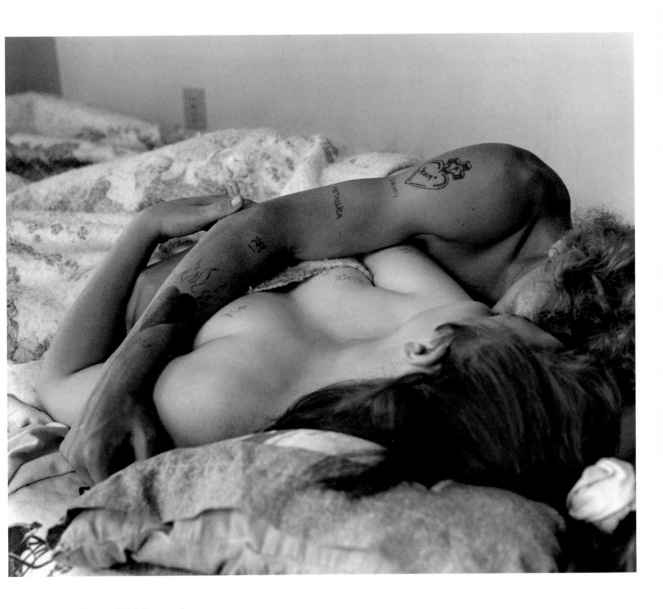

Portland, Maine, 1996

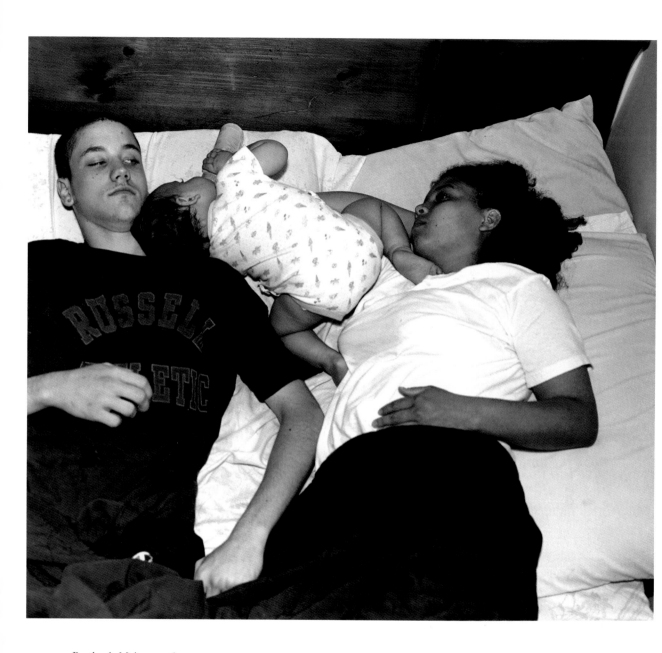

Portland, Maine, 1996

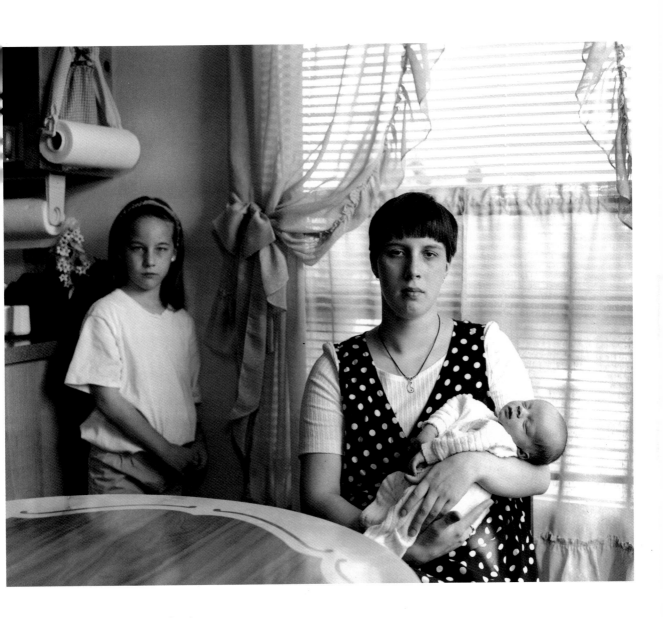

Bridgewater, Nova Scotia, 1995

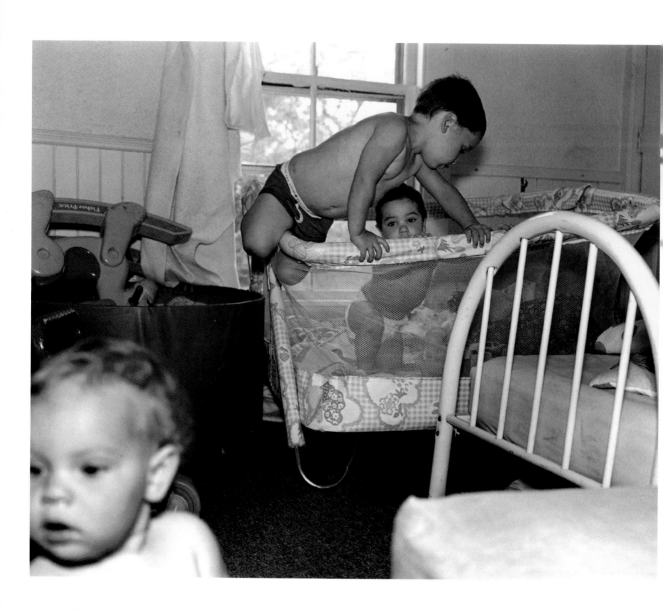

Portland, Maine, 1996

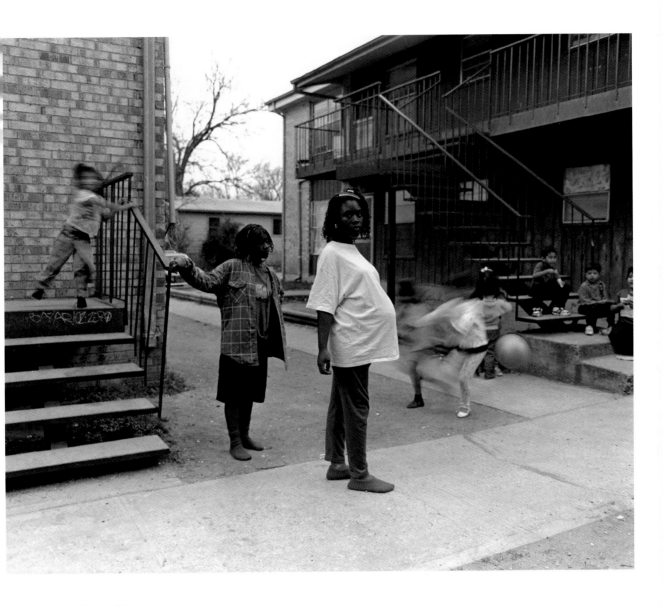

Austin, Texas, 1993

Portland, Maine, 1995

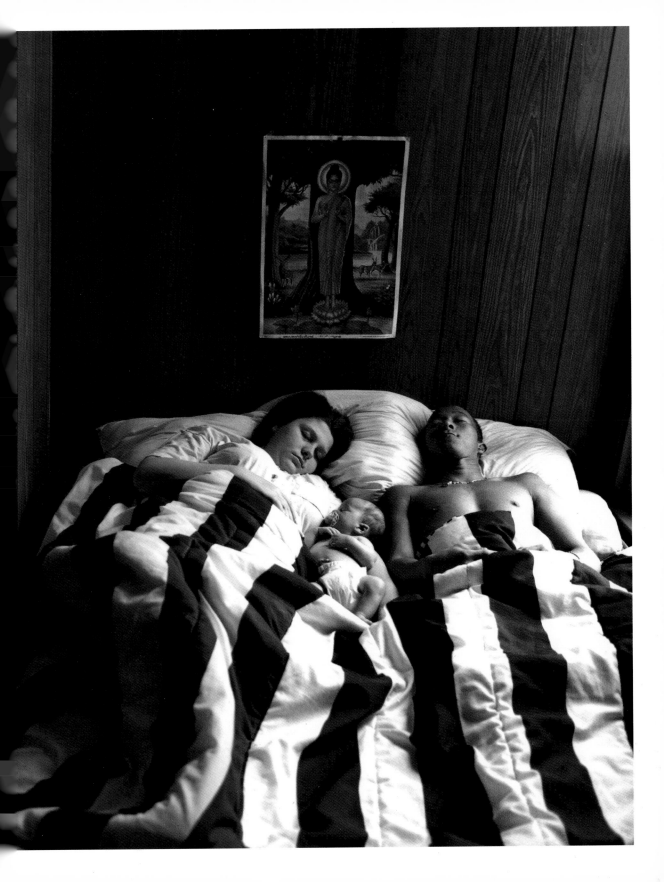

# Photographs by John Moses

Since 1986, I have been working as a doctor and a photographer in the Piedmont of North Carolina. In the clinic where I work as a general pediatrician, I help care for teenagers, not a few of whom become parents at an early age. In working with these teens and their children as patients, I've heard many informative stories and witnessed the telling gestures and phrases and silences that constitute important clues to a patient's condition. But the atmosphere of the clinic, like that of most hospitals and doctors' offices, can limit how much a teenager (or patient of any age) is inclined to reveal. And so, in an effort to better understand teenage pregnancy, I decided to visit teenage parents in their homes and neighborhoods and schools.

One or two afternoons a week, I left behind my familiar professional world. With the help of nursing and social work colleagues, I made contact with twenty-five adolescents in the city of Durham and surrounding rural counties. In a sense I became a doctor making a kind of home visit, though my diagnostic tools were exchanged for the camera. Along the way, the tables were turned. I was out of my element, on others' turf, on others' terms. I soon began to fill in gaps in my education.

When I first went out to photograph, I was filled with a mixture of curiosity and hesitation and confusion. Just what was I looking for? I wasn't

sure. I now realize this state of mind may have worked to my advantage. No longer the confident, all-knowing doctor, I became unwittingly open to new possibilities, new ways of looking at and thinking about the issue of adolescent pregnancy.

I introduced myself as a doctor who wanted to learn directly from others what it was like to be a parent at a young age. I explained that I had read medical articles and newspaper stories about teenage pregnancy but sensed there was more to discover—and I thought that photographs might be a useful way to show what things were like. Those I sought to photograph welcomed me with little hesitation. I was, after all, a rather unexpected and novel guest.

I visited most homes several times, often returning with photographs I had taken previously. At first I was concerned with how the teenagers and their families would respond to certain images (those that were too "serious" or stark), but invariably they regarded my work with intense interest; these photos were apparently quite unlike any that had been taken of them before! In some cases a kind of visual dialogue emerged as the teens showed me their own snapshots and portraits. As it turned out, we were often interested in each other's photographic point of view. I left behind dozens of prints in the homes I visited; I returned to one home to find two photographs I had taken, now framed and on display.

Each home I visited held some visual appeal. One rural home I was especially drawn to appeared somewhat disheveled from the outside. It was a work in progress, having been assembled largely with scrap materials. It housed four generations. The inside was comfortable and fascinating to behold. One wall of the living room was formed by a mural of Jesus and the children, salvaged from a local church that had been torn down. There was a garden out back. At the end of most visits, the grandmother of the teens I was photographing would appear with a gift of tomatoes or greens.

On the one hand I found what I thought I was looking for: poor, rel-

atively "uneducated," unrestrained, undisciplined, "sexually active" "children having children." The tragedy, the social dysfunction of it all, was there before me to record for others to see.

On the other hand, I found the views and notions I brought along on my visits were often confounded, challenged, even derailed by what I saw and heard and felt. I observed some teenage parents to be more capable and devoted to their children than I had anticipated. I found myself wondering if in some situations the birth of a child was not a kind of stabilizing influence on a family, a kind of adaptive response to a life otherwise chaotic or destructive or worse. And not surprisingly, I had a chance to reflect on my own life: Why was I, a "secure," "responsible," adult "professional" rather wary of parenthood? More than once, I felt I was being visited *upon* by those whose lives I sought to enter into and record.

Though I was primarily concerned with making photographs, my hosts frequently reminded me that I was a doctor. They often had questions and concerns about their children. Could I help? Before long I had tucked a prescription pad in my camera bag. I was eager to help when I could, to offer a bit of advice as thanks for being welcomed.

The teenagers I photographed taught me a lot, even as many of them struggled with serious challenges in their own lives. Having gone out to meet with them in their world, I came away with no neat formulations about teenage pregnancy but rather a richer, more accurate context in which to see them, and I hope, better understand their experience.

I want to thank the Lyndhurst Foundation for its generous support, which made my work possible. I'm especially grateful to Alex Harris and Robert Coles, who have provided essential help, instruction, and encouragement for many years. It has been a privilege to work with the staff of the Center for Documentary Studies at Duke University. Betty Compton and John Hughes, who work extensively with adolescents, kindly introduced me to many of the teens I photographed. My colleagues at Duke

University Medical Center, in particular Thomas Frothingham, Peter English, Deborah Squire, and Dennis Clements, have given me unusual support and a home base from which to operate. Special thanks go to my family and friends, who have provided nurturing and advice. Finally, I want to acknowledge the teenagers who allowed me to photograph them, to whom this book is dedicated.

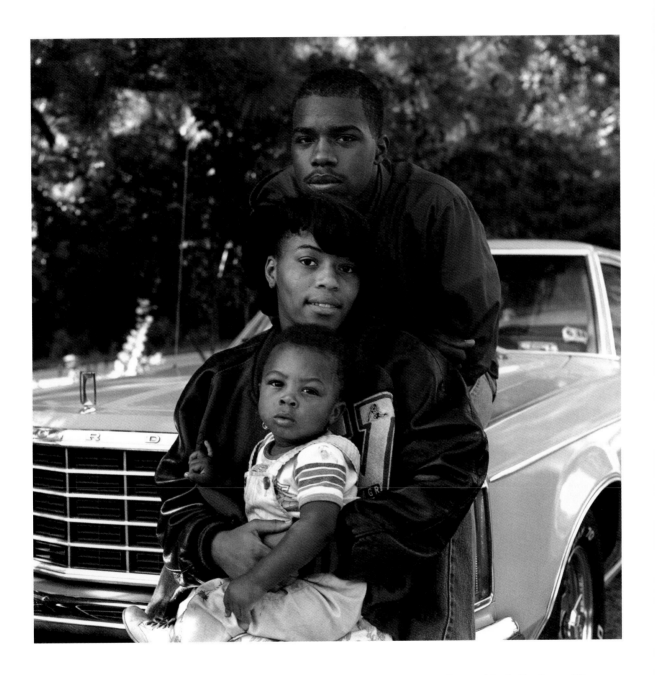

Vance County, North Carolina, 1988

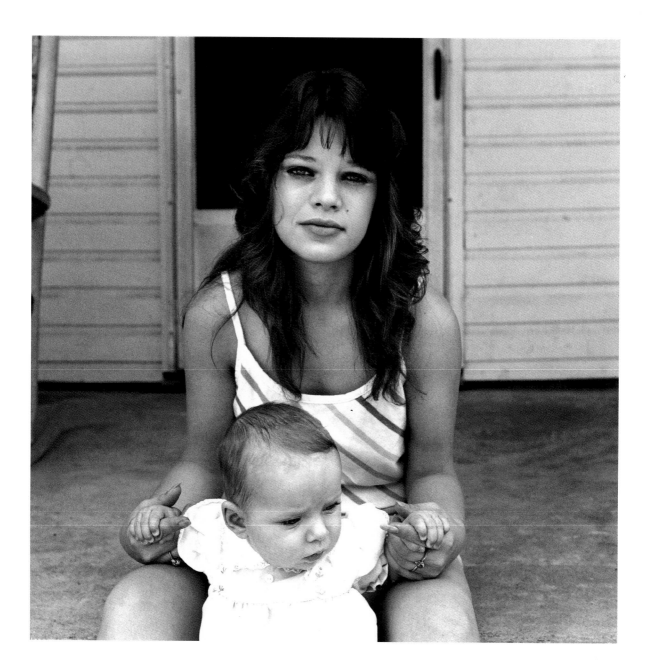

Durham, North Carolina, 1987

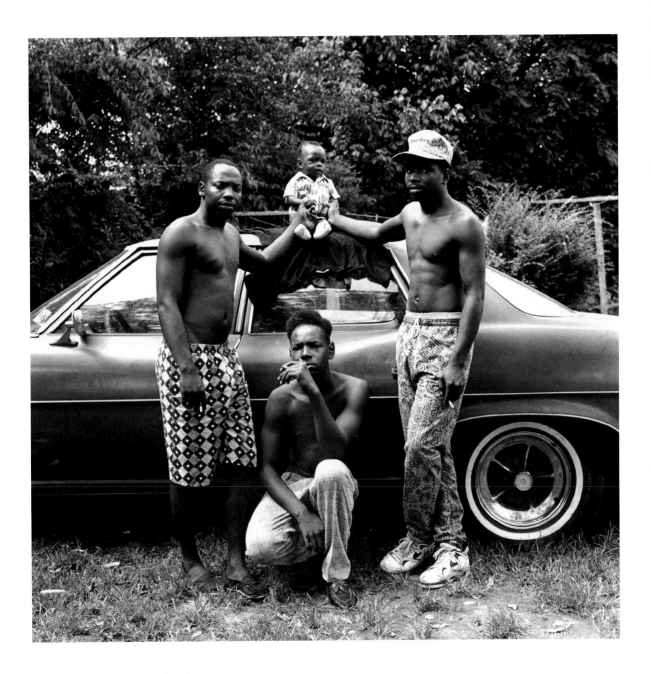

Henderson, North Carolina, 1990

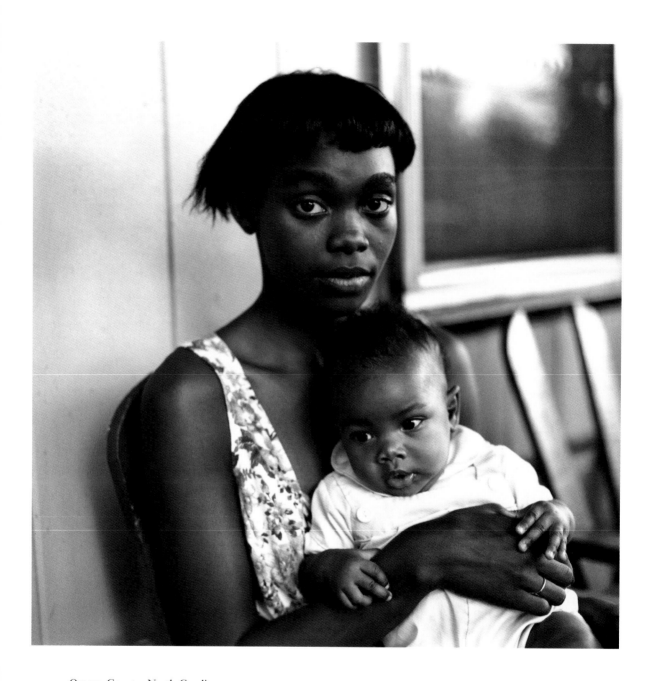

Orange County, North Carolina, 1994

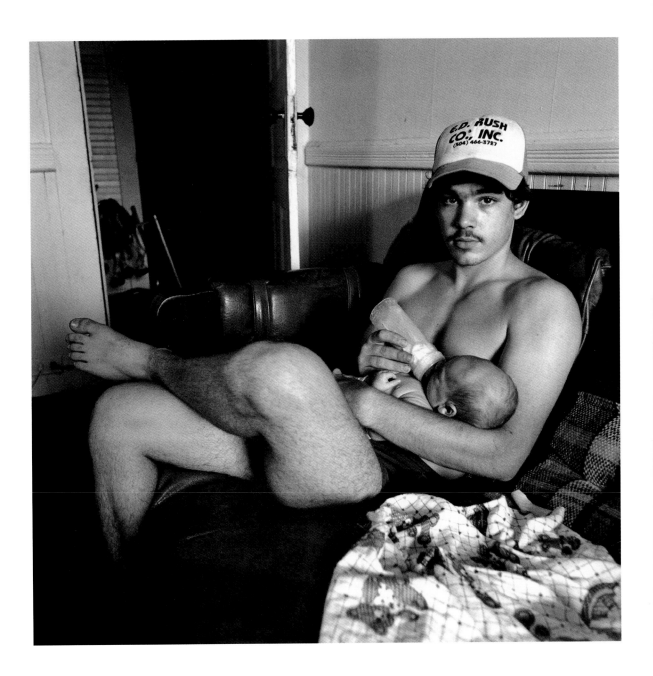

Henderson, North Carolina, 1989

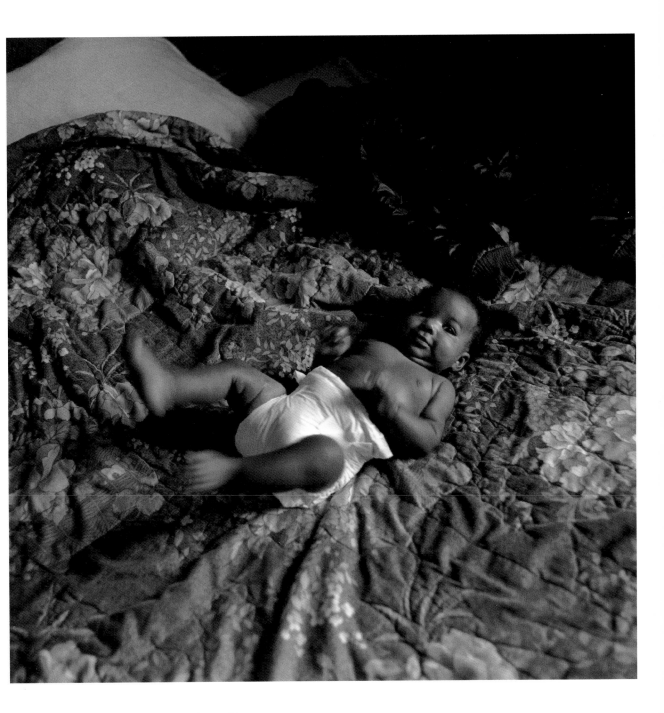

Henderson, North Carolina, 1986

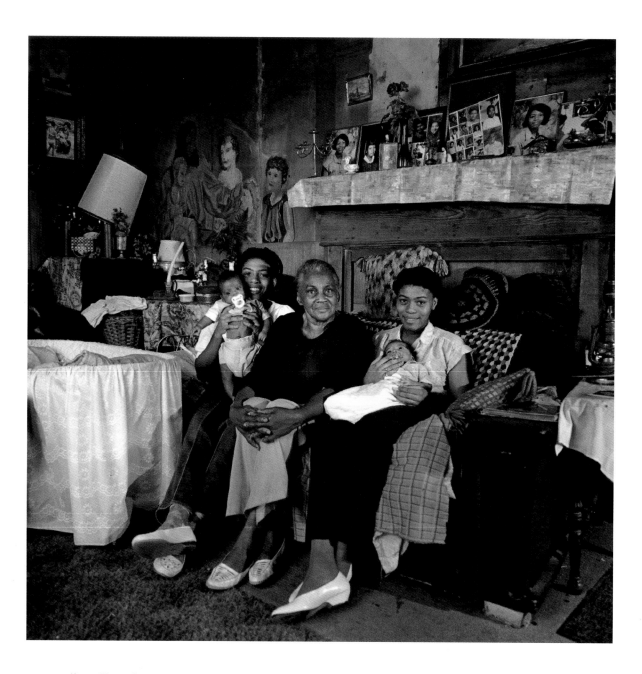

*Above:* Vance County, North Carolina, 1986  *Opposite:* Orange County, North Carolina, 1989

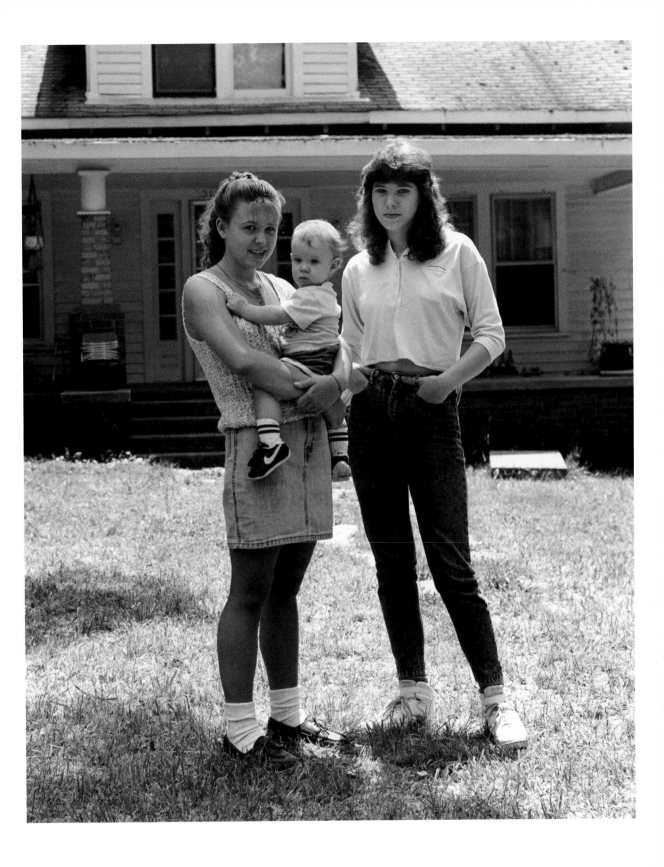

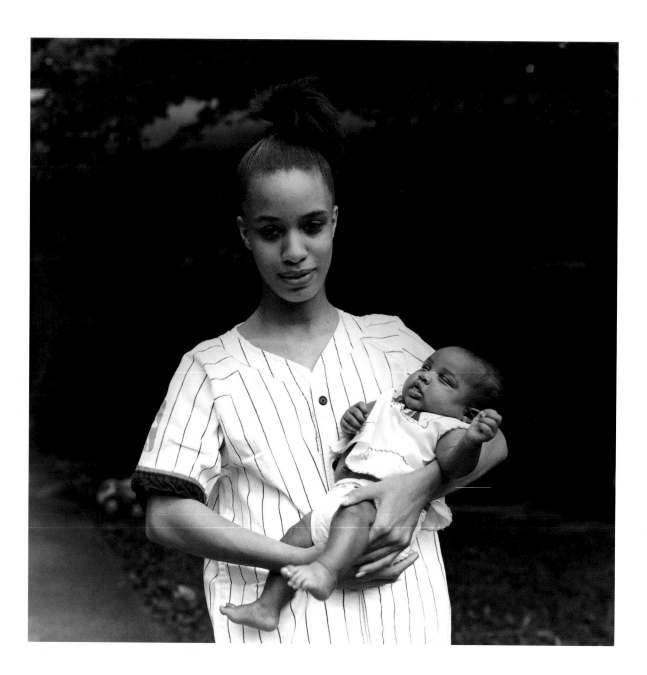

Orange County, North Carolina, 1994

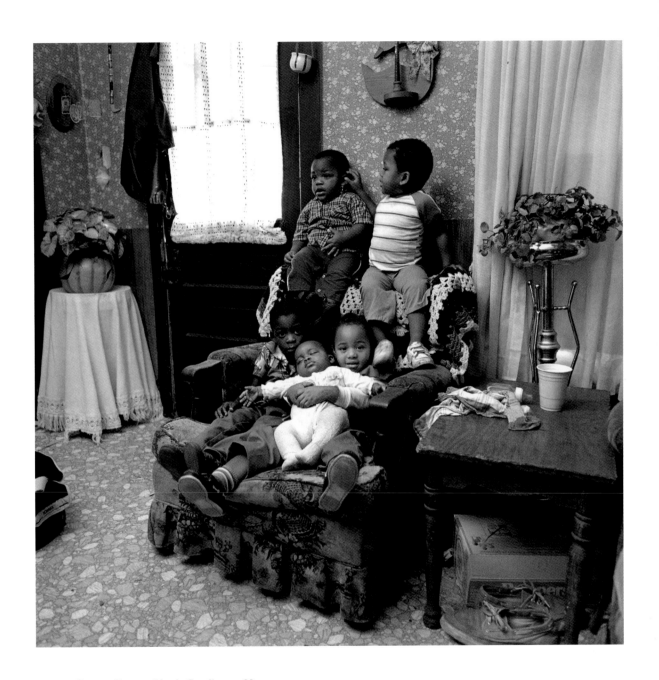

Orange County, North Carolina, 1988

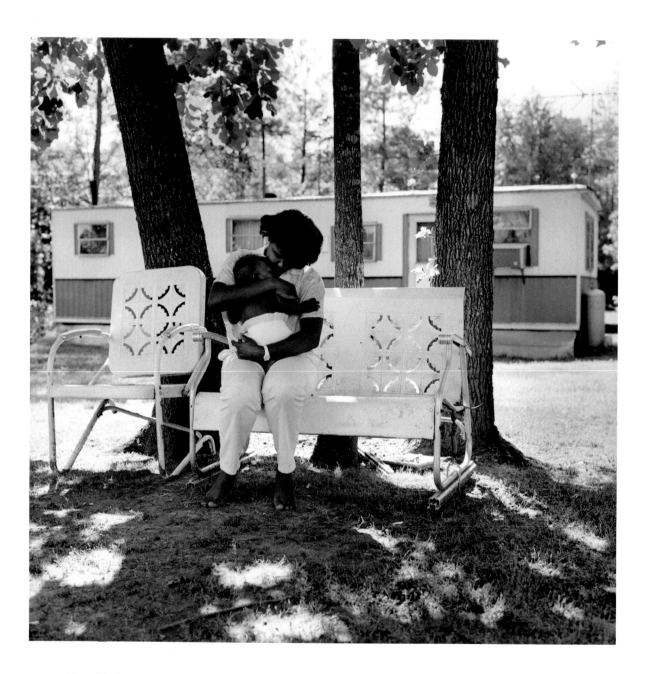

Granville County, North Carolina, 1987

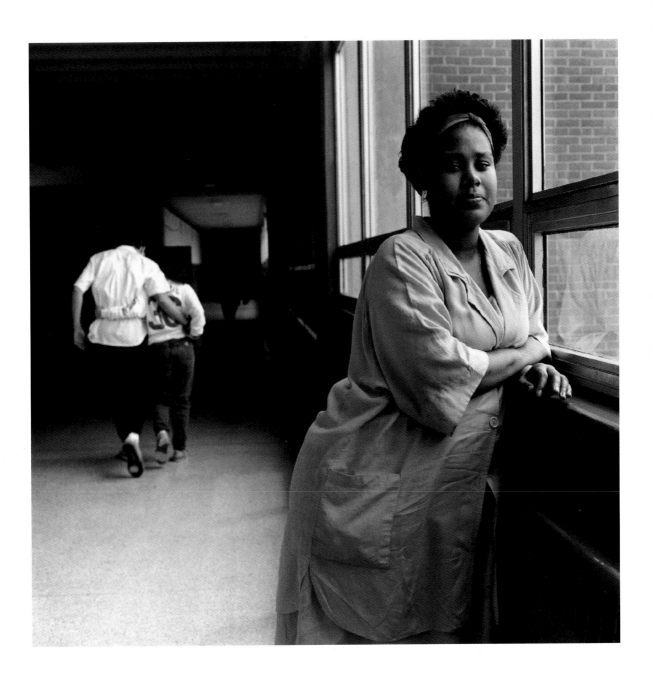

Orange County, North Carolina, 1989

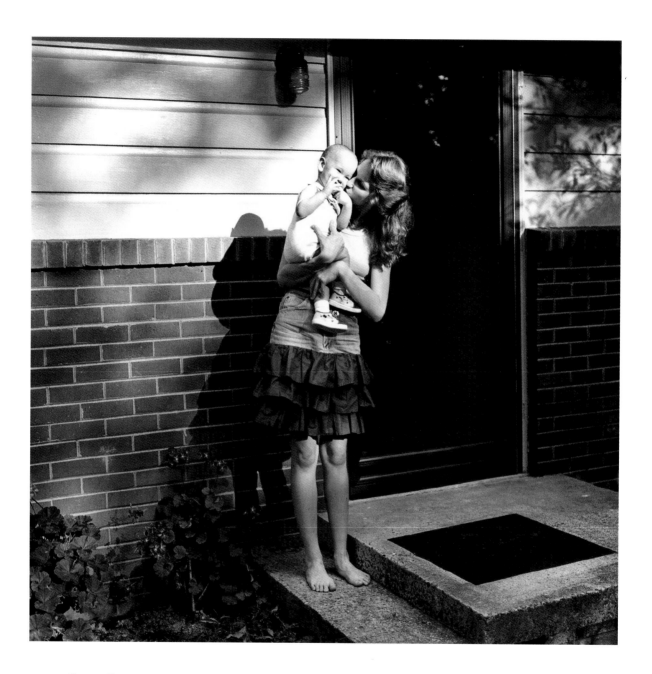

Orange County, North Carolina, 1989

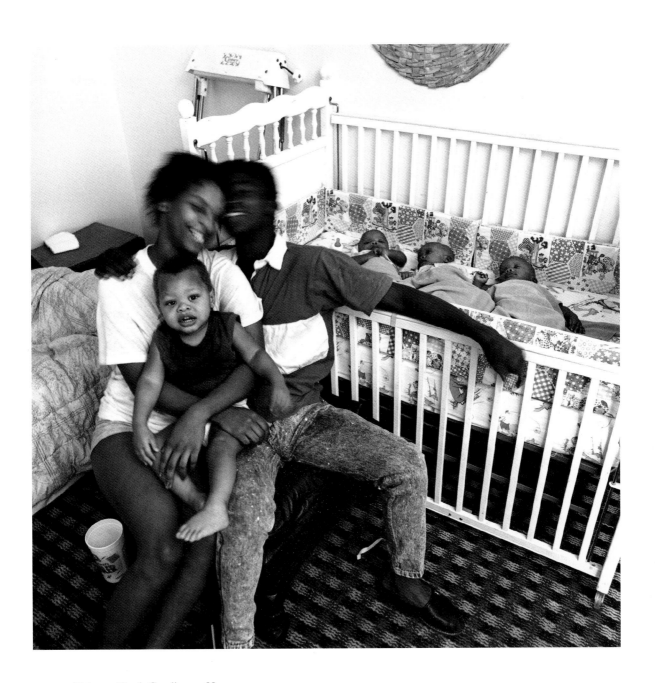

Mebane, North Carolina, 1988

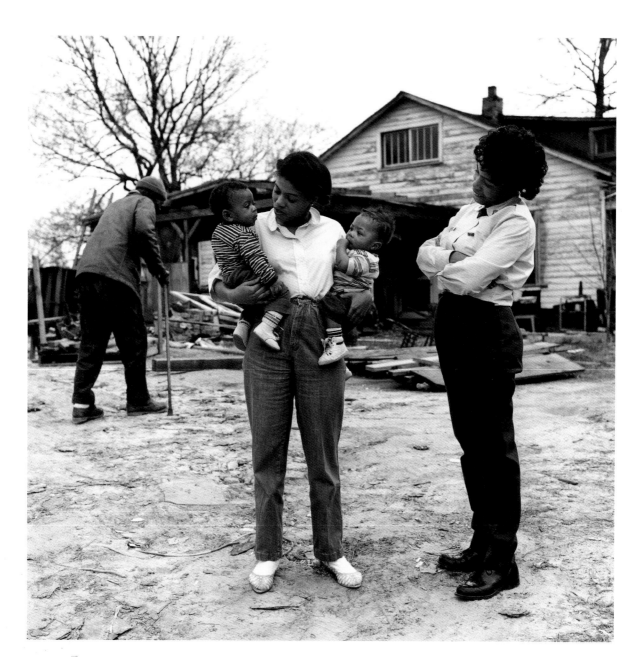

Vance County, North Carolina, 1987

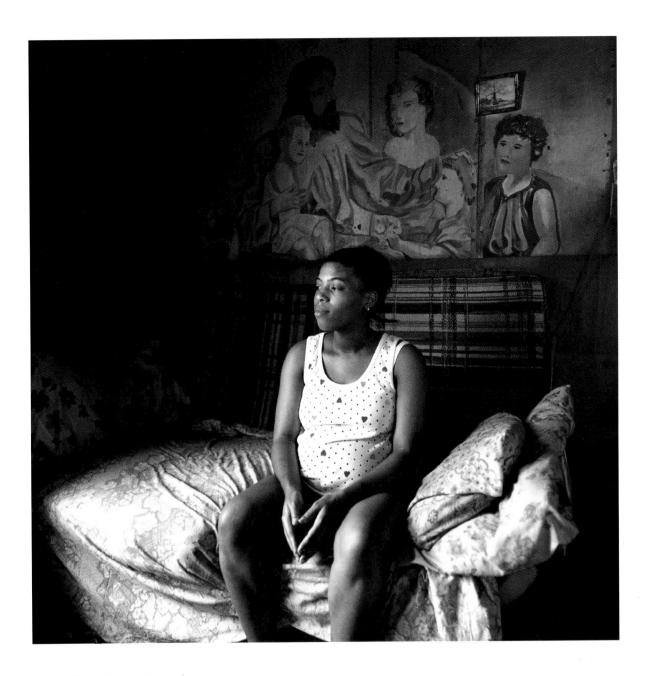

Vance County, North Carolina, 1989

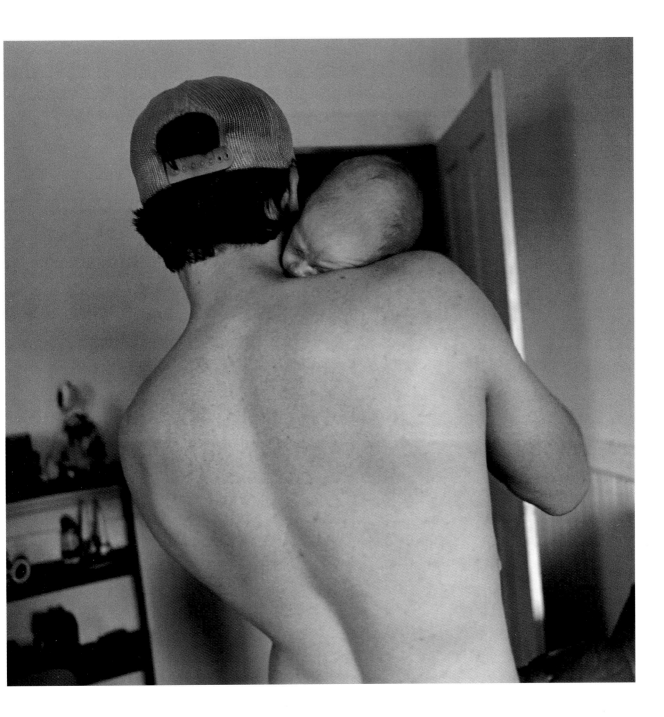

Henderson, North Carolina, 1989

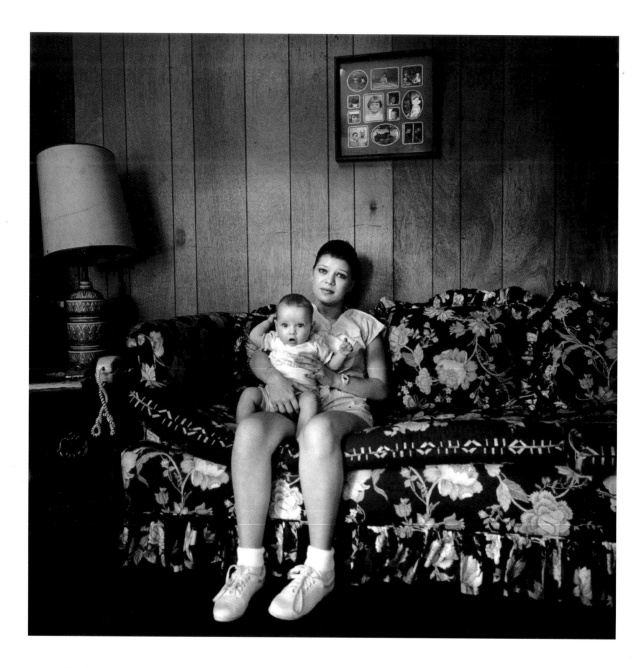

Durham, North Carolina, 1987

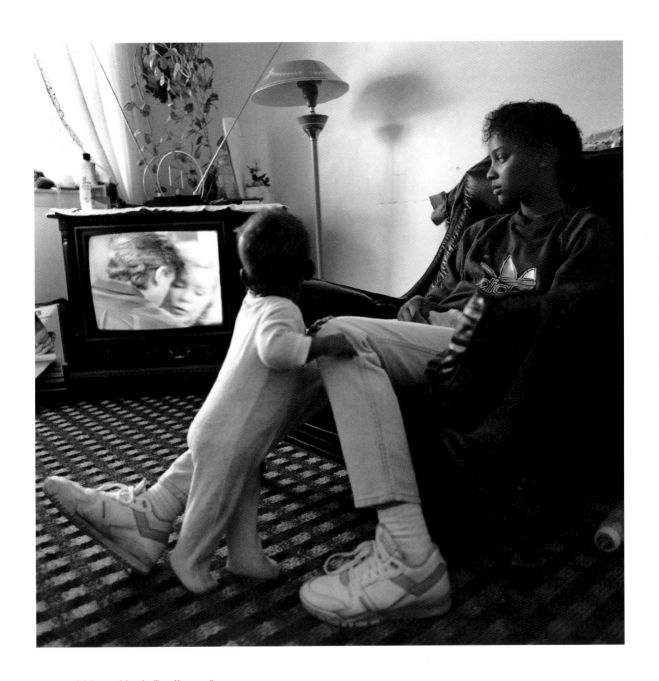

Mebane, North Carolina, 1989

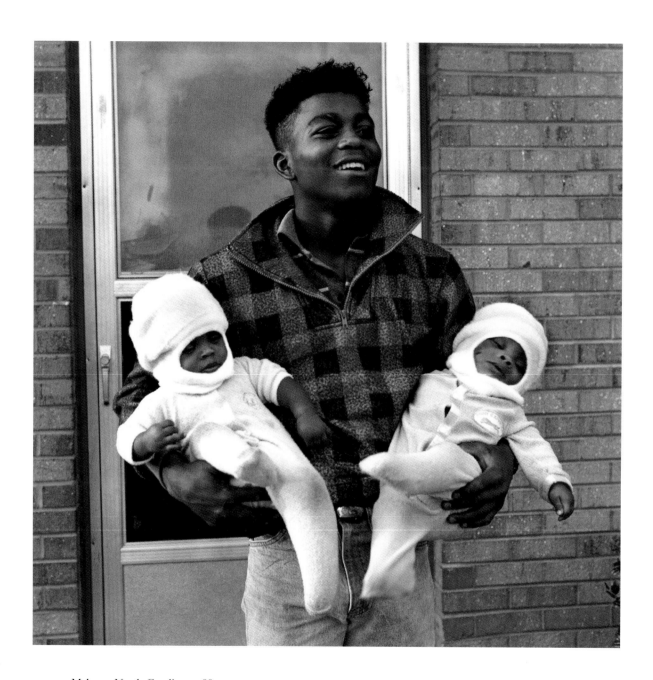

Mebane, North Carolina, 1988

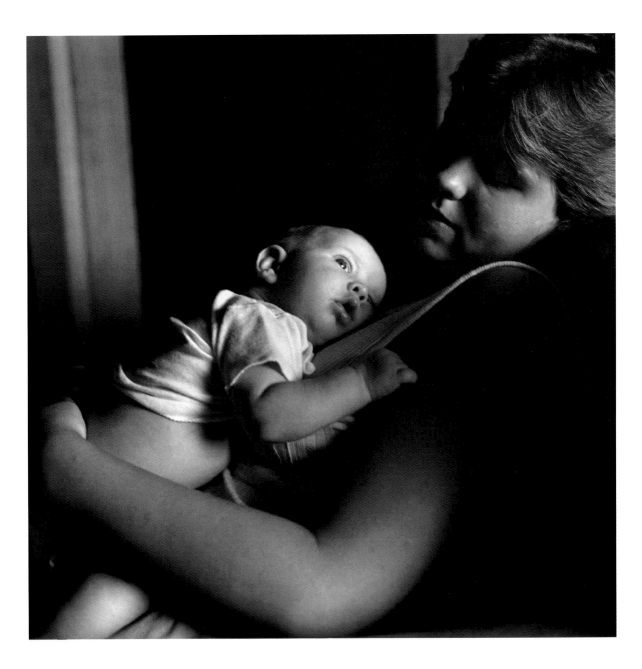

Hillsborough, North Carolina, 1988

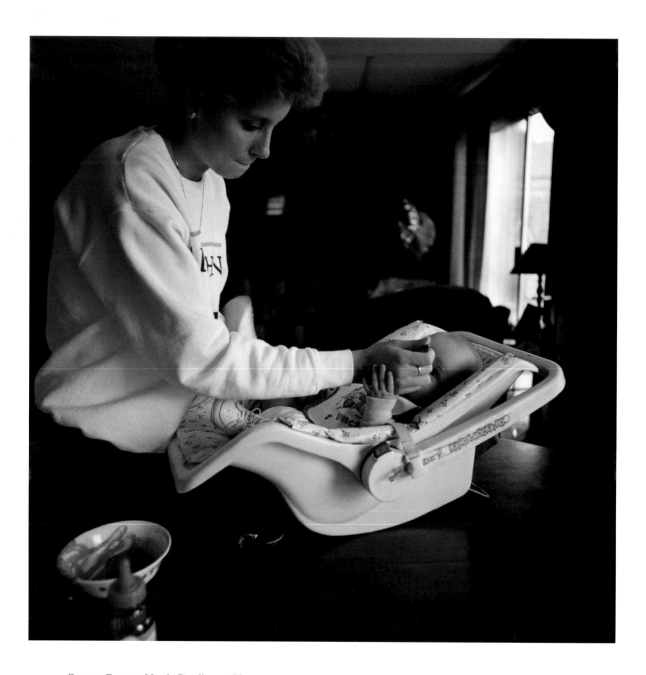

Orange County, North Carolina, 1988

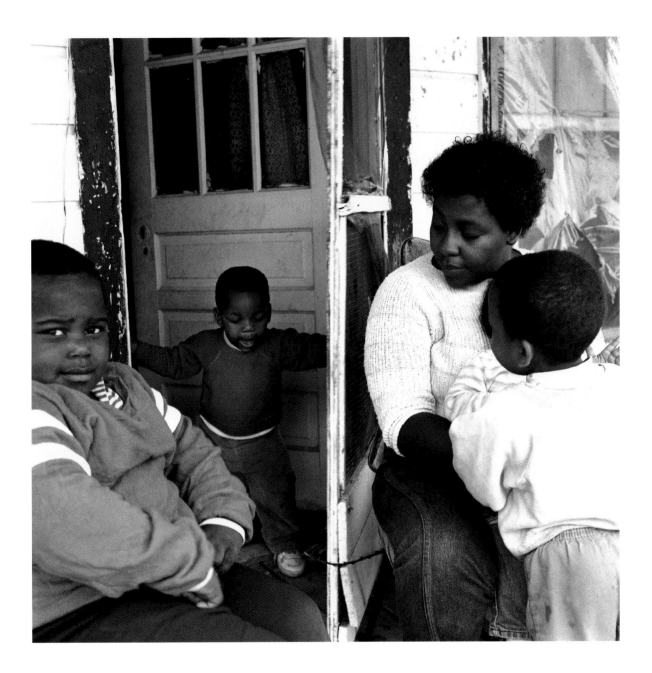

Orange County, North Carolina, 1988

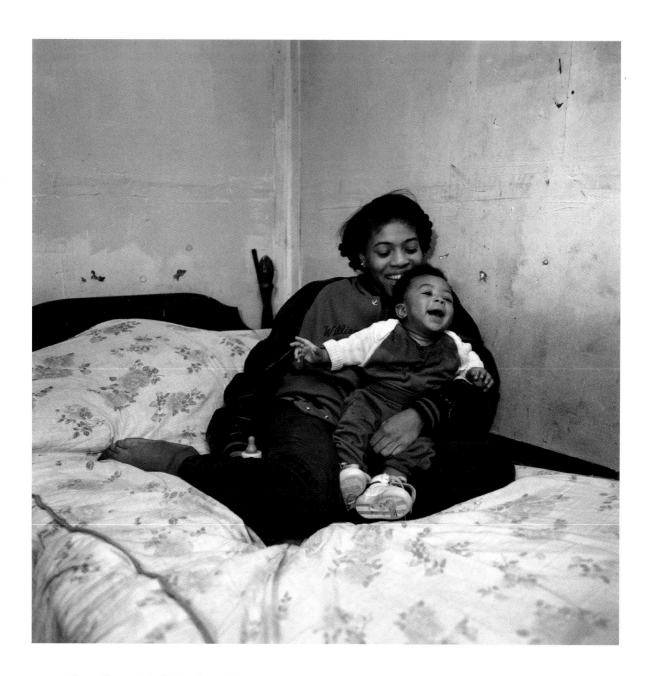

Vance County, North Carolina, 1988

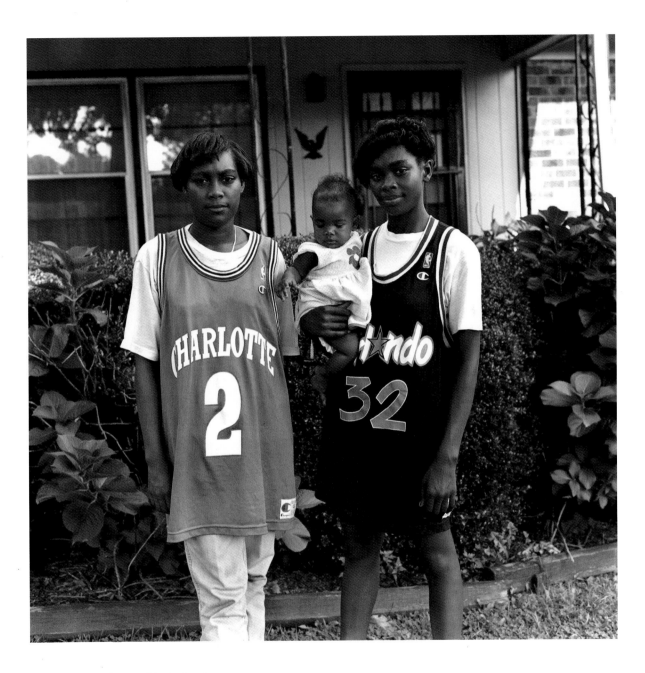

Orange County, North Carolina, 1994

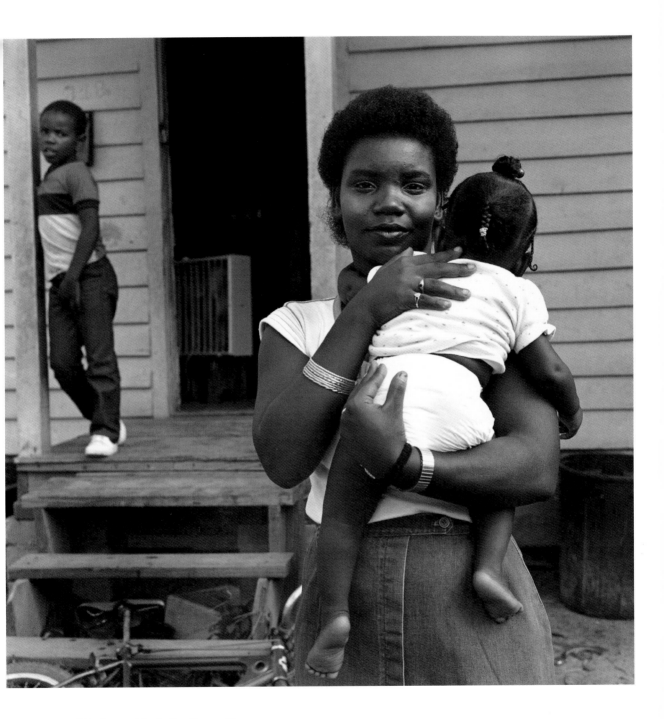

Henderson, North Carolina, 1986

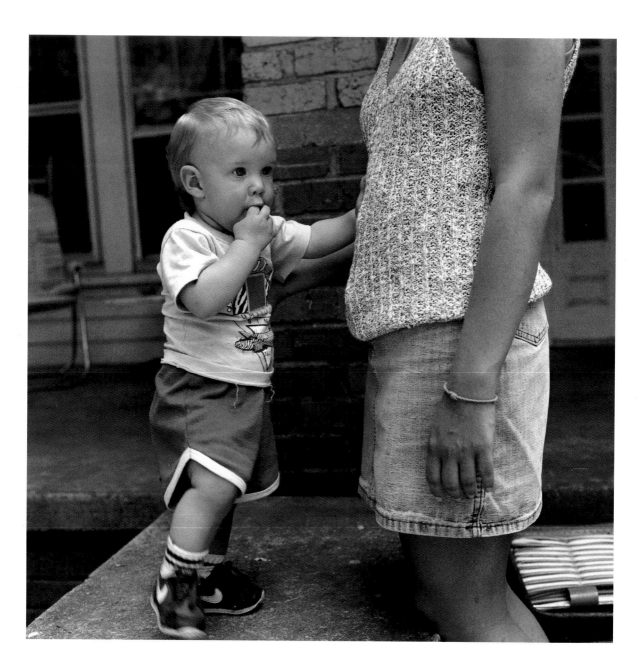

Orange County, North Carolina, 1989

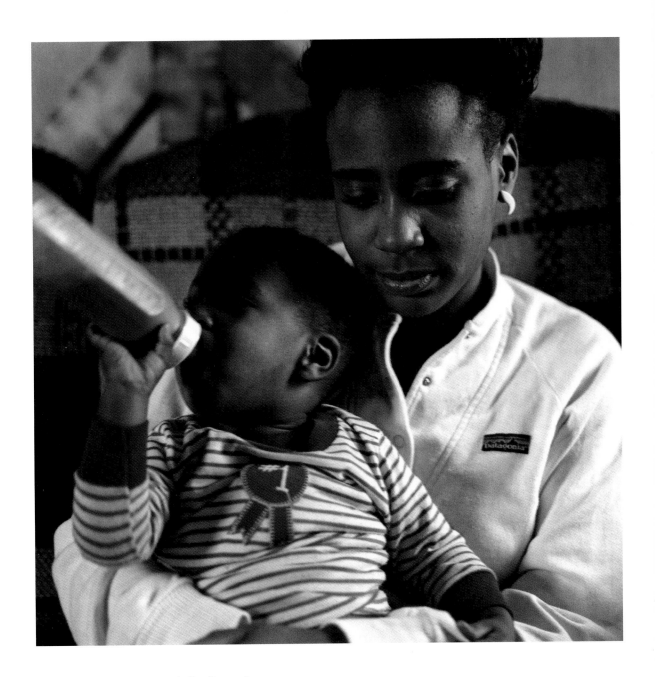

Orange County, North Carolina, 1987

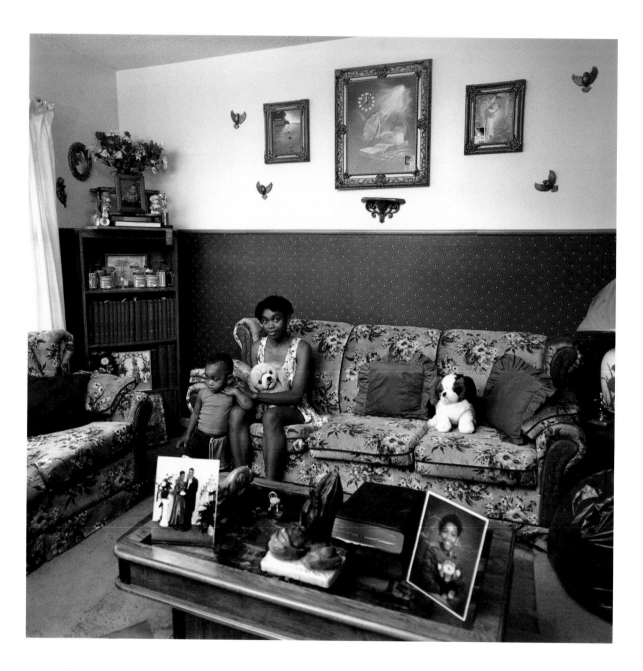

Orange County, North Carolina, 1994

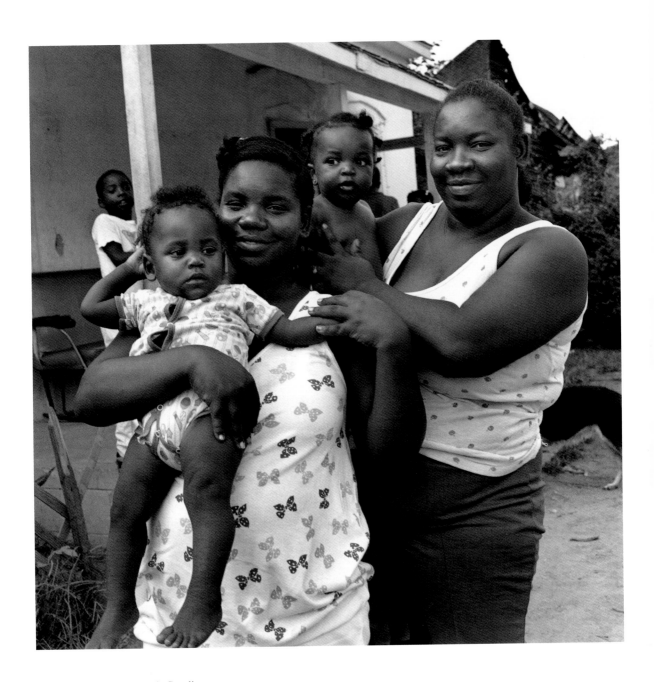

Henderson, North Carolina, 1990

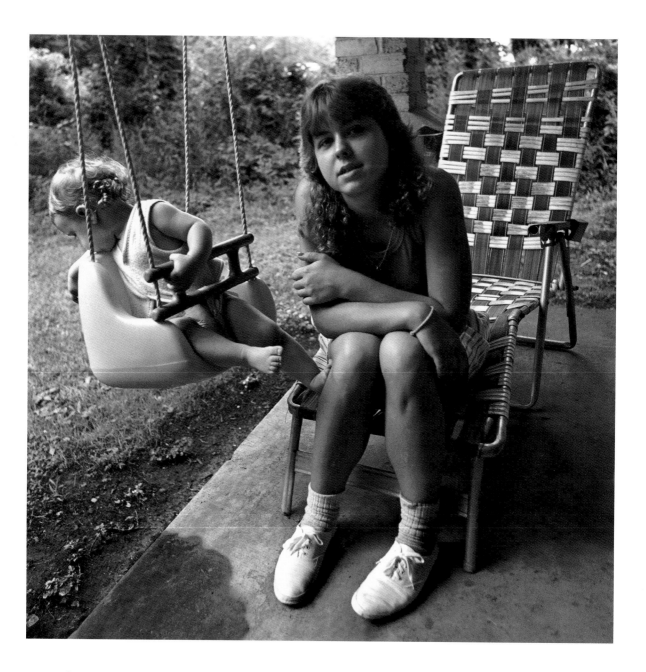

Orange County, North Carolina, 1989

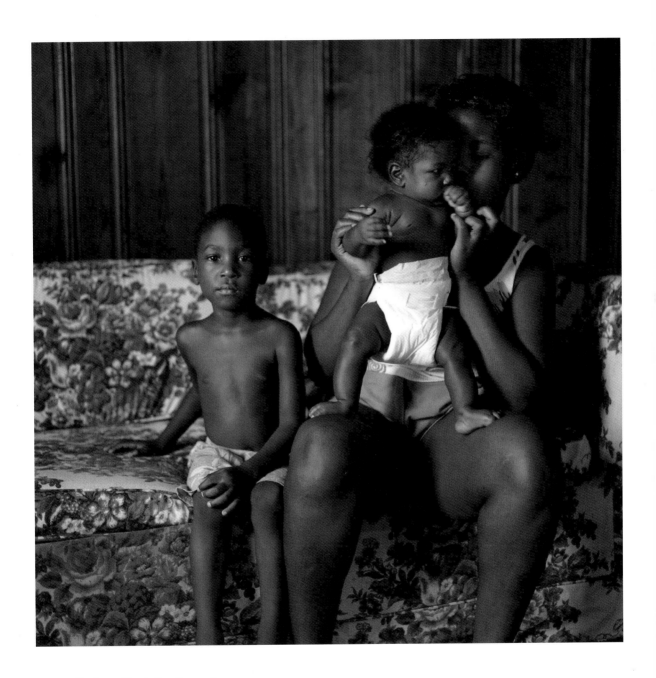

Durham, North Carolina, 1989

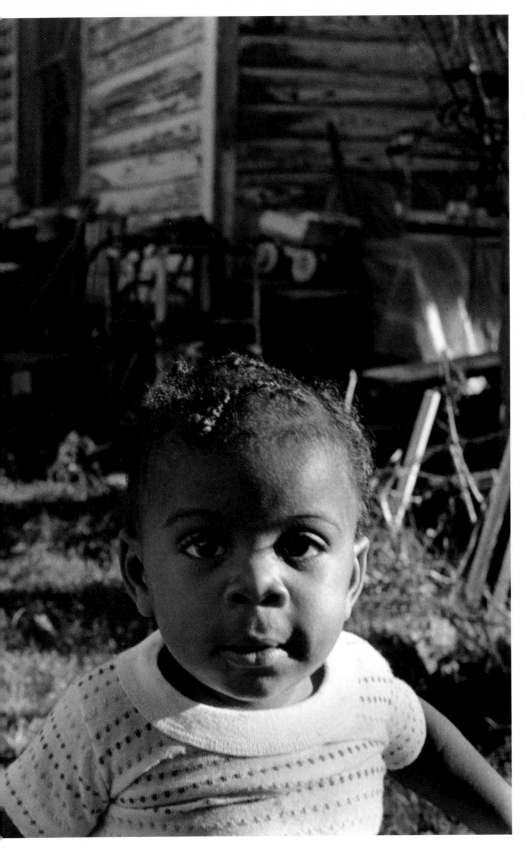